TAMARA de LEMPICKA

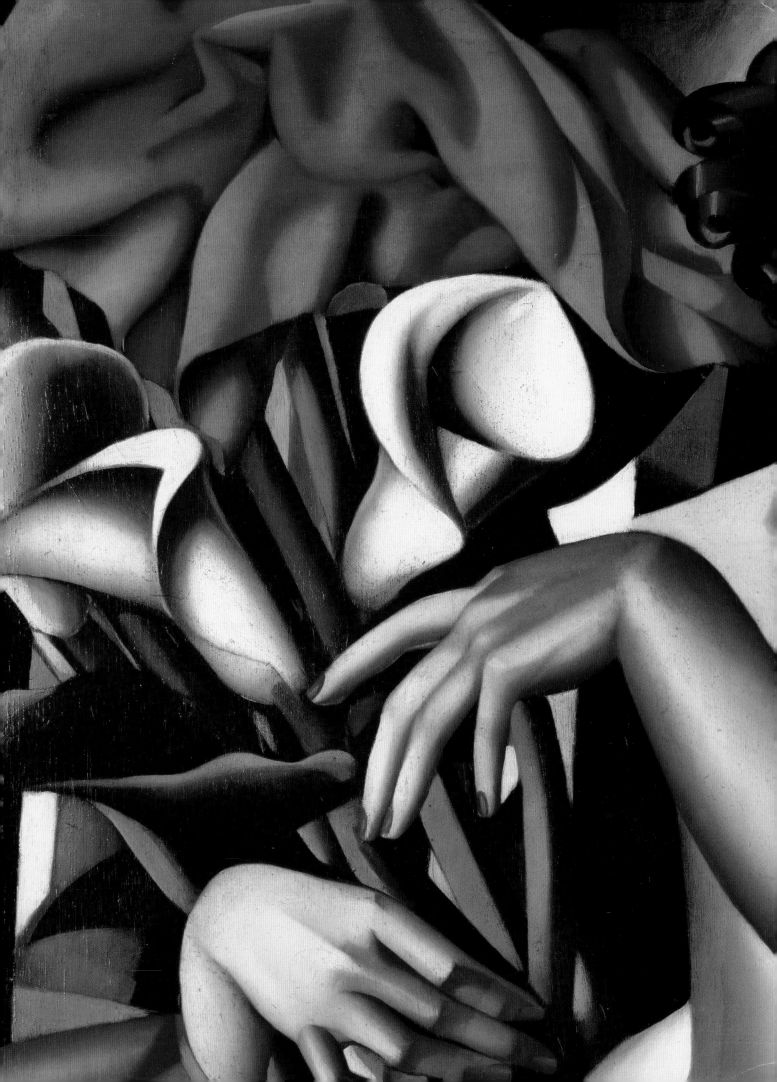

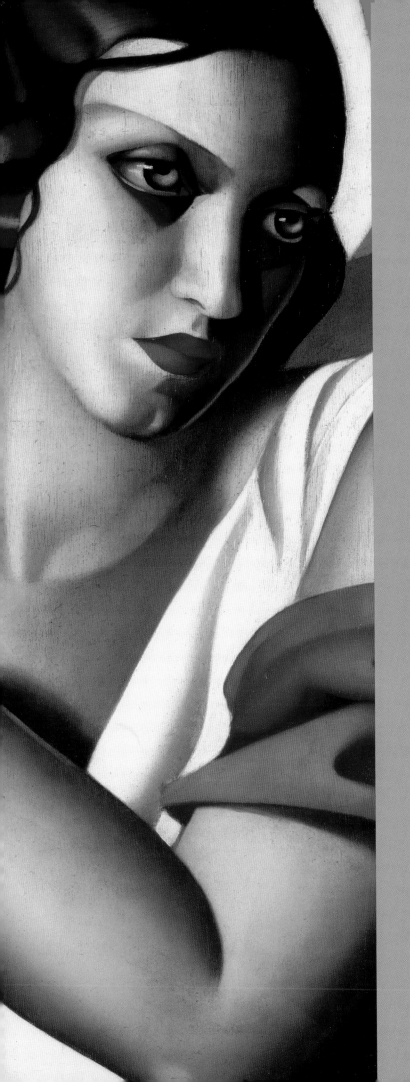

TAMARA de LEMPICKA

Art Deco Icon

Royal Academy of Arts

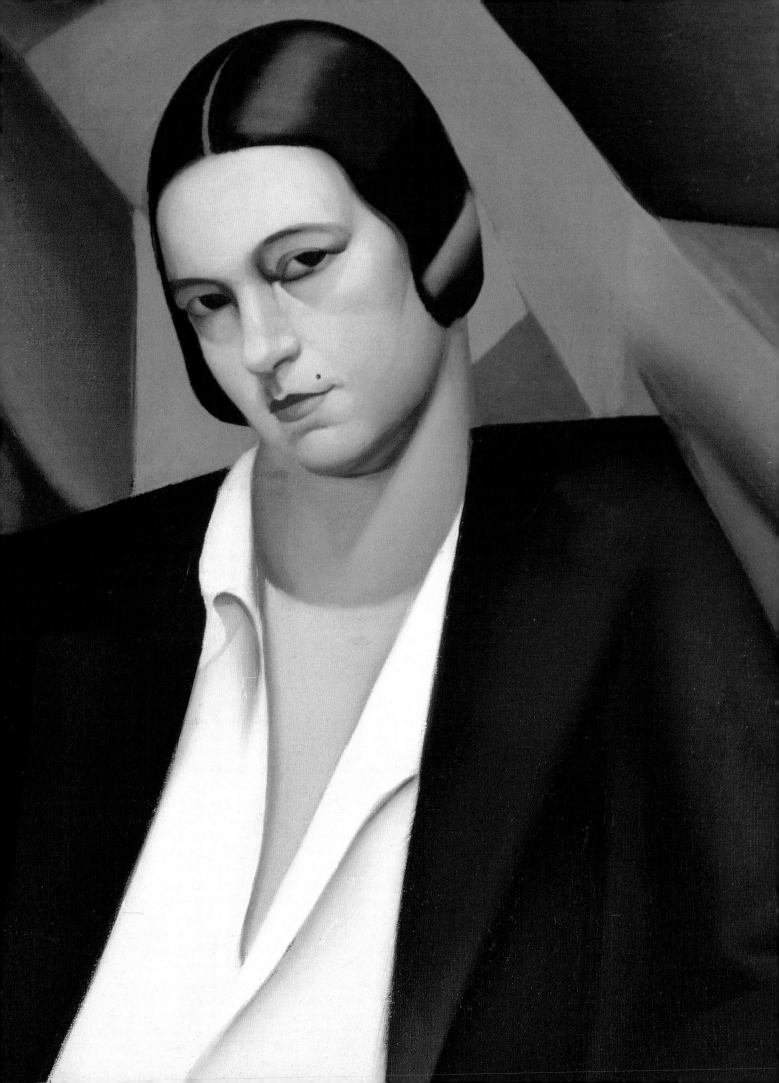

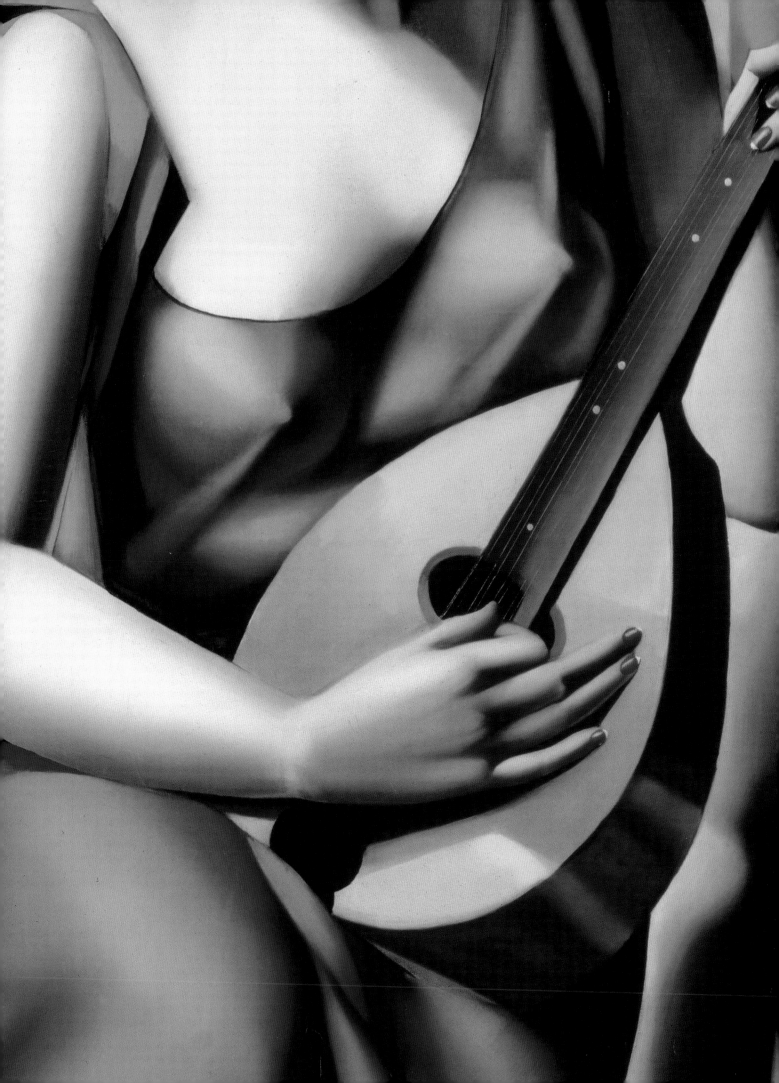

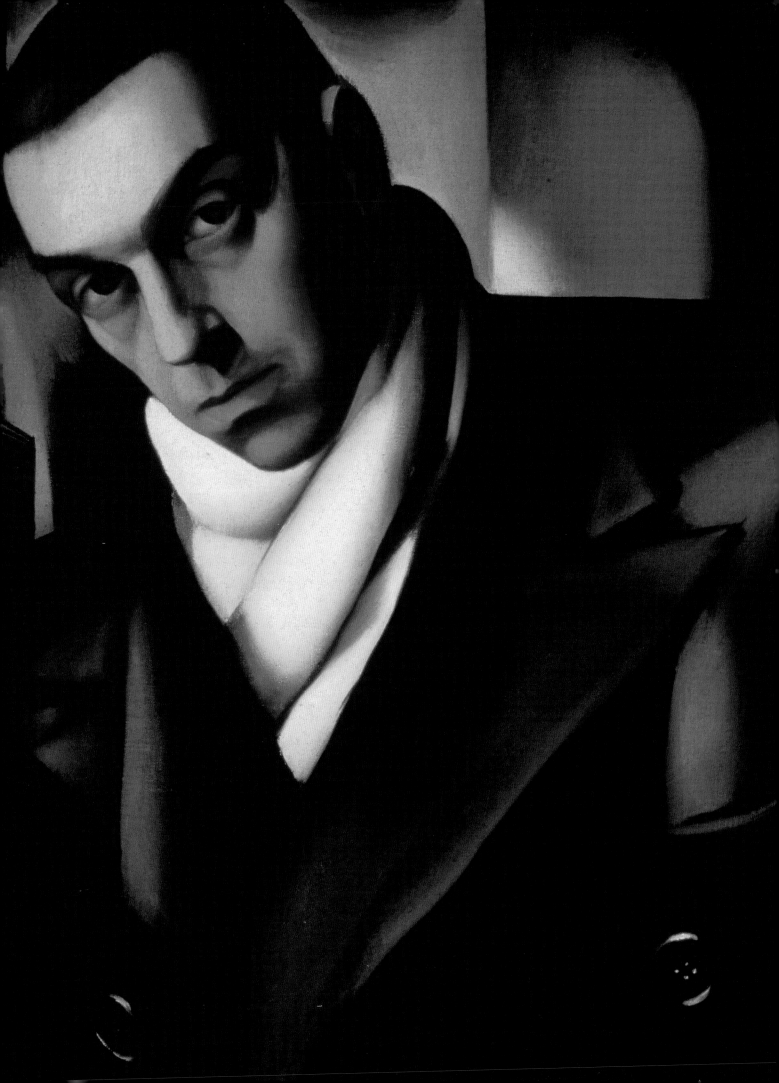

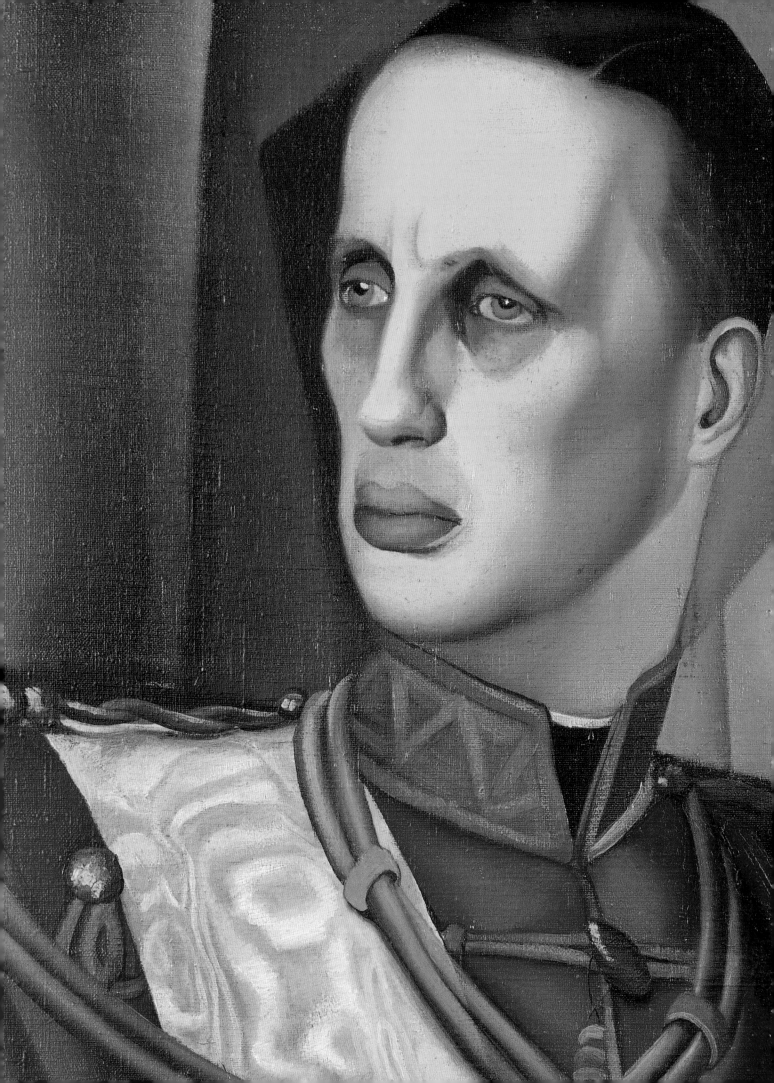

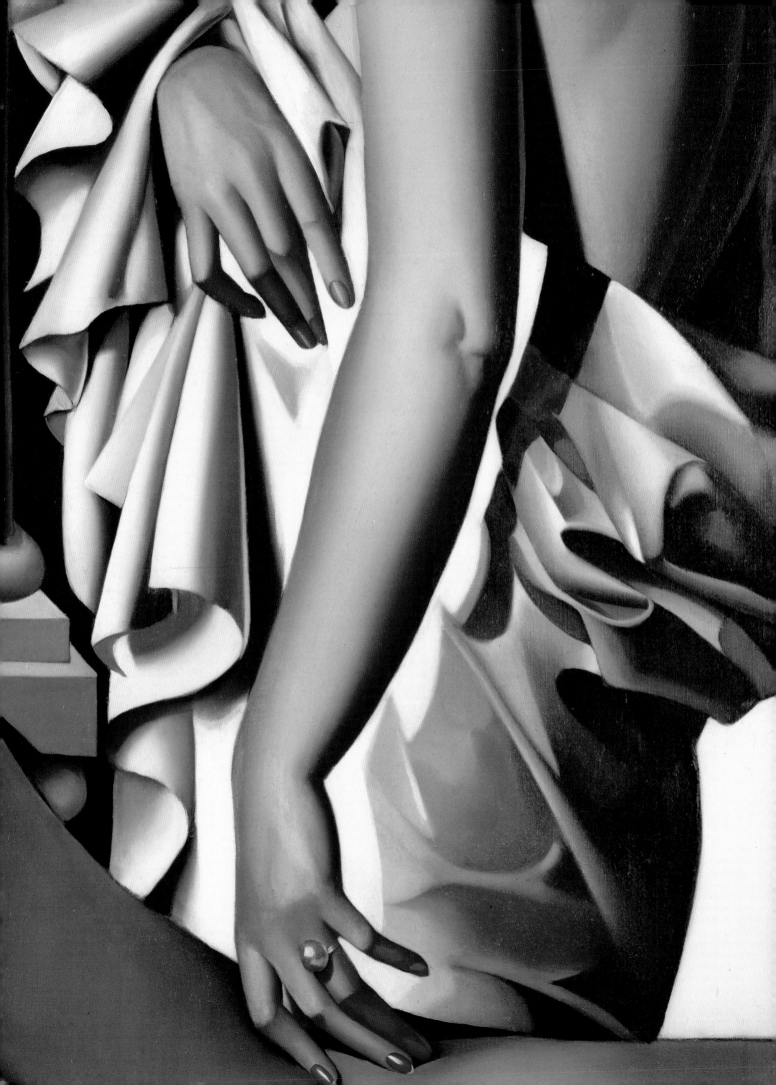

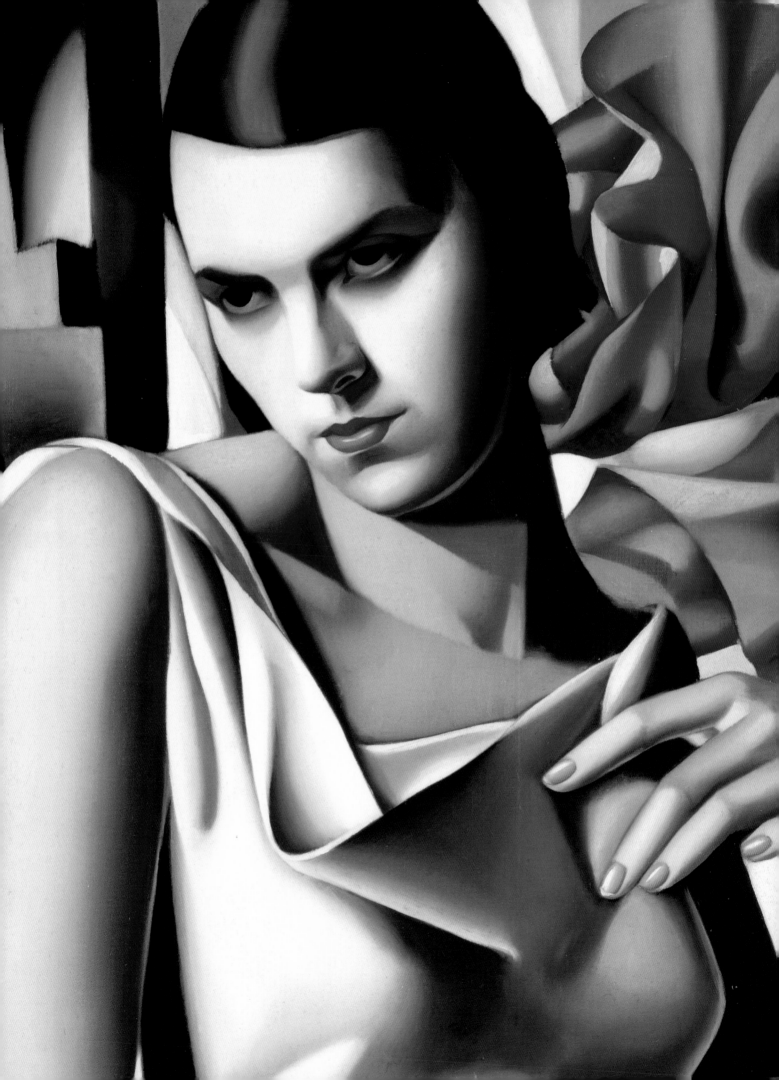

First published on the occasion
of the exhibition
**TAMARA de LEMPICKA:
ART DECO ICON**

Royal Academy of Arts, London
15 May – 13 August 2004

Kunstforum Wien, Vienna
15 September – 2 January 2005

This exhibition has been organised
by the Royal Academy of Arts, London,
and the Kunstforum Wien, Vienna

The Royal Academy of Arts is grateful
to Her Majesty's Government for agreeing
to indemnify this exhibition under the
National Heritage Act 1980, and to the
Museums, Libraries and Archives Council
for its help in arranging the indemnity.

Exhibition curators
Royal Academy of Arts, London
Simonetta Fraquelli
Norman Rosenthal

Kunstforum Wien, Vienna
Evelyn Benesch
Ingried Brugger

Exhibition organisation
Royal Academy of Arts, London
Lucy Hunt
Emeline Winston

Kunstforum Wien, Vienna
Angelika Scholz

**Photographic and copyright
co-ordination**
Roberta Stansfield

Catalogue
Royal Academy Publications
David Breuer
Harry Burden
Carola Krueger
Fiona McHardy
Peter Sawbridge
Nick Tite

Translation from the French
 (Alain Blondel): Caroline Beamish
Translation from the German
 (Ingried Brugger): Fiona Elliott
Design: 01.02
Colour origination: DawkinsColour
Printed in Italy by Graphicom

British Library Cataloguing-in-
Publication Data

A catalogue record for this book is
available from the British Library

ISBN 1-903973-43-0 (paperback)

ISBN 1-903973-42-2 (hardback)
Distributed outside the United States
 and Canada by Thames & Hudson Ltd,
 London
Distributed in the United States
 and Canada by Harry N. Abrams, Inc.,
 New York

Editorial note
Measurements are given in centimetres,
height before width.

'B' references in the List of Works
on p. 139 correspond to Alain Blondel's
*Tamara de Lempicka: Catalogue Raisonné
1921–1979* (Lausanne, 1999).

Illustrations
Pages 2–3: detail of cat. 37
Page 4: detail of cat. 17
Page 5: detail of cat. 31
Page 6: detail of cat. 28
Page 7: detail of cat. 18
Page 8: detail of cat. 47
Page 9: detail of cat. 48
Page 13: detail of cat. 27
Page 14: detail of cat. 38
Page 58–59: detail of cat. 6
Pages 128–29: detail of cat. 25

Contents

Foreword

Tamara de Lempicka: Art Deco Icon has been jointly organised by the Royal Academy of Arts and the Kunstforum Wien, in a collaboration that has brought the two institutions together for the first time.

The exhibition – the first dedicated to Tamara de Lempicka in either the United Kingdom or Austria – considers the work of an artist whose reputation has seen its fair share of vicissitudes. In the 1920s and early 1930s Tamara de Lempicka was the toast of Paris, and her striking society portraits and sensual nudes encapsulated the glamour of the French capital. Her works were highly sought after and her reputation seemed assured. However, after her move to the United States just before the Second World War, her career waned. By the time she was in her seventies, she had been all but forgotten by the exhibition-going public and the critics.

But then, in 1972, a critically acclaimed exhibition of her early work at the Galerie du Luxembourg in Paris, organised by the young Parisian dealer Alain Blondel, did much to restore her reputation. Today, artists such as De Lempicka, who cannot easily be categorised within the established artistic movements of the twentieth century, are being reconsidered by a younger generation of art historians and critics. De Lempicka is generally identified as the embodiment of the Art Deco style of Paris in the 1920s.

We hope that this exhibition, which reunites some of the artist's most important works of the 1920s and 1930s, will allow a public and critical reappraisal of De Lempicka's position and her iconic role within the development of early twentieth-century art. Over the last twenty years, art criticism has readdressed the issue of figuration and realism with renewed intensity, and artists such as Tamara de Lempicka, Frida Kahlo, Edward Hopper and Francis Picabia are winning a new, contemporary status in art history.

The Royal Academy and the Kunstforum Wien are delighted to have worked together on this landmark exhibition. They would like to extend their particular thanks to those museums and private collectors who have generously agreed to lend their treasured works. We are most grateful also to Alain Blondel and Barry Friedman, who have both been instrumental in locating a number of De Lempicka's most significant works. Erika Brandt of the Friedman Gallery in New York has been resourceful and tireless in her assistance.

The idea for this exhibition was first discussed by Ingried Brugger, Director of the Kunstforum Wien and co-signatory of this foreword, and Norman Rosenthal, the Royal Academy's Exhibitions Secretary. We would like to thank all the staff of our two institutions, in particular the curators, Evelyn Benesch and Simonetta Fraquelli, who have collaborated most successfully; the exhibition organisers Lucy Hunt and Angelika Scholz; and the photographic co-ordinator Roberta Stansfield.

Dr Ingried Brugger
Director, Kunstforum Wien

Professor Phillip King CBE
President, Royal Academy of Arts

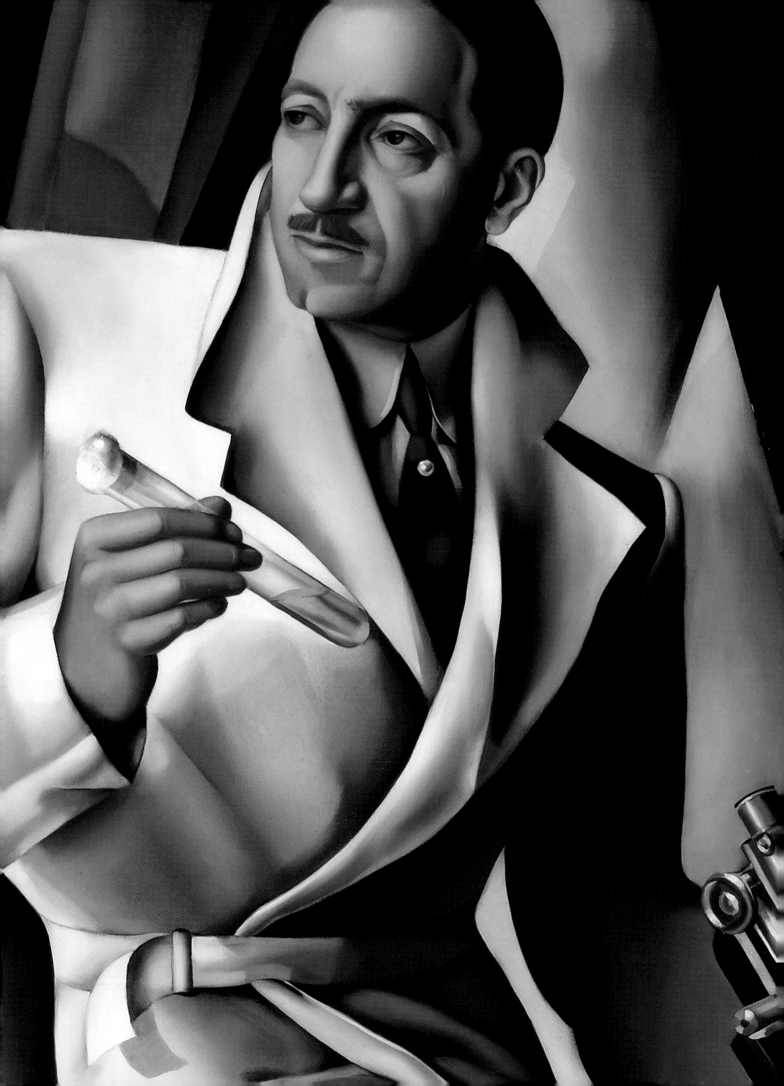

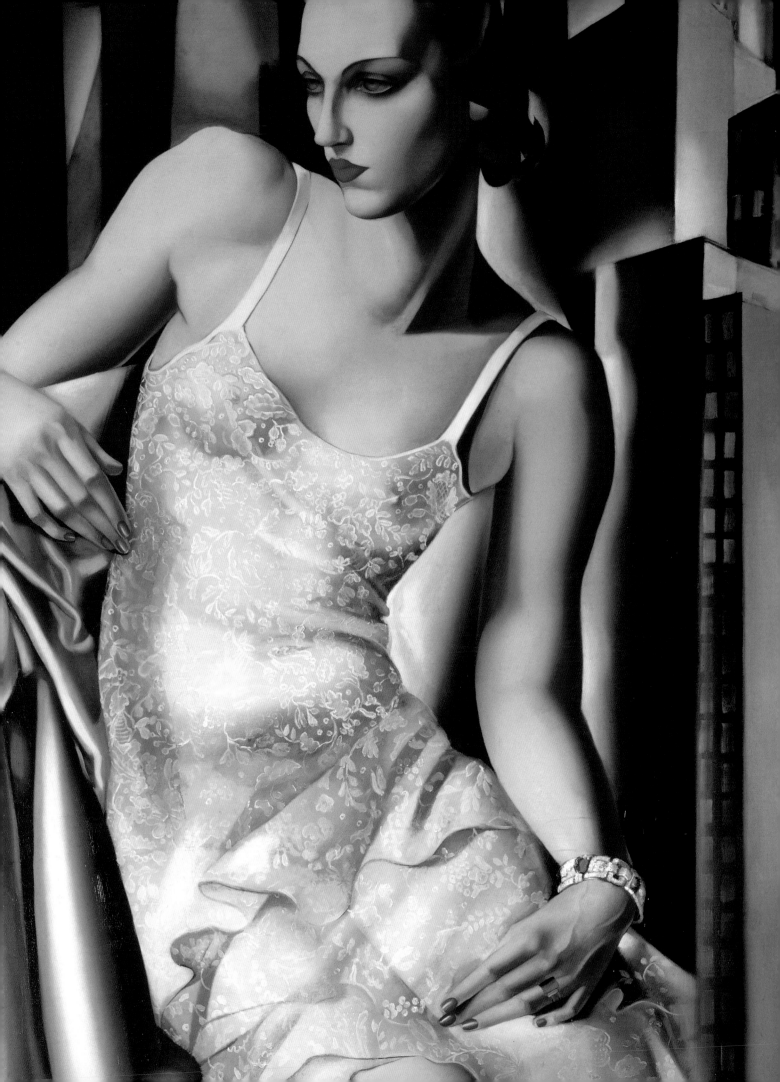

Acknowledgements

The curators and organisers extend their particular thanks to all the lenders who have so generously agreed to part with their works for a long period of time.

We owe a special debt of gratitude to Alain Blondel and Barry Friedman for their tireless efforts in helping us to locate several of De Lempicka's most important works that are now in private collections. The efficiency and ceaseless enthusiasm of Erika Brandt at the Barry Friedman Gallery have been essential for our success and we thank her wholeheartedly. We also thank Rory Howard for his invaluable assistance with the entire project. In addition, we offer our thanks to the following individuals who have contributed in various ways to the realisation of *Tamara de Lempicka: Art Deco Icon* and to the publication that accompanies it:

Katia Ahrens
Maria Alonso
Olivier Camu
David Collins
Stefan Connery
Jeffrey Deitch
Hamish Dewar
Patricia Evans
Claudia Gian Ferrari
Hans Furer
Claude Ghez
Marilyn Goldberg
Carol Haworth
Christopher Holloway
Wolfgang Joop
Ellen Josefowitz
Barbara and Peter König
Jason Leblond
Edwin Lemberg
Linda Lloyd Jones
Adrian Locke
Nick Mclean
Gioia Mori
Lorcan O'Neill
Felipe Ortiz-Monasterio
Alfred Paquement
Dawn Perlin
James Roundell
Annie Starkey
Claudia Stone
Toni Stooss
Cecilia Treves
Luisa Villegas
Arthur Wayne
and others who wish to remain anonymous

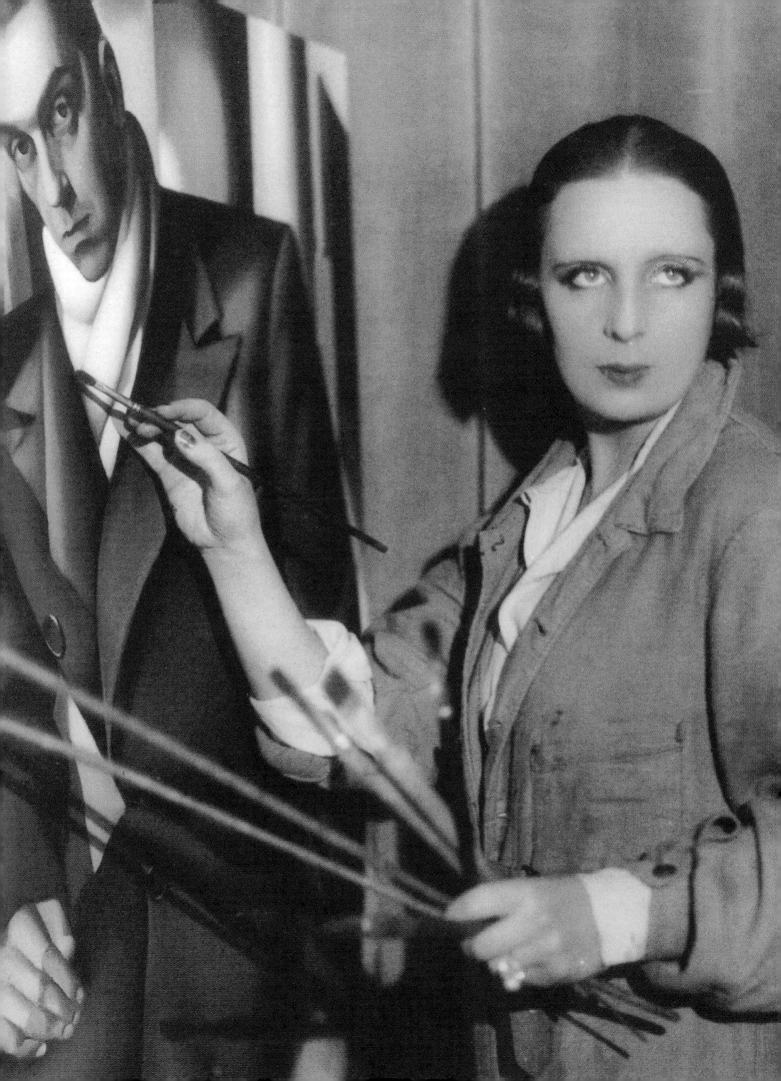

Tamara de Lempicka: An Introduction

Alain Blondel

'What singular, happy contradictions enable her to convey the impression of such modernity (intense modernity, in my view), while using such purely classical resources? With the apparently chilly style that she sometimes pushes to extremes, by what means can she suggest feelings (not to mention sensations) that are generally connected with the opposite pole? How can she shift from the expression of sensual pleasure to the expression of chastity, unless of course we find it difficult to distinguish one from the other?'
Arsène Alexandre[1]

Tamara Gorska-Lempitzky escaped from Russia when it fell to the Bolsheviks, arriving in Paris in 1918/19 under difficult circumstances. She was twenty and married to a man who, despite his aristocratic patronymic, had neither job nor connections in France; and she already had a child to raise. The contrast between her present, not very favourable, situation and her privileged childhood must have seemed stark indeed.

In 1911, De Lempicka's grandmother had taken her to Italy. Kizette, De Lempicka's daughter, reports in her memoir of her mother: 'Madame took her protégé through every museum she could find in Florence, in Rome, in Venice, always talking, instructing, pointing out the Renaissance masters, explaining the modelling of a cheek, the foreshortening of a hand, composition, chiaroscuro, impasto. It was a trip the young girl would never forget.'[2]

Welcomed and housed in Paris by some considerate cousins, De Lempicka withstood the shock of exile with unusual energy. Paris, still celebrating victory, offered opportunities that she seized. She decided immediately to continue with the art studies she had begun in St Petersburg, enrolling first with Maurice Denis at the Académie Ranson, then at the Académie de la Grande Chaumière, where she met André Lhote. With his theories based on a type of modified cubism, Lhote was to exercise a decisive and durable influence on De Lempicka's work. Under his tutelage she effortlessly absorbed the lessons of neo-cubism, creating a synthesis that left space for her classical culture. Her exceptional technical skill allowed her to make rapid progress. The critic Georges Remon wrote in 1931: 'The Cubists, André Lhote, Maurice Denis, Ingres as seen by Picasso, this is the roll-call of influences that have guided her art, and the painter does not deny it.'[3]

The application of Lhote's lessons can be detected in *The Kiss* (*c.* 1922; cat. 3) in which the composition is structured on a series of triangles. Behind the lovers the subject of city nights appears for the first time. It was often to be repeated thereafter. The man wears full evening dress, as does De Lempicka's husband in her full-length portrait of him painted six years later (cat. 28). The woman could easily be an idealised self-portrait.

During this period of tentative experiment De Lempicka's taste for expressiveness led her to focus on people whose bodies and faces had strong features. At the same time, she was beginning to introduce accessories into her portraits to reveal the subject's psychology or social status. The *Portrait of a Polo Player* (*c.* 1922; cat. 2) is typical. This is the first of her male portraits in which the subject pouts arrogantly. The carriage of the head and the gloved hand holding a horse-whip give a foretaste of her later portraits of Italian aristocrats.

Shortly after this, in 1922, De Lempicka began to participate in the various Paris *salons*. The Salon d'Automne and the Salon des Tuileries in particular were, at the time, very well attended and much commented upon in the press.[4] After 1923 her style developed rapidly. At the outset, she had used a classical treatment with very broad brush strokes; now she moved towards a smoother technique and lighter palette, deliberately restricting her range of colours. If some

Fig. 1
Detail of a photograph by Thérèse Bonney, *c.* 1928, showing De Lempicka with *Portrait of a Man* (cat. 28), a portrait of her husband Tadeusz

Fig. 2
Photograph by
Constantin Stiffter of
De Lempicka's studio
in the Place Wagram,
c. 1924, showing
*Woman in a Black
Dress* (cat. 7)

Fig. 3
The Model
1925
Oil on canvas
116 × 73 cm
Private collection

photographs taken in her studio in *c*. 1924 (fig. 2) are studied with a magnifying glass, the titles of two books can be distinguished: *Der Expressionismus* by Paul Fechter and *Pensées d'Ingres* by an author whose name is illegible. Her paintbrush hovered somewhere between the two. When painting the *Seated Nude* (*c*. 1923; cat. 4) she leant towards the first. Torn between opposites she chose sometimes very virile females and sometimes pensive young women as subjects for her portraits. In 1923 she began to manifest an unmistakable personal style in paintings such as *Woman in a Black Dress* (1923; cat. 7), which could be described as the first of her paintings to bear her true signature: the figure fills a tall, narrow picture plane. The doleful subject wears a black dress and clutches a small red book to her chest.

Lhote's sagacious advice was bearing fruit, but thanks to the acuity of her gaze the student was by now overtaking her teacher. De Lempicka's curiosity about people, her sharp appreciation of their vanities, their seductions or the cracks in their armour, was becoming the true 'subject' of her paintings. In *Double '47'* (*c*. 1924; cat. 8), for example, she produced a highly ambiguous piece: a double portrait of a single woman wearing a boyish haircut. The sitter is undoubtedly a prostitute: at this time in the streets of Paris large numbers on a house indicated that it was a brothel.

By now, De Lempicka was beginning to pay great attention to modelling, using subtle shading on the spherical and cylindrical forms from which she constructed her female figures, as in *The Model* (1925; fig. 3), a composition designed to achieve a measure of monumentality with its rippling abstract background. Her models were chosen with a sculptor's eye: whether naked or clothed, the women are always solid and well-built, yet feminine. This tendency can be observed clearly in *Rhythm* (1924; fig. 19), the largest painting she ever produced. Implicit in the title of this group of monumental nudes (with not a percussion instrument in sight) is that the artist is referring to the rhythm of the lines.

During this period, the assertiveness in her images is reminiscent of the Neue Sachlichkeit movement. A new taste for still-life is revealed in *The Open Book* (*c*. 1924; cat. 9) and its pendant, *The Red Bird* (1924; cat. 10), in which the juxtaposition of unusual objects, unconnected in any way, suggests a kind of puzzle. Frequent visits to Italy, however, and the discovery of Realismo Magico, gradually modified these early leanings.

De Lempicka's career began to take off with the exhibition in 1925 at the Bottega di Poesia in Milan. The gallery's director, Count Emmanuele di Castelbarco, himself a painter, introduced her into high society in the wealthy metropolis, and she forged some lasting friendships. She found the city teeming with social stereotypes. To begin with, she painted two superb portraits of Marquess Guido Sommi, a music-lover and avant-garde composer who was married to Princess Pignatelli (known as Mananà), herself a talented sculptress. The couple introduced De Lempicka into Futurist circles and the first

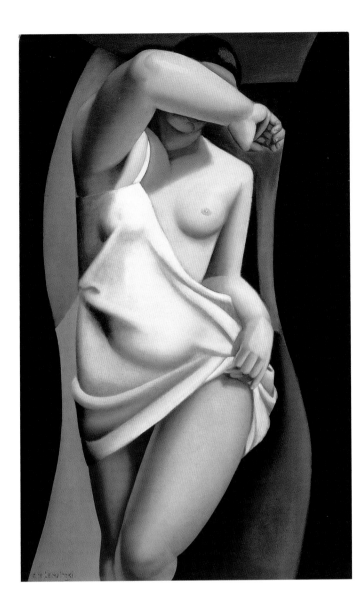

of her two portraits of Sommi (1925; cat. 16) could be said to reflect this connection. The second (1925) is more official: wearing an overcoat with a princely fur collar the marquess-musician certainly inspires respect. Behind him a heavy curtain is drawn back to reveal his domain: the city of Milan by night. An emerald adorns his left hand. This portrait is the precursor of De Lempicka's portrait of her husband (1928; cat. 28).

By 1925 De Lempicka had found her own style. A number of writers have tried to define the essence of her art, a unique synthesis of influences that still has the power to affect the widest public. Germain Bazin emphasises De Lempicka's intuitive adherence to the laws of composition that are deeply embedded in Western art: 'The *linea serpentina*, to sixteenth-century Italian theorists the supreme expression of beauty, animates Tamara's figures: with bodies twisting from top to toe they touch the edge of the painted surface at various points...A painting by Tamara is generally presented like a bas-relief with a single, powerful figure filling the whole canvas – to the extent quite often that the top of the head is cut off by the upper edge.'[5] This formula is also related to a certain type of photographic portrait, characterised by a very close-fitting frame, that was produced in the 1920s by numerous photographers. Use of this formula can be seen in the masterly *Portrait of André Gide* (c. 1925; cat. 15), in which the writer wears an agonised expression; he is not wearing his glasses and his eyes are black and empty (a technique used by sculptors). With regard to the artist's intuitive eye, Bazin notes: '...like all great portrait painters, she covers over the individual with the social type that attaches him to the period at which he lived'.[6] This is exactly why her portraits continue to exert such fascination. Historical distance adds to the truth of the individuals represented, as for example in the *Portrait of the Duchess de La Salle* (1925; cat. 17), a powerful-looking horsewoman standing firmly on a staircase whose red carpet looks more suitable for the entrance to a cabaret than the vestibule of a ducal residence.

De Lempicka returned to Milan in 1926 to paint the portrait commissions she had attracted at her exhibition. During this second stay she accepted an invitation from Gabriele d'Annunzio to visit his home at Vittoriale on Lake Garda. The exuberant poet, then sixty-three, immediately succumbed to the charms of the young Polish artist (she was only twenty-eight) and commissioned her to paint his portrait. Impressed by the celebrity of her prospective sitter, De Lempicka accepted eagerly. Her second visit to Vittoriale to execute the commission (a portrait and nothing more, despite what her lascivious client might have imagined) came to an unfortunate end. One morning at dawn she took flight and the portrait was never painted.

Back in Paris De Lempicka settled down to work. In a long interview in a Polish magazine, *Kobieta Wspolczesna* (*The Modern Woman*), she describes how her days are filled: 'I work from eight in the morning to five in the afternoon, which means I do three portrait

Fig. 4
Sharing Secrets
1928
Oil on canvas
46 × 38 cm
Private collection

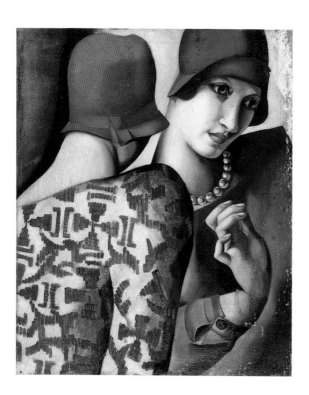

sittings.[7] Later we learn that this sustained pattern of work was punctuated by periods of respite: 'champagne, bath, massage'. A 1978 interview in *Houston City Magazine* reveals that most of the great portraits were painted in three weeks.[8] This was certainly the case with the impressive *Portrait of His Imperial Highness the Grand Duke Gabriel* (*c.* 1926; cat. 18), the perfect portrayal of an exiled prince trying to deceive himself by dressing up – for the time it took to paint a portrait – in his tawdry finery. Once again De Lempicka's analysis of her subject's psychology is merciless: although the features are hard, there is an unmistakable look of mild disorientation on the exile's face. The thick, red lips contrast with the pale, emaciated face, making the spectator feel somewhat uneasy.

De Lempicka met Dr Pierre Boucard, a rich collector who had made a fortune in the pharmaceutical business, in Paris. He was to become a generous and keen patron. Determined to make a collection of De Lempicka's paintings, he began by commissioning a series of portraits. De Lempicka started with his daughter Arlette (1928; cat. 29), depicting her lying stretched out against a background of the harbour at Cannes where her father's yacht (named *Lactéol* after the medicine which had made his fortune) is berthed. The painting is a perfect illustration of the lifestyle of the leisured classes at the end of the 1920s. Next De Lempicka painted her patron (1928; cat. 27), surrounded by microscopes and flasks. The solitaire pearl on his tie, his narrow moustache and the raised collar of his white coat show that the doctor was also a man of the world. Three years later it was the turn of his wife (1931; fig. 39) in whose portrait De Lempicka proves that she was the only twentieth-century painter carrying on the tradition of grand portraiture. She repudiates none of the conventions that in earlier centuries had made portraits of this type outward signals of power and pride. Here, as in a Renaissance portrait, the city in the background seems subject to the power of a wealthy, lavish character.

Accustomed as she was to expressing her feelings in paint, De Lempicka painted some admirable portraits of her daughter. *Kizette in Pink* (*c.* 1926; cat. 20) shows a small, serious girl with a book on her knees wearing a spotless white summer dress (the merest hint of pink is there to justify the title). She gracefully hides a shoeless foot. De Lempicka's first official sale, the portrait went to the Musée des Beaux-Arts in Nantes soon afterwards.

Over the next year De Lempicka produced a series of sensual nudes. The model was the same throughout. In her biography of her mother, Kizette de Lempicka-Foxhall reveals that the 'beautiful Rafaëla' was approached by De Lempicka during one of her daily early morning walks in the Bois de Boulogne. De Lempicka was apparently struck by the beauty of the young woman, whom she presents as a not particularly venal nymphomaniac: 'She is the most beautiful woman I have ever seen – huge black eyes, beautiful sensuous mouth, beautiful body. I stop her and say to her, "Mademoiselle, I'm a painter, and I would like you to pose for me. Would you do this?" She says,

"Yes, why not?" And I say, "Yes, come. My car is here."[9] De Lempicka was apparently very pleased with her model and made use of her services for more than a year. A number of major paintings were the result, including *The Pink Tunic* (1927; cat. 19), in which the famous black eyes are contrasted with the clear red of the full lips. Another of the series, *La Belle Rafaëla* (1927; fig. 25), showing the full figure of the model lying stretched out on her back, is one of De Lempicka's masterpieces. The background and colour scheme are reduced to a minimum: a piece of red fabric stands out against a black background and is arranged to hide the model's feet; the artist uses this skilful trick to fill the picture plane as much as possible. The spectacular perspective is emphasised by Caravaggesque lighting.

During this period the artist began to forge her reputation as a female painter of women. Her work came to the attention of the editor of a celebrated women's magazine in Germany, *Die Dame*, and she was asked to supply several covers, including *The Orange Scarf* (1927; cat. 23); the figure on the left has the face of De Lempicka's cousin Irène, the one on the right is the model with the hypnotic gaze whom she was to reuse in *The Bride* (1928). Other female couples were to follow: *Sharing Secrets* (1928; fig. 4), *The Green Turban* (1929), *The Girls* (c. 1930) and *Spring* (1930).

Intense activity and dedication to her career were certainly no recipe for a contented family life. De Lempicka and her husband Tadeusz were divorced in 1928, when her portrait of him, laconically entitled *Portrait of a Man* (cat. 28), was still unfinished: the left hand, on which the wedding ring is worn, remained a sketch. His pose might be interpreted as a premonition: Tadeusz is shown with his coat buttoned and hat in hand, ready to depart. The composition, in various shades of grey, and the determination of the figure, standing impatiently against a background of skyscrapers looming beneath a wintry night sky, express a tough, disturbing strength.

The year 1928 saw her paint a series of portraits so representative that it has become emblematic of the period. While leaving unfinished the portrait of her husband Tadeusz, De Lempicka was painting a portrait of Baron Kuffner (1928, fig. 16), who was later to become her second husband. The images of the two men, possibly unreconciled, belong to the collection of the Musée National d'Art Moderne in Paris. Baron Kuffner had a mistress; naturally he could not wait to take her to De Lempicka's studio. This produced the vigorous portrait of the Spanish dancer Nana de Herrera (1928/29; fig. 5), naked under black lace. Nana possessed a communicative energy which artists found irresistible (her lively silhouette has danced for more than half a century on packets of Gitanes cigarettes).

Shortly after the series of portraits commissioned by Dr Boucard, De Lempicka moved to a glamorous new studio in a block of flats designed by Robert Mallet-Stevens, the celebrated exponent of modernist architecture (fig. 11). De Lempicka summoned her sister Adrienne Gorska to decorate the studio; Adrienne was an architect

Fig. 5
Nana de Herrera
1928/29
Oil on canvas
121 × 64 cm
Private collection

Fig. 6
The Slave
1929
Oil on canvas
100 × 65 cm
Private collection

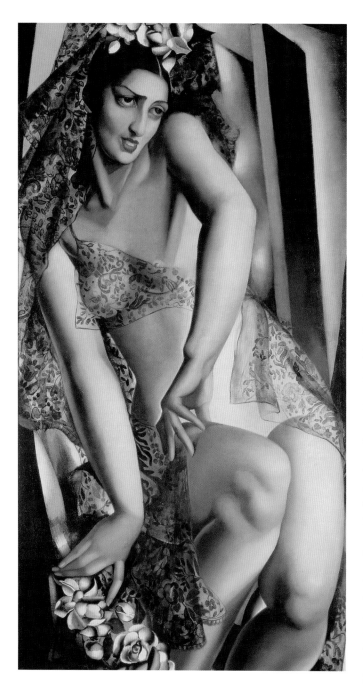

too and, like Mallet-Stevens, a member of the prestigious Union des Artistes Modernes (UAM), a group that boasted among its membership all the most prominent architects and designers. Adrienne transformed the apartment and filled it with modish furniture and objects typical of the period. The journalist writing for the Polish magazine quoted above noted that the minimalist décor was the perfect 'casket for the lady of the house, who is the sole decorative item'. The art press treated the whole enterprise as the embodiment of the modern spirit.

The portrait of Adrienne's husband Pierre de Montaut (1931; cat. 41), also an architect and a member of the UAM, conveys very clearly the group's modernist tendencies. The background shows a cul-de-sac in Auteuil, all of whose buildings were designed by Montaut's colleague Mallet-Stevens. The modern flavour of the painting did not escape the critic Magdeleine A. Dayot, who wrote in 1935: 'Her many portraits vibrate with remarkable life. In the portrait of Dr Pierre Boucard, and the portrait of M. de Montaut, for example, the psychology of modern man is analysed with unusual subtlety.'[10]

Enjoying great success at this time, De Lempicka used her female sitters to their very best advantage, adding indicators of the new spirit to their elegance, nonchalance, sensuality and physical vitality. The portraits and even the still-lifes of this period manifest a youthful, communicative optimism that radiates triumphant modernism. De Lempicka produced *St Moritz* (1929; cat. 33), an image of a modern woman carrying a ski stick under her arm, for the cover of the German magazine *Die Dame*. If this had been a painting it would certainly have been new, but might have been unconvincing. In this magazine cover, however, the proud sportswoman lifts her gaze to the heavens and it is not difficult to imagine the reflection in her eyes of the gods of the stadium marching past. The same allegorical content can be found in *The Musician* (1929; cat. 31), in which the synthesis of two contrasting aesthetics can be observed. The first, inspired by the Italian Renaissance, is evident in the attitude of a semi-angelic figure plucking a few notes of celestial music in melancholy fashion; the other, contemporary, is conveyed by the futurist metropolis in the background. Equally allegorical is *The Slave* (1929; fig. 6) which makes the spectator wonder who the cruel master might be. The grey, depressing suburbs of a European city behind the chained beauty indicate that she is certainly not the slave of some oriental despot. One interesting suggestion, made by Gioia Mori (on examining a photograph of De Lempicka), is that the painting might be seen as a self-portrait.[11] Perhaps the work is the mute lament of a wife caught up in conjugal shackles from which she was hoping to break free?

In 1929, at the end of the 'roaring twenties', De Lempicka's career was at its zenith. Thanks to the art and fashion press, her fame had finally crossed the Atlantic. In February 1927, *Vanity Fair* had devoted an article to her and her work, illustrated by reproductions of three paintings. In September 1929, De Lempicka travelled to New York

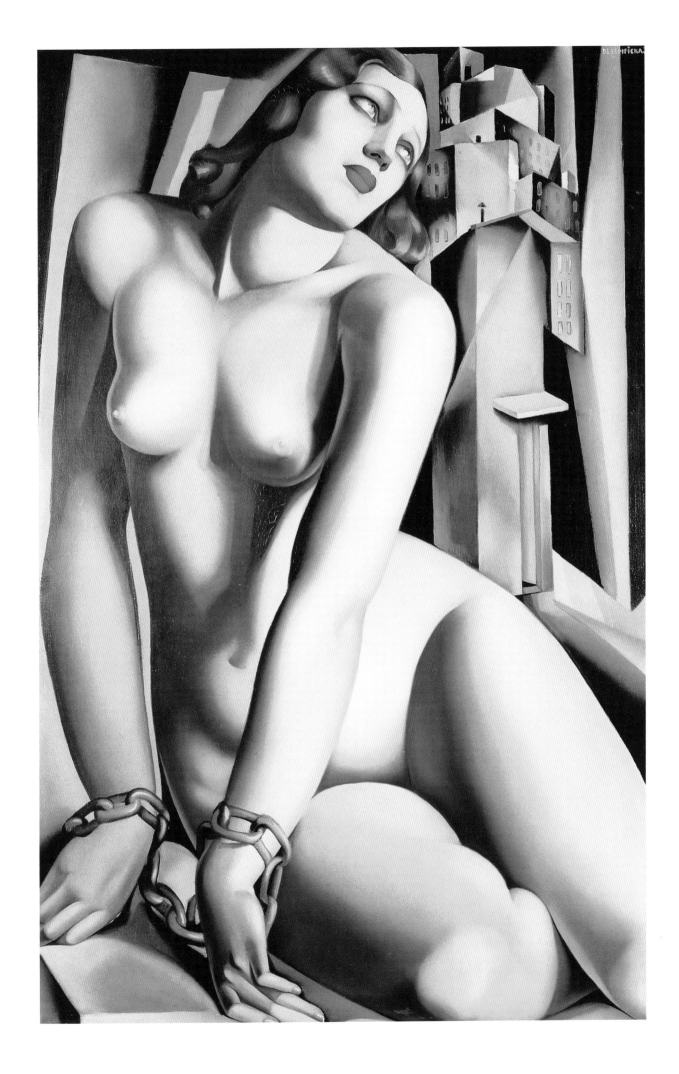

Fig. 7
Portrait of Mrs Bush
1929
Oil on canvas
122 × 66 cm
Private collection

Fig. 8
Young Lady with Gloves
1930
Oil on plywood
61 × 46 cm
Musée National d'Art
Moderne, Centre
Georges Pompidou,
Paris

to execute a portrait commission. In her biography Kizette describes the ostentation of the young millionaire Rufus Bush who, having met De Lempicka in her studio in Paris, immediately invited her to come to New York at his expense to paint a portrait of his nineteen-year-old fiancée. The resulting *Portrait of Mrs Bush* (1929; fig. 7) is a masterpiece. Three years later, however, the young couple divorced and the painting was put away and forgotten. Sixty years on, their daughter rediscovered it, and hastened to write to Kizette. During her stay in New York, De Lempicka painted other portraits, such as the *Woman in a Yellow Dress* (1929), a young, fair-haired woman in a saffron gown with a grey, stormy sky in the background who wears an air of profound disillusionment as she lies on a sofa in almost exactly the same pose as Madame Récamier.

Although exhibitions were planned in the United States, the Wall Street Crash of October 1929 brought the generosity of patrons and galleries to an abrupt halt. All De Lempicka's plans were overturned, and she returned to Paris, where the worst effects of the crisis were yet to be felt. There she resumed her hectic painting schedule, while continuing to lead a very active social life. Celebrated for her beauty and her elegance, De Lempicka was more concerned with her image than any other artist. She painted many self-portraits and spent long hours posing for photographers like a professional model. Her time in Hollywood some years later and her attempts to penetrate the world of cinema suggest that she dreamt of a screen career. A screen test made by Pathé News in 1932 shows her descending the staircase of her immaculate studio in the Rue Méchain in regal fashion, holding an immensely long cigarette holder.

Her portraits of women at this period are manifestly erotic; *Young Lady with Gloves* (1930; fig. 8) might as well have been entitled 'The Navel', since this anatomical detail, visible under the model's tight-fitting silk dress, is so exaggerated. The frank sensuality of the painting presented no problem to the purchasing committee of the Musée du Luxembourg, who acquired it at the Salon des Indépendants in 1932. The *Portrait of Ira P.* (1930; cat. 37), its sitter a woman friend of De Lempicka's for the past ten years, is a masterpiece of amorous portraiture: the artist depicts the caress of the white satin dress with consummate skill in order to emphasise the soft curves of Ira's figure. The arum lilies in her arms curl inwards with the same sensuality as the white fabric on her body. Arum lilies occupy an important place in De Lempicka's work. Their white corollas evoke an ideal purity, while their tumescent pistils are the embodiment of concupiscence. Perhaps the flower expresses the dysfunctional marriage of sanctity and lust within the artist's character.

De Lempicka returned from New York with images of a futurist city in her mind. Her studies of blocks of flats executed in America are reminiscent of dark crystals, and these crystalline silhouettes occupied the backgrounds of her portraits of women for a time. Henceforth her portraits were perfectly matched to these

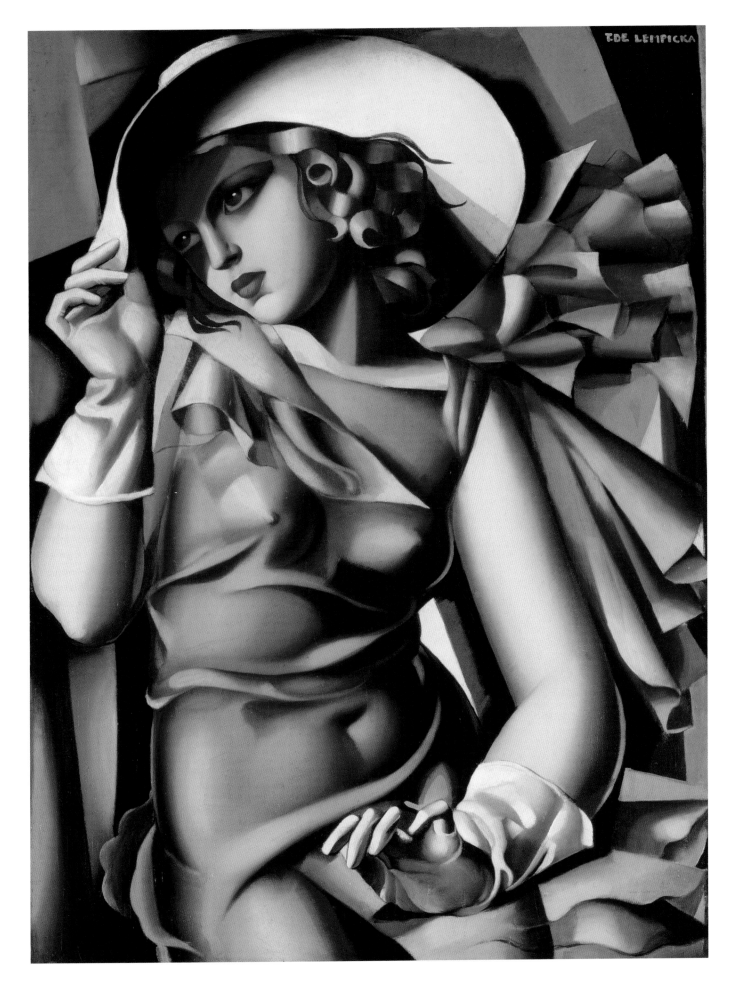

Fig. 9
St Anthony
1936
Oil on panel
35 × 27 cm
Private collection

Fig. 10
Madonna
c. 1937
Oil on panel
Diameter 33 cm
Musée de Beauvais

26

LEMPICKA.

dehumanised backgrounds. For example, in *Nude with Buildings* (1930; cat. 35) the young, naked woman appears to have abandoned all her defences. The twig of the frail olive branch she clutches seems to represent the natural world, a distant memory in the chilly urban wasteland that surrounds her. Much more optimistic, indeed almost triumphant, is the *Portrait of Mrs Allan Bott* (1930; cat. 38), the quintessence of De Lempicka's art. The beautiful, rich American woman seems to float among the surrounding skyscrapers like a personification of the ecstasy of capitalism. Most typical of the works from the period after De Lempicka's return from America is the celebrated *Adam and Eve* (1931; cat. 42) in which a city more arrogant than Babel replaces the Garden of Eden. In Kizette's biography amusing light is thrown on De Lempicka's fresh approach to this oldest of subjects: the male model who posed as Adam was a policeman whom De Lempicka had approached in the street while he was on his beat. Many years later, she still remembered him carefully folding his uniform and placing it on a chair with his pistol on top.

In the portraits of this period the women are at the height of the seductiveness, yet their souls seem ravaged and they make a glacial impression. In *Woman with Dove* (1931), the bird, love's messenger, is dead and the sweetheart's dreams shattered. The sunset, painted with dramatic chiaroscuro, emphasises the sadness of the subject. *The Convalescent* (1932; cat. 46) is a melancholy portrait painted with a degree of compassion for the model unusual in twentieth-century art. The portrait of Marjorie Ferry (1932; cat. 47) is certainly the sharpest of all De Lempicka's portraits. The balcony and columns, implacably lit from above, look as if they are made of sheet steel. Even though Marjorie's glance invites the spectator to succumb to the arrows of desire, this painting has come a long way from the serene sensuality of the *Portrait of Ira P.* of two years earlier.

De Lempicka's career as a portraitist came to an end in about 1932–33. Times had changed, new tastes had developed and the planes and solids of Art Deco had gone out of fashion. In the *Portrait of Miss Poum Rachou* (1933; cat. 51), De Lempicka expressed little tenderness for the small girl she was portraying, yet in the early 1920s she had painted a very similar subject, a charming portrait of her daughter Kizette holding a placid-looking teddy bear in her arms (c. 1922). In the later portrait the soft toy has unusually sparkly eyes and looks ready to bite.

Portraits that followed were not commissions; their sitters came from her immediate circle of friends. The portrait of Count Vettor Marcello (c. 1933; cat. 52) was painted at the count's Venetian villa in which De Lempicka had stayed several times. The modernity of this handsome, serious portrait is striking. The harbour behind the sitter suggests new departures, hopes of discovery and liberating releases.

Some subjects correspond to the profound disturbance that gripped De Lempicka at this point in her life. After an attempt at a retreat in a convent in Tuscany, she painted *The Mother Superior* (1935; cat. 49). The two tears running down the nun's cheeks were

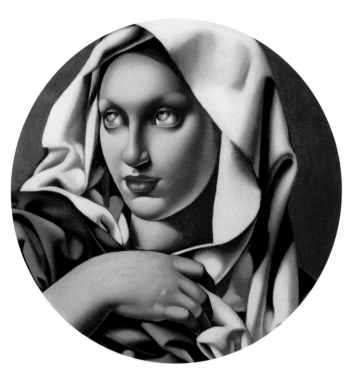

very badly received by the critics. During a travelling exhibition organised by Julien Levy in California, the critic of the *San Francisco Bulletin* wrote: 'It is admirably conceived and scrupulously performed, but two unpardonable glycerine tears cheapen the whole effect.' The painting, reminiscent of Rogier van der Weyden, was painted at a critical time; its anachronism seems deliberately provocative. De Lempicka regarded this icon as better than anything she had produced before. In 1936 she painted a *St Anthony* (fig. 9), afterwards making three obsessional replicas of it. On the day she died in Cuernavaca the last was still on her easel. The saint's face was that of the psychiatrist who had treated her for depression in a Zurich clinic.

This mental affliction slowed her production considerably. Such was her distress that only religious subjects had any meaning for her. She painted several young Madonnas with pure, oval faces. More testing subjects, old or blind people, bore witness to ever more intense soul-searching. Her increasing uncertainty persuaded her to refer constantly to the art of the Renaissance. She was determined to pit herself against the old masters, and made a number of replicas and compositions inspired by paintings she had seen in museums or in books. The *Madonna* (*c*. 1937; fig. 10), for example, was inspired by a drawing by Michelangelo, now in the Louvre.

From 1937 she gradually recovered her serenity and began to make extremely detailed paintings of simple folk and peasants. This departure represented a temporary conversion to a set of moral virtues deliberately opposed to the worldly vanities to which she was so susceptible. But by 1938, De Lempicka appeared to have recovered her creative energy. The prospect of an exhibition in New York the following year gave her added motivation. She renewed her contact with galleries in America and once more took part in the annual international exhibition in Pittsburgh.

On 24 February 1939 De Lempicka, with her husband and her most recent paintings, boarded the SS *Paris* for New York, where she was going to hang her exhibition at the Paul Reinhardt Gallery. The opening took place on 2 May 1939 and the press reaction was favourable. A new life was beginning. Also in her luggage were some of her most successful earlier paintings, such as *The Musician* (1929; cat. 31), which she hung alongside more recent works. *Escape* (*c*. 1940; cat. 53), depicting the misfortunes of war in Europe, uses an American format and must therefore be one of the first paintings executed after her move to the United States.

The Kuffners moved into a property in Beverly Hills which had formerly belonged to the film director King Vidor. De Lempicka had always been fascinated by the cinema and in Beverly Hills she devoted all her energies to establishing herself in Hollywood society. The baron never missed an opportunity to escape to go hunting in Montana.

In 1941 De Lempicka showed twenty-two paintings at Julien Levy's gallery, one of the best known in New York. She was relying

Fig. 11
Photograph by M.
Gravot, 1930, of
De Lempicka's studio
at 29 Rue Méchain,
a building designed by
Robert Mallet-Stevens

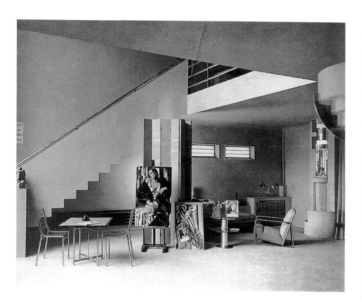

1 Arsène Alexandre, 'Tamara de Lempicka',
 La Renaissance de l'art français et des
 industries de luxe, July 1929.
2 Kizette de Lempicka-Foxhall and Charles
 Phillips, Passion by Design: The Art and
 Times of Tamara de Lempicka, Oxford
 and New York, 1987, p. 24.
3 Georges Remon, 'Architectures modernes:
 L'Atelier de Mme de Lempicka', with
 photographs by M. Gravot, Mobilier
 et décoration, 9, 1, January 1931.
4 When De Lempicka first appeared in public
 she was presented under the masculine form
 of her name: Lempitzky. This is the name
 she inscribed at the bottom of her paintings
 even though, according to Polish custom,
 she should have signed herself Lempitzka.
 Her true identity, 'Tamara de Lempitzka',
 was not established until 1925, during
 her first big exhibition in Milan, at the
 Bottega di Poesia. The definitive French
 version of her name – 'de Lempicka' –
 did not appear until 1927.
5 Germain Bazin and H. Itsuki, Tamara
 de Lempicka, Tokyo, 1980.
6 Bazin and Itsuki, 1980.
7 I. Zaslawsaka, 'Tamara de Lempicka',
 Kobieta Wspolczesna (The Modern Woman),
 20 July 1932.
8 Joanne Harrison, 'A Portrait of the Artist',
 Houston City Magazine, August 1978.
9 De Lempicka-Foxhall and Phillips, 1987, p. 80.
10 Magdeleine A. Dayot, 'Tamara de Lempicka',
 L'Art et les artistes, 156, April 1935.
11 Gioia Mori, Tamara de Lempicka, Paris,
 1920–1938, Florence, 1994, no. 59.

on the exhibition to re-establish her fame in the United States. The inclusion of some older works, including one from 1923, suggests that she wanted to show that she had a successful career behind her. The exhibition lasted only two weeks and was considered a success, although more so with the public than the critics. Among other paintings she presented *At the Opera* (1941; cat. 55), which she may have begun in Paris. In it, she reused elements from earlier works, including the column from the portraits of the Duchess de La Salle and Marjorie Ferry, and Nana de Herrera's lacy gown. Also in the exhibition was *Wisdom* (1940/41; cat. 54), a demonstration of perfectionist technique. The arrangement of the subject and the position of the figure are reminiscent of the Flemish master Quentin Matsys. De Lempicka later made several replicas of this work.

The success of this exhibition encouraged Levy to mount another; the following year, with a show of work by De Lempicka, he opened a second gallery on Sunset Boulevard in Los Angeles. Some paintings shown in New York had been sold so the show was smaller, but the works were hung in a novel and spectacular fashion. Small, jewel-like paintings were hung in a dark room with a spotlight trained on each. This unusual lighting effect created a sensation, as did the brilliant private view, which was attended by all the leading figures in Hollywood society. This was to be the last great party given by De Lempicka. Outside the United States the world was in turmoil and parties no longer seemed appropriate. In 1942 the Kuffners left for New York.

There they bought an imposing two-storey apartment at 322 East 57th Street, and De Lempicka started redecorating at once. After the steely Art Deco geometry of the studio in Rue Méchain in Paris, tastes had developed towards a more eclectic, theatrical style (fig. 12). Full-length curtains framed high bay windows and low furniture emphasised the ceiling height. A beige and grey colour scheme created a luxurious, padded atmosphere. Rococo furniture from the baron's castle in Hungary gave the apartment a deliberately theatrical flavour, reminiscent of an Ernst Lubitsch film set.

After the war, during which she undertook charitable work on behalf of her Polish compatriots, De Lempicka wasted no time in re-establishing contact with battle-scarred Europe. In 1944, shortly after the liberation of Paris, she sent a painting to the Salon d'Automne. She returned to Italy for the first time in 1949, visiting various cities and staying in the luxury hotels that had survived the hostilities. Her untiring visits to museums inspired new paintings, which were always strongly influenced by her prolonged contemplation.

The years that followed were spent in incessant travel between the United States, France, Italy, Cuba and Mexico. In 1955, between two trips, De Lempicka renewed contact with the Parisian public, who had almost forgotten her, at the Galerie André Weil in Avenue Matignon, but her exhibition of paintings in a new, highly Italianate style aroused little interest.

These frenzied travels may have concealed a feeling of artistic distress. Refusing to be outpaced by her period, De Lempicka launched into abstraction but soon tired of it. It was at this time that she discovered the pleasure of paint itself, and of working with a palette-knife. From one day to the next, she abandoned everything that had previously defined her image: sharp contours, smooth surfaces and glazes. She threw herself headlong into work. Her output, mainly still-lifes and replicas of earlier compositions, was once more abundant.

The results were shown in an exhibition in Paris in 1961. At the age of sixty-three, De Lempicka thought it essential to take stock of her *oeuvre*. She advertised herself in the magazine *Arts* on 31 May 1961 thus: 'Tamara de Lempicka: neo-cubism, abstract and figurative art'. This mixture of genres left the public completely cold. Paintings that are today famous, including *The Musician* (cat. 31), *The Communicant* (cat. 25) and *Kizette in Pink* (cat. 20), went almost unnoticed. It was not yet time for a revival. In the early 1960s, anything belonging to the Art Deco style was considered unfashionable and provoked almost universal rejection.

In 1961, Baron Kuffner died on the steamer from Paris to New York. De Lempicka sold the apartment in New York and moved to Houston to be near her daughter. She took to spending more and more time in Mexico, at Cuernavaca. Although she continued to paint, she appears to have considered her public career to be at an end. Then one day in 1967 as she was passing through Paris she answered the telephone in her studio: a group of young dealers had just discovered her work in some old magazines. She broke with her resolution to stay out of the public eye, and enjoyed this newfound celebrity until her death in 1980.

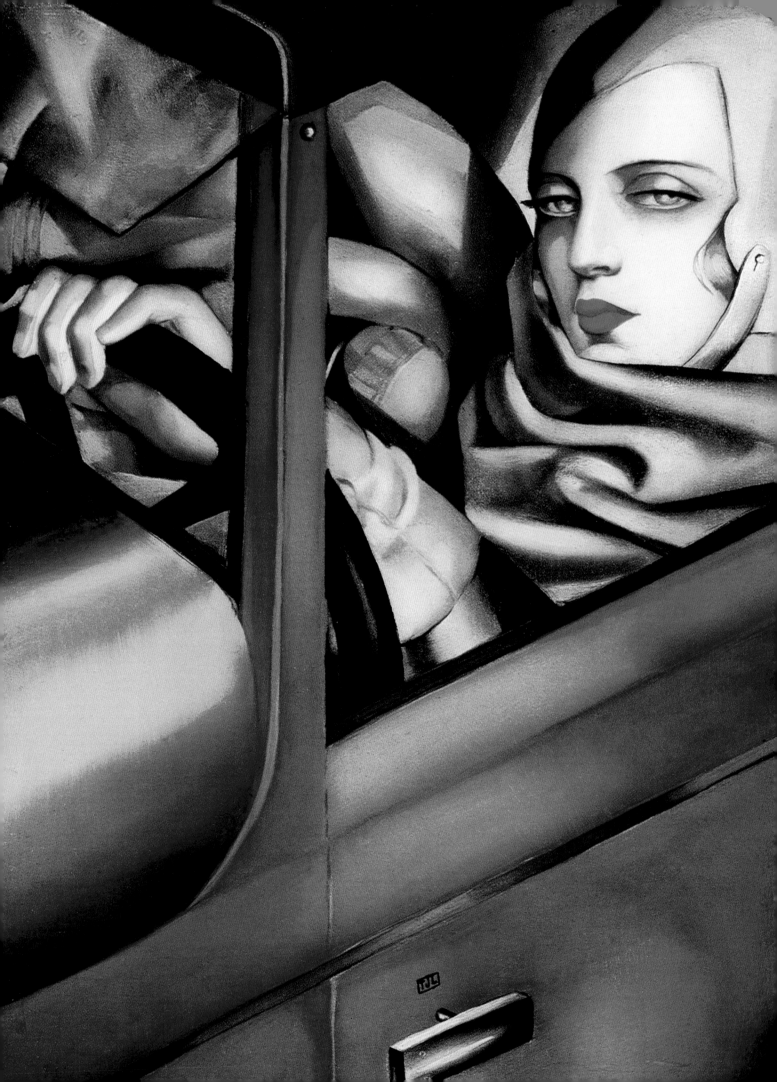

Sang-froid and Frenzy

Ingried Brugger

Tamara de Lempicka's tantalising pictures have the compelling attraction of a *journal intime*, written by a personality with a tendency towards homoeroticism and a compulsion for auto-eroticism and the wanton lassitude of a *laissez-faire* society that openly flaunted its own decadence.[1]

Wrapped in the 'cool gaze' of that time, rigidified into distinct poses, forced into the corset of their own naked bodies or armoured with the strict rhythms of draped garments, De Lempicka's figures are consumed by an inner fire. The beauty of the painter as she portrayed herself in *My Portrait* (1929; cat. 34) is as cold as ice, and all the more provocative as a result. This is a beauty hidden behind make-up, leather headwear and arrogance; far from ingratiating, it is perilously eccentric. De Lempicka presents herself as a modern amazon; naturally the expensive, green automobile is hers – she is the owner of that ultimate symbol of freedom, speed, mobility, power and riches.

Although De Lempicka led the kind of life that fascinated the popular press, the range of heads and human forms she produced has little to do with the topics that usually fill gossip columns. Anyone leafing through illustrations of her work will be unable to ignore its biographical indicators or its voyeurism. And yet, these elements only ever occupy the background.

De Lempicka's paintings of people – her principal subject matter, with only a few exceptions – raise questions about what is expressed, in the sense of communicated content, and what is not expressed, in that they lack psychologically normative traits. The former is closely connected with De Lempicka's own life and the struggle for emancipation typically expected of a 'modern woman' of that era; the latter is connected with her own artistic drive towards formalism, leading from narration to formally autonomous expression. Expression *vis-à-vis* non-expression: De Lempicka's work takes up the challenge – both moral and aesthetic – issued by modernism.

The outcome is a body of work that persistently eludes the categorical stylistic concepts of modernism. The picture of the artist that emerges is that of an outsider, whose unique *oeuvre* created certain difficulties for the public and her sitters and patrons. On the one hand, De Lempicka's works are more than just a full-colour account of the life of a *femme fatale* (a guise that perfectly fitted her own self-image as a 'modern woman'), and more than mere painterly offshoots of the Art Deco movement. On the other hand, the presence of the *femme fatale* and the Art Deco influences in De Lempicka's work are distinctly at odds with the aspirations embodied by the avant-garde, with the result that she cannot really be counted among their number, either as a painter or in view of her lifestyle – that of a capricious socialite turning heads in fashionable salons.

De Lempicka's commercial success in Paris cannot be disentangled from the portrait commissions she received from the upper echelons of society, to which she belonged by birth and in whose salons she had spent her formative years in Moscow and, more particularly, St Petersburg. Initially disbarred from this level of society in Paris, she succeeded in winning it over in a few years by becoming its chosen painter.

Having only seriously started to study painting in Paris, De Lempicka insisted throughout her life that she had pursued her artistic vocation so that she could take control of her straitened financial circumstances. There can be no doubt that her early days as an exile were forlorn. Exhausted and lost, Tamara and her Polish husband Tadeusz de Lempicki had arrived in Paris by 1919, having taken a circuitous route from Russia through Denmark and Warsaw. Their daughter Kizette was born at this time. Their fate was that of many Russian aristocrats whose 'native language' was French and who now eked out an existence as émigrés, impoverished and robbed of their privileges.

Fig. 13
Detail of cat. 34

Fig. 14
André Lhote
14 July at Avignon
1923
Oil on canvas
145 × 175 cm
Musée des Beaux-Arts,
Pau

The only help for De Lempicka came from her similarly exiled relatives, who had managed to bring some of their wealth with them. Her uncle, Maurice Stiffter, in whose St Petersburg home Tamara had spent much of her girlhood, loved like a daughter by her Aunt Stefa, had rapidly found his feet both financially and socially in France, and now came to her aid. Estranged from her husband who was unable to forget his internment by the Bolsheviks, without means of her own and with no appreciable prospect of social acceptance, Tamara de Lempicka set her sights on a career as a painter, not least, perhaps even primarily, with the aim of making a name for herself, socialising with the *haute bourgeoisie* and radically improving her financial situation. All of this she achieved within a matter of years.

By 1920, she had enrolled at the Académie Ranson. One of her teachers there was Maurice Denis, a member of the Nabi group of painters. His didactic method relied on constant repetition and a particular spiritual outlook, both wholly alien to the young painter who had, as long as she lived, an aversion to any form of mysticism and its supposed opposite, Bolshevism. She eventually found a new mentor in André Lhote (fig. 14).

Lhote, an ardent champion of the classical ideal, for whom the 1920s cry of 'return to order' came at just the right moment, confirming his own ideas, was one of the few established artists of his day who not only accepted the notion of 'decorative art' but also promoted it. De Lempicka consistently denied that Denis had any influence on her development (as though refusing to admit it to herself), but always acknowledged Lhote when referring to her training, even if this meant linking her name with that of an artist who had been admonished for his moderate views by the cutting-edge avant-garde. In his discourse with the avant-garde, Lhote's position was as an advocate of synthetic cubism, with its distinctly representational tendencies, and never as a follower of analytical cubism.[2] Lhote saw to it that De Lempicka had the tools she needed to modify cubism according to her own neoclassical ideas.

However, De Lempicka's ideal of the human form was perhaps less influenced by Ingres – so inspirational for the classical revival in Paris in the 1920s – than by the artists of the high and later Italian Renaissance. The hypertrophied bodily forms of Michelangelo were a rich source of ideas for her.[3] Ingres's canon of arrested affects, his timeless poses and the shimmering surfaces of his paintings did, nevertheless, leave an unmistakable mark on De Lempicka's work. And the productive interplay in her paintings between Ingres and the plastic excess of the faces, figures and draped fabrics of the Renaissance led to a constant toing and froing of stasis and motion, inertia and vitality.

De Lempicka's determination to win recognition and success first bore fruit in 1922. While still an art student, she exhibited her work at the Salon d'Automne. The critical response was positive.[4] Her social ambitions and related career strategies were proceeding very satisfactorily. Soon frequenting the most exclusive salons,

she received all the most sought-after invitations and persuaded influential members of the Salon jury to champion her cause. And she reaped rich benefits from her acceptance into the salon of the writer Natalie Barney, one of the leading intellectuals in the city and possibly the best-known lesbian in Paris, aside from Gertrude Stein. Barney's salon attracted such personalities as James Joyce, Jean Cocteau, André Gide, Isadora Duncan and Colette; homosexual love was openly discussed and glamorous living and cultivated pastimes were the order of the day.

De Lempicka's interest in Barney, in her salon and circle – a source of numerous commissions for portraits and paintings in the coming years – says much about the strategy of an artist who measured her own self-worth against her commercial success and social advancement. She took no interest whatsoever in the weekly meetings of intellectuals convened by Gertrude Stein or Ernest Hemingway, once referring to these two leading thinkers as 'boring people who wanted to be what they were not – he wanted to be a woman and she wanted to be a man'.[5]

This is not the place to explore how much truth there was in Tamara de Lempicka's claim to have 'tried everything' because it was her duty as an artist.[6] However, if her biographers are to be believed, her eccentric lifestyle was a consequence both of her constant determination to be centre stage and of her later urge always to present her past self as the very embodiment of the glamour and the decadence of the interwar years. This aspect of her character fits perfectly with her liaison with commerce, which she openly admitted, and the shrug of the shoulders that was all she would muster for artists on the left bank of the Seine.

And her paintings? Wherein lies the commercial calculation, and what was their artistic impact? Wolfgang Joop, among the most important collectors of De Lempicka's paintings today, has described her as the first 'Pop artist in the history of art'. This is an apt contemporary take on an artist who set herself the challenge of staking her claim to an artistic position somewhere between high-brow and low-brow, between high art and commerce. In a sense it sums her up very accurately. But works that are met with comprehension, even recognition, today were relegated in 1920s Paris to a bourgeois corner, and banned altogether from the avant-garde camp.

De Lempicka's first, widely respected solo exhibition – at Count Emmanuele di Castelbarco's Bottega di Poesia, Milan, in 1925, her entrée to international circles – marked the real beginning of her career. It was followed by years of success and lucrative sales. Her collaboration with *Die Dame*, Germany's leading fashion magazine, ensured that her paintings reached many households and readers.[7] Her self-portrait in a green automobile (cat. 34) appeared on its cover in 1929. In part because the magazine was distributed so widely, the image became an icon for a whole era, and was regarded by many as the ultimate 'hymn to the modern woman'.

Fig. 15
High Summer
1928
Oil on panel
35 × 27 cm
Private collection
This painting was
a commission for the
cover of *Die Dame*
magazine in August
1928

Fig. 16
*Portrait of Baron
Kuffner*
1928
Oil on panel
35 × 27 cm
Musée National d'Art
Moderne, Centre
Georges Pompidou,
Paris

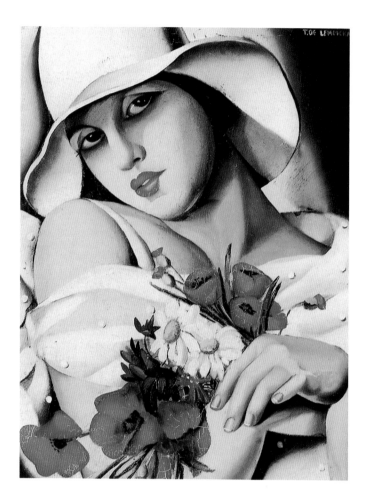

Die Dame's target reader was the modern career woman. In those days the editors made a point of commissioning leading women artists to contribute illustrations to the magazine. One was the German avant-garde artist Hannah Höch. But Höch's free artistic expression had little to do with the mind-set of a fashion magazine. There was a striking reciprocity, however, between De Lempicka's commercial commissions for the magazine and her 'own' paintings, as is exemplified by a work such as *High Summer* (1928; fig. 15). Not only did her art seem to capture the spirit of the fashion magazine, but at times her works even looked like trademarks transplanted into art – another affinity with the output of the later American Pop artists.

Tamara de Lempicka and her pictures enjoyed wide popularity. She received major portrait commissions and her reputation spread abroad, above all in the United States. Profitable commissions, such as those from the millionaire scientist Dr Pierre Boucard (1928; cat. 27), and the generosity of her new lover and later her second husband, Baron Raoul Kuffner (fig. 16), whom she met while she was working on a portrait of his then mistress, Nana de Herrera (1928/29; fig. 5), meant that De Lempicka was soon able to afford an elegant apartment designed by Robert Mallet-Stevens in strict Art Deco style. In 1929 a portrait commission (fig. 7) from the American millionaire Rufus Bush took her to New York for the first time, where she stayed until 1930, fascinated by the many possibilities offered by the New World.

On her return to Paris, she immediately resumed the life of excess pursued by the social élite, who continued to throw parties regardless of the economic crisis that was daily gaining ground. In the spring of 1930, the Galerie Colette Weil presented her first solo exhibition in Paris, a great success. De Lempicka always claimed to have made her first million by the time she was 28. Despite this, she had to contend with financial, professional and private pressures throughout the 1930s. For her, this was a time of personal crises and bouts of depression, liaisons with both sexes, and the constant struggle to maintain her glamorous lifestyle and survive financially.

Contemporary critics always remarked on the high degree of realism in De Lempicka's paintings. Looking more closely at her images of women, however, one cannot help but be struck by the fact that only in very specific cases does she create 'recognisable' individuals. The generality of the body or of the face, the fundamental message inherent in them – in terms of both formal aesthetics and content – seems to take precedence. Astonishingly, the same may be said of the portraits.

De Lempicka's preferences are easily listed. Above all she favoured single figures, reduced to just the head, upper body and hands, or possibly a little more. She rarely depicts a full-length figure. There are only a small number of groups, the best-known perhaps being *Rhythm* (1924; fig. 19), and pictures of women together, with unmistakably lesbian or at least erotic undertones, even in pictures

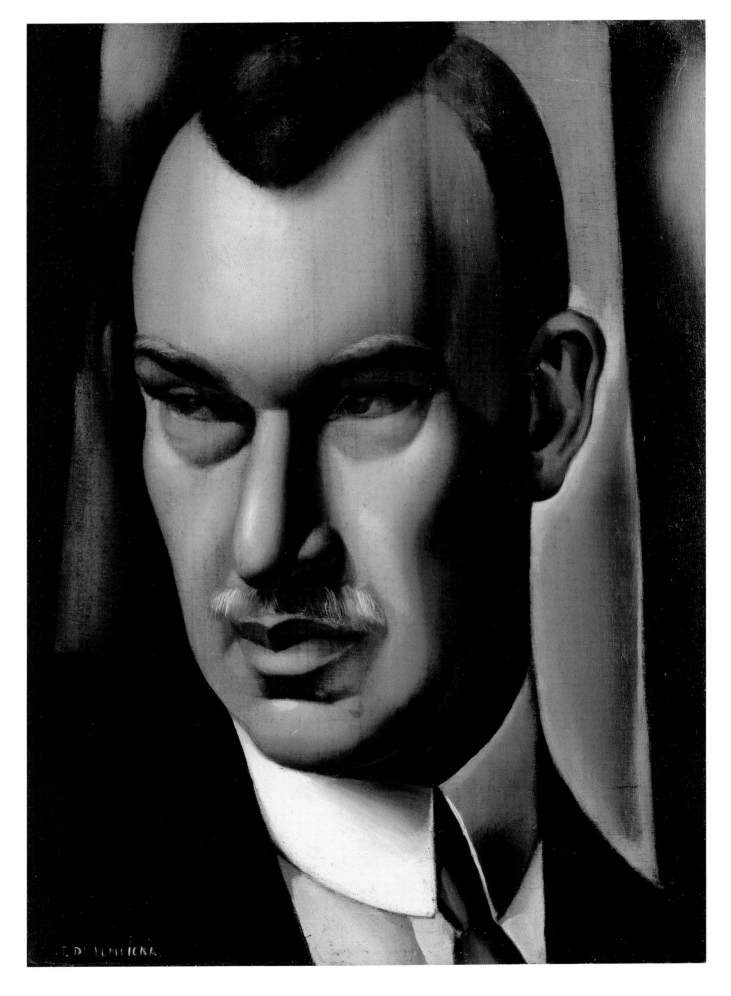

Fig. 17
Group of Four Nudes
c. 1925
Oil on canvas
130 × 81 cm
Private collection

Fig. 18
Pablo Picasso
Friendship
1907/08
Oil on canvas
152 × 101 cm
State Hermitage
Museum, St Petersburg

Fig. 19
Rhythm
1924
Oil on canvas
160 × 144 cm
Private collection

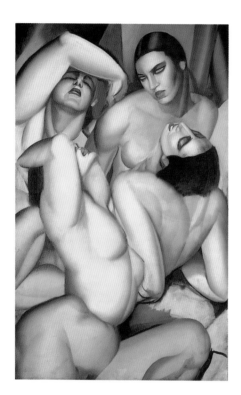

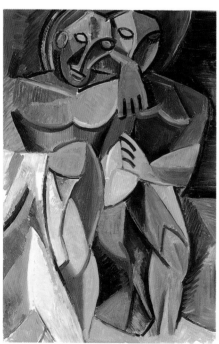

of innocent girls, such as *Two Little Girls with Ribbons* (1925; cat. 13). In rare cases, albeit increasingly in the 1930s, De Lempicka also painted genre scenes with one or more figures, such as *Adam and Eve* (1931; cat. 42),[8] *Idyll* (1931) and *The Refugees* (1931; cat. 50).

The overall aspect of the figures in De Lempicka's work is distinctly asocial. Rarely do they appear with attributes that could draw them into an activity, and those that there are seem to be disconnected additions, be it the book De Lempicka's daughter Kizette is holding but will never read (*c.* 1926; cat. 20), or the flaking backdrop of apartment-block façades in a city where the subject never lived, or the microscope and flask that Dr Boucard is holding but not using for any purpose (1928; cat. 27). These attributes are fakes in one sense, but they point to another motif that underpins almost all of De Lempicka's work: the notion of alienation and rigidification in a world that is no longer home.

The intimate 'I', with its private secrets and inner fire, is concealed within an armoured interior, and is perhaps seductive for that very reason. Sitters hide behind the nonchalant poses that smart society dictated. And in De Lempicka's figure paintings the more general aspect of these poses dominates the distinctive facial features to be found in the portraits, specifically the commissioned works.

But broadly speaking for De Lempicka there is no very clear divide between portraiture and figurative painting. In paintings such as *Group of Four Nudes* (*c.* 1925; fig. 17) or *Rhythm* (1924; fig. 19), and similarly in her numerous depictions of reclining nude or semi-nude female figures, De Lempicka is clearly more interested in physiognomic variations and the configurations of particular forms than in mimetic replication or capturing an accurate likeness.

She borrowed this artistic licence from the avant-garde, whose dissolution and ultimate negation of representationalism and whose preference for formalism had created the conditions for the autarkic work of art. In keeping with this, De Lempicka's work took something of a 'neo-cubist' approach at the outset of her career, at least in its attempt to develop largely independent forms from the architecture of the female body, as in *Seated Nude* (*c.* 1923; cat. 4). The large-format images of women related to the *Demoiselles d'Avignon* (Museum of Modern Art, New York) that Picasso arrived at through his study of primitivism (fig. 18) may have directly inspired De Lempicka in this respect. In Picasso's case, the development of the revolutionary vocabulary of cubism soon brought about the complete disappearance of psychological, normative traits. De Lempicka never went quite this far. Whereas Picasso's motifs were fully autonomous by 1906/07, her formal variety remains rooted in representationalism.

Picasso's response to the demise of the omniscient narrator in literature, as in the writings of Hugo von Hofmannsthal or Paul Valéry, and to a new scepticism in artistic circles was to incorporate them into the mix that became cubism. Whereas in the *Demoiselles* he revolutionised genre painting, in his *Portrait of Gertrude Stein* (1906; Metropolitan Museum of Art, New York) he revolutionised portraiture.

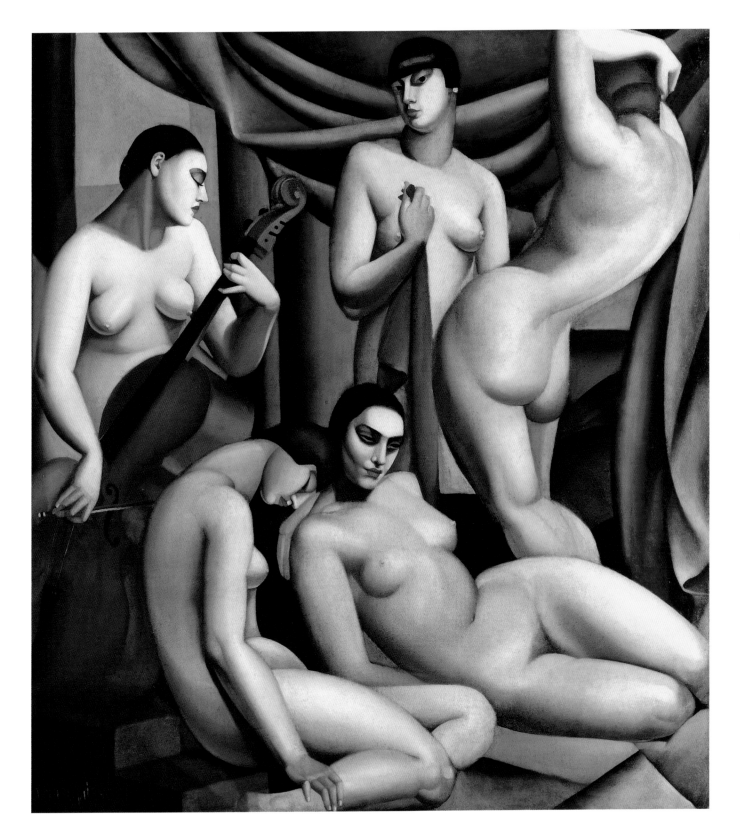

Fig. 20
Mother and Child
1931
Oil on panel
33 × 24 cm
Musée de Beauvais

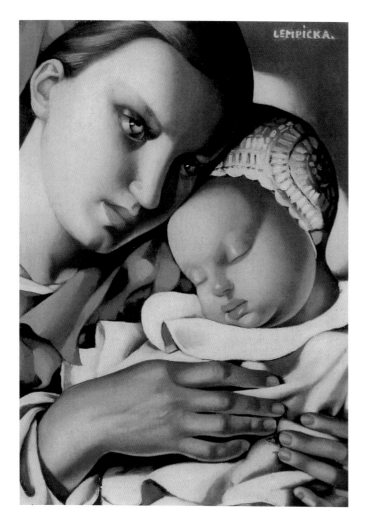

Picasso required ninety sittings of the American writer, a protracted, ephemeral struggle during which his practice of laying claim to the world around him died a slow death.[9] Not only are the Stein portrait and the *Demoiselles d'Avignon* manifestations of a completely new kind of pictorial autonomy, they also bear witness to the scepticism typical of that time, the 'age of suspicion', which saw many great artistic and intellectual achievements emerging in its wake.

De Lempicka's early days as an artist had coincided with a general move towards a new form of representationalism that spread throughout Europe in a variety of guises, from neoclassicism to the new objectivity to post-suprematism. Apart from a short period of abstraction in the 1950s, figurative painting was always the foundation of De Lempicka's artistic dogma and commercial calculations. Having been socialised according to the precepts of the *haute bourgeoisie*, whose outlook she never questioned, and with a conservative political outlook (if at all), she had no interest in the anti-bourgeois thinking of Dada and the Surrealists, nor in the aesthetic of the humble object, heralded by Marcel Duchamp. Any objections or scepticism De Lempicka may have had towards normative beauty and standards were only ever aired in the high-society circles and salons she frequented. As an artist, she devised a form of figurative painting that could reveal the fragmented nature of the individual persona, torn between social considerations and hidden passions.

The static, calculated poses that her figures adopt are part of the formal language that she used to express this 'game'. The constant repetition of these forms, with every structural detail subjected to the closest scrutiny, runs through her *oeuvre* like a thread. After the emphatically plastic, wildly conjoined bodily fragments of her female nudes from the early 1920s (see cats 4–6), her attention turned increasingly to the notion of marshalling the entire composition as one formal entity, as in *Young Lady with Gloves* (1930; fig. 8). Splintered, broken forms find a *modus vivendi* with rounded plastic shapes; each complements the other in a rhythmic interplay of acceptance and resistance. The entire pictorial surface is criss-crossed by lines and shadowy craters, drawn with hyper-realistic accuracy. Draped fabrics stiffen into elaborate pictorial architectures, and fanciful headwear becomes a sculptural event. Formal correspondences integrate figures into their surroundings. The human form becomes part of a spectacular decorative scheme and, as such, is no longer present as a living body.

The life – or inner fire – that De Lempicka breathes into her figures is apparent in the finer points: in subtle adjustments to the positions of limbs and fingers, in a minimal twist of the head or in the uncomfortable angle of the upper body, and above all in the gaze, which can range from dark melancholy through chilly cynicism to supreme elation. But the gaze is never optimistic, and practically never makes direct contact with the viewer. Coolly considering, focused on themselves or on a vision that we can only guess at, De Lempicka's figures look out onto a world that is closed to the

viewer. Even in works containing two or three figures, such as *The Girls* (*c.* 1930), there is an utter lack of interconnection: no understanding glances, no reciprocal actions or emotions. These women casually embracing each other remain strangers; the mother's gaze in *Mother and Child* (1931; fig. 20) is directed somewhere beyond the baby she is holding. In Tamara de Lempicka's paintings any complicity between individuals or with the world has been ruled out. Everyone concerned – the painted figures as much as the viewers – is locked into an isolated cocoon. Ultimately the viewer is drawn into various levels of reality. We read the figures in her paintings simultaneously as formal constructs *and* as manifestations of the human form, and we recognise their facial expressions both as a reflection of the life they have lived *and* as painted attitudes.

In the decorative through-composition of the picture plane that characterises her work, with its mannered vocabulary of forms, abbreviated details, ornamental lines and accentuated plasticity, De Lempicka does at times replicate Art Deco elements in her paintings. The movement's hybrid aesthetic had been on abundant display in 1925 in Paris at the exhibition that was later to give the style its name, the Exposition Internationale des Arts Décoratifs Industriels Modernes. Rejected by the avant-garde as the epitome of bourgeois taste and commercialism, Art Deco influenced the look of a whole epoch, from works of art down to the simplest everyday objects. Like certain works by the American Georgia O'Keeffe, De Lempicka's paintings played a part in creating the style of that time. Yet they are much more than merely a direct translation into painting of an innovative decorative style.

In fact her paintings cannot be penned into the *Gesamtkunstwerk* of Art Deco. Inscribed with the cool demeanour that typified that time, their figures keep the viewer at a distance and yet have immense presence. They are immediately recognisable with their mixture of all-pervasive sensuality and manipulated forms. For, as paradoxical as it may sound, De Lempicka succeeds in replacing the individual, unique human body with a decorative construct of forms, but always without ruining the intrinsic nature of human flesh, without destroying its fascination. In paintings such as *The Slave* (1929; fig. 6), for instance, we see that a work displaying the smoothest painterly technique, with a figure constructed in as mannered a style as any by Pontormo and relying on entirely artificial affect (to the point of appearing downright ridiculous) can be so sensual that one is hard put to resist.

This is due in part to the compelling rhetoric of De Lempicka's figures. Every configuration, every finger position, however contrived, every gaze, however artificial, every shadow delineating the undulations of the human form is reinforced to convey a particular expression, and is hence all the more eloquent. And this is heightened yet further by the artful enlargement of forms, almost as in modern poster art, and the removal of extraneous details. Everything is designed for maximum effect.

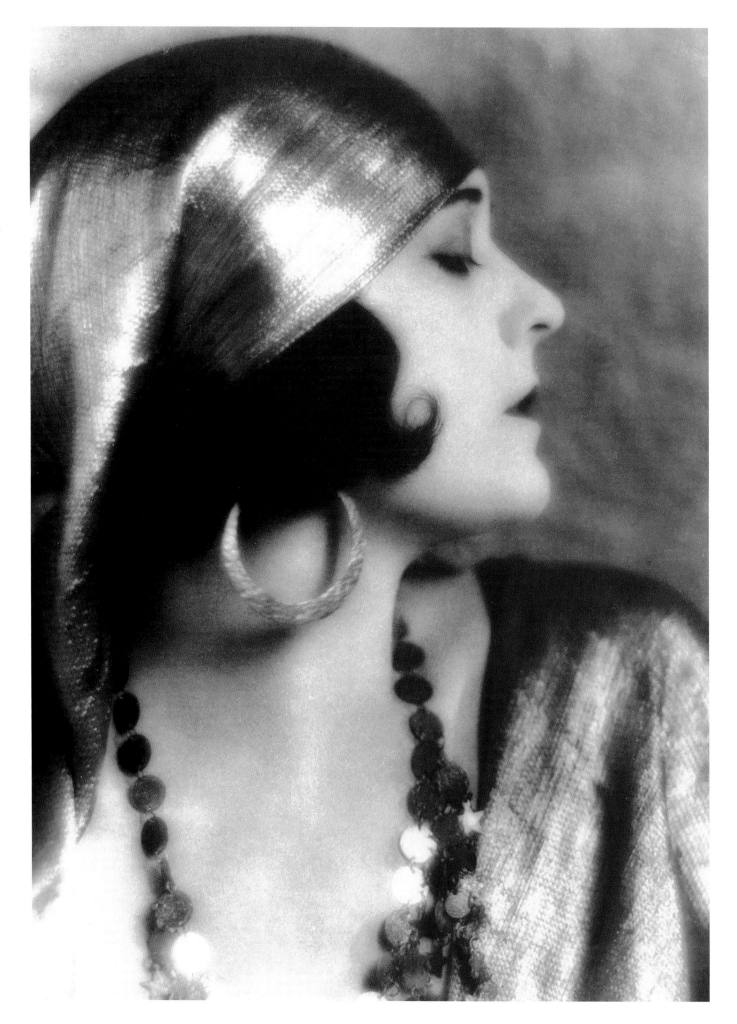

Fig. 21
Portrait photograph
of Pola Negri,
c. 1925

Fig. 22
Lya de Putti in
'Midnight Rose'
(Paramount), 1928

41

De Lempicka is a master of theatricality. Her most important teachers in this respect were the cinema, *the* performing medium of her age, and its stars. Greta Garbo and Mae West, Pola Negri and Lya de Putti were famed for their roles as glamorous vamps (figs 21–22), and De Lempicka borrowed their looks and demeanour for her own protagonists. 'From Europe to Hollywood' was the catchphrase in the international movie world in the 1930s – a route that De Lempicka was herself to take, to add another element to the *mise-en-scène* that was as much a part of her art as of her life.

Somewhat like film stills, De Lempicka's paintings openly declare the underlying subtext of her occasionally frivolous subject matter: her interest in expression was in fact only equalled by her lack of interest in narration. This attitude too has a certain affinity – in the best sense – with the world of poster production.

In *The Slave* she quite blatantly presents 'woman' as a naked, chained prisoner, who achieves a new sexual freedom despite the existing constraints on her gender. The lascivious undertone of the painting is augmented by the languishing gaze taken from the religious iconography of ecstasy, the same gaze that stood for deep emotion in the cinema of the day. Nana de Herrera (1928/29; fig. 5) is presented as a disreputable fury, with a dark bridal veil that teasingly reveals her nakedness: an accessory for adults only. This strange, commissioned portrait of the mistress of her later lover and husband Baron Kuffner appeared on the cover of *Die Dame* in April 1929; the artist's daring interpretation was evidently not at odds with the prevailing conventions of this widely read magazine. In *The Communicant* (1928; cat. 25), the little girl ready for her first Communion, decked out in virginal white and modelled by De Lempicka's daughter Kizette, already carries within her an awareness of lost innocence. With its pointed mixture of symbols, the composition is probably more provocative than any more direct interpretation of the theme could be. De Lempicka replaces compositional narrative with unambiguous symbolism, often in surreal combinations. The dove representing the Holy Ghost at the first Communion is already drawing the veil off the young girl's face, while her ecstatic gaze already speaks of sensuality. In *Woman with Dove* (1931) the white symbol of innocence lies spent in the arms of a naked young woman. And the combination of a photograph and a bunch of lilies in a rectangular vase in *Arlette Boucard with Arums* (1931; cat. 43) makes full use of the symbolic import of the white blooms, opening like so many vulvas.

Although De Lempicka painted relatively few still-lifes, a number include arum lilies (cat. 45). Like the blooms opening in the paintings of Georgia O'Keeffe, they symbolise the female sexual organ, a vision of the female sex that recalls the precepts of Surrealist painting and the 'effect of distant realities'. De Lempicka also uses this highly charged flower in her figure compositions and portraits. In the last portrait she painted of Ira Perrot (1930; cat. 37), the subject embraces a luxuriant bouquet as though it were a long-lost lover.

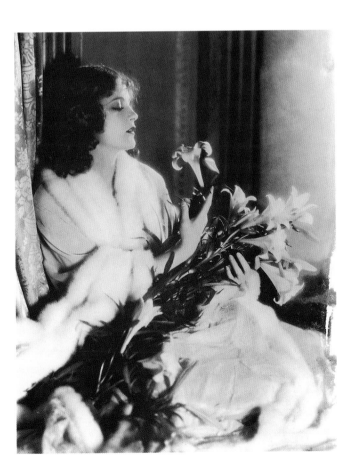

Fig. 23
Paula Modersohn-Becker
*Self-portrait on
My Sixth Wedding
Anniversary*
1906
Oil on canvas
101.5 × 70.2 cm
Kunstsammlungen
Böttcherstraße, Paula
Modersohn-Becker
Museum, Bremen

Fig. 24
Greta Freist
The Dancer
1938
Oil on canvas
100 × 78 cm
Österreichische
Nationalbank, Vienna

42

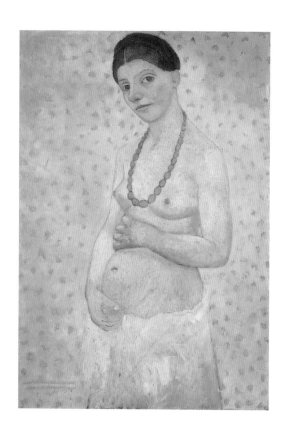

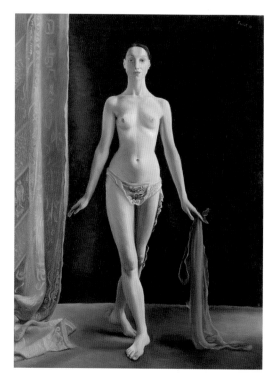

At the date of this portrait Ira Perrot had been De Lempicka's closest friend and favourite model for years and had in all likelihood been one of her first female lovers. Shortly after the portrait was made, the friendship between the two women broke down.

The female body occupies a central position in De Lempicka's work, be it nude or semi-nude, elaborately clad or indecently casually dressed, or in the guise of a symbol. These images reflect not only the artist's personal thematic interest but are also part of the history of the emancipation of art produced by women.

Broadly speaking, the story – leaving aside notable exceptions such as the Renaissance painter Artemisia Gentileschi and the classicist Angelica Kauffman – began in the last third of the nineteenth century when women won the right to a proper training in art. In terms of the genres they tackled, the line of development ran from landscape painting, then lowly, through figurative compositions – often of women – to the depiction of the female body.[10] In fact, the act of painting one's own body – or that of a nude woman – became a declaration of one's own self-determination as a woman. It was a deeply emancipating gesture, first seen in Paula Modersohn-Becker's images of herself in the nude (fig. 23). Even before the female body became synonymous with the aspirations of forward-looking women painters, following a renewed interest in the interwar years in figure compositions and life studies, women artists in Paris such as Suzanne Valadon had already discovered the female nude. Nude self-portraits, however, remained the exception: the taboos were just too powerful. A rare exponent of the genre was the Austrian Greta Freist, who had emigrated to Paris, and who, in the spirit of the Neue Sachlichkeit, portrayed herself as a naked dancer (fig. 24). The reappropriation of the female body continued to be a crucial cause in women's art throughout the feminist actions of the 1960s and 1970s and until very recently. With the collapse of the gender debate in recent years, the notion of a woman striving for self-determination over her own body has all but disappeared from contemporary art.

In the paintings De Lempicka made in Paris, the female form stands for the self-determination of women, portrayed at times as independent, modern, urbane creatures, at times as the incarnation of free, homosexual love. In De Lempicka's extended sequence of female nudes, none is described as a 'nude self-portrait'. Nevertheless, we can discover the stylised features of the artist's face, as it were *incognito*, in paintings such as *Myrto* (1929; fig. 27), with its two female nudes.[11]

Any history of the emancipation of women artists ought to record not only De Lempicka's artistic strategies, but also the methods she adopted to further her career. She was one of the most commercially successful artists in the French capital. Her conspicuous consumption of the rewards of this success, for which she was constantly reproached and which even then raised the suspicion that she need not be taken seriously as a painter, can also be seen in a more positive light: the fact is that De Lempicka was a far more skilled salesperson than many of her male colleagues.

Fig. 25
La Belle Rafaëla
1927
Oil on canvas
65 × 92 cm
Private collection

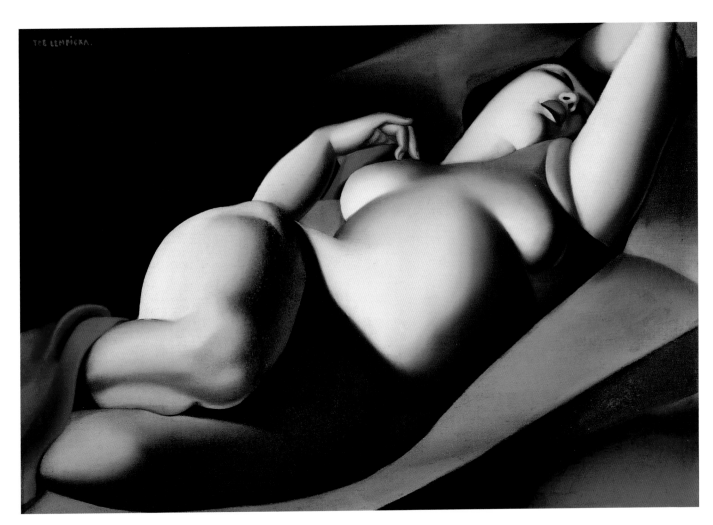

By 1927, the year De Lempicka painted Rafaëla (fig. 25, cat. 22), she had already produced numerous female nudes, including such provocative pictures as *The Model* (1925; fig. 3), which concentrates entirely on the female body; as we have seen, other compositions portray groups with openly lesbian undertones. *La Belle Rafaëla* was one of her most extraordinary works. The model was a young *demimondaine* whose outstanding beauty struck the artist as she walked in the Bois de Boulogne.[12] Rafaëla sat for at least six nude paintings, despite the danger of her being accused of a lesbian dalliance. The majority of the bourgeois public in the 1920s had by no means come to terms with homosexuality, and when the writer André Gide, a close friend of De Lempicka, openly broached the subject in *Corydon*, the response was hostile enough to do lasting harm to his election to membership of the Académie Française. The expectation was that men and women alike would, at the very most, only toy with the notion. De Lempicka went further than most in this respect, both in her private life and in some of her very explicit paintings.

44

1 For more on the biography of Tamara de
 Lempicka, see Laura Claridge, *Tamara de
 Lempicka: A Life of Deco and Decadence*,
 New York, 1999.
2 Lhote defended classicism as 'new cubism'.
 In 1912 he co-organised the exhibition *La
 Section d'or*, which was intended to make
 cubism accessible to a wider public and
 contained works specifically selected to
 draw attention to synthetic cubism's
 representational aspect. It seems likely
 that De Lempicka saw this show on one
 of her trips to Paris.
3 She had travelled in Italy and studied Italian
 art since her earliest years. Numerous
 records exist of her active interest in
 Italian painting from the fifteenth and
 sixteenth centuries.
4 See Claridge, 1999, p. 89.
5 Kizette de Lempicka-Foxhall, Interview with
 Laura Claridge, Houston, March 1997, cited
 in Claridge, 1999, pp. 97–98.
6 Comment by Victor Contreras, De Lempicka's
 last partner, made in June 1996 to Laura
 Claridge in Cuernavaca, cited in Claridge,
 1999, p. 103.
7 For more on De Lempicka's work for *Die
 Dame*, see Claridge, 1999, pp. 149–51.

8 The male model for Adam was a police
 officer on the beat in De Lempicka's
 neighbourhood. The painting itself was
 intended as a poster for a film entitled
 Sexuality that was banned after the
 intervention of the police chiefs in Paris.
 See De Lempicka in I. Zaslawsaka,
 'Tamara de Lempicka', *Kobieta Wspolczesna*
 (*The Modern Woman*), 20 July 1932.
9 For more on Picasso's Portrait of Gertrude
 Stein, see Werner Spies, 'Das Porträt als
 Manifest', in Werner Spies, *Kunstgeschichten.
 Von Künstlern und Bildern im 20.
 Jahrhundert*, Henning Ritter (ed.), vol. 1,
 Cologne, 1998, pp. 53–60.
10 See Ingrid Brugger, 'Natur – Figur –
 Körper', in *Jahrhundert der Frauen. Vom
 Impressionismus zur Gegenwart. Österreich
 1870 bis heute*, Ingried Brugger (ed.),
 Vienna, 1999, pp. 21–42.
11 This painting, acquired by Pierre Boucard,
 a collector of De Lempicka's work, and
 requisitioned by the Nazis, has never
 re-emerged.
12 See Claridge, 1999, p. 151.

Lost to the world in her own voluptuous, self-confident nakedness, *La Belle Rafaëla* immediately catches the viewer's attention with her narcissistic pose. The figure itself is composed of weighty, plastic forms; her sharply outlined musculature swells in the highs and lows of a dramatic chiaroscuro that owes a debt to Caravaggio and his school. The colours are kindled by the glowing red of her lips, the red drapery and the milder echo of red in the floor area. The body and the couch are painted in delicate tonal colours whereas the background behind the gleaming upper thighs sinks into deepest black.

However eloquent, this female form is entirely bereft of any realistic detail, of the sort that had been so shocking in Gustave Courbet's scandalous *The Origin of the World* (fig. 26): no pubic hair, no open vulva, no sense of the flesh seeming arousing or material. And even in a comparison with the work of Christian Schad – closer to De Lempicka in art-historical terms and one of the outstanding exponents of the Neue Sachlichkeit in Germany – her uncompromising avoidance of any embellishment or narrative detail is very apparent.

Rafaëla's body and its message are transposed into an exalted realm. De Lempicka constructs the pictorial figure from symbolic, tailor-made forms (substitutes for 'real' flesh), and thereby plays with two possibilities: the overall image – and its obviously figurative nature – and the *pars pro toto*, which is autonomous in its form. The puppeteer Hans Bellmer, albeit following a very different path, later experimented with something very similar.

The transfer of content into form, as in paintings such as *La Belle Rafaëla*, catapulted the artist into one of the main currents of modernism, as had the liturgy of isolation intoned by her work in the 1920s and 1930s. Again and again De Lempicka endows her female figures with characteristics that set them apart from genre painting, mythology or religious iconography. Their sophisticated air and studied gestures compensate for the impossibility of their social integration. No motif was too clichéd for her, no attitude too sentimental to be included in a painting as a figure's possible – but ultimately impossible – escape route.

De Lempicka loved the views framed by windows in Italian Renaissance portraits, and adapted the technique to suit her own work. Typical Renaissance elements are replaced by motifs from modern life: the skyline of Manhattan, yachts as the playthings of the leisured classes, modernist forms. In the paintings of the Italian masters, views of the outside world add another layer of narrative that breathes additional life into the subject. By contrast, the modern background designs in De Lempicka's portraits, as static as the pictorial figures themselves, underline the separation of the subjects from the world around them. The urban desert in *Nude with Buildings* (1930; cat. 35) is petrified and cold, the body of this half-nude of a young woman seems to have been frozen. Hopelessness and melancholy are encapsulated in her gaze; rigid gestures and the inability to communicate are her lot.

Fig. 26
Gustave Courbet
The Origin of the World
1866
Oil on canvas
46 × 55 cm
Musée d'Orsay, Paris

Fig. 27
Myrto
1929
Oil on canvas
Dimensions unknown
Whereabouts unknown

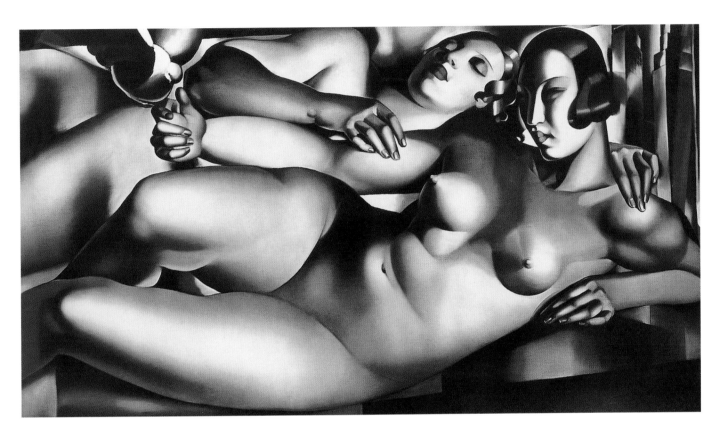

The upward gaze from the green eyes of *The Convalescent* (1932; cat. 46) appears to be a plea for sympathy and yet it is only a game; the modesty that compels her to adjust her lace gown to hide her nipple is pure calculation. In De Lempicka's hands the iconography of St Teresa of Avila turns into a profane image of unrequited sensual ecstasy. De Lempicka's modern-day Andromeda remains chained, and the grand gestures and attitudes of wealth and power that attach to so many of the personalities she painted evaporate in the realm of an all-consuming ego.

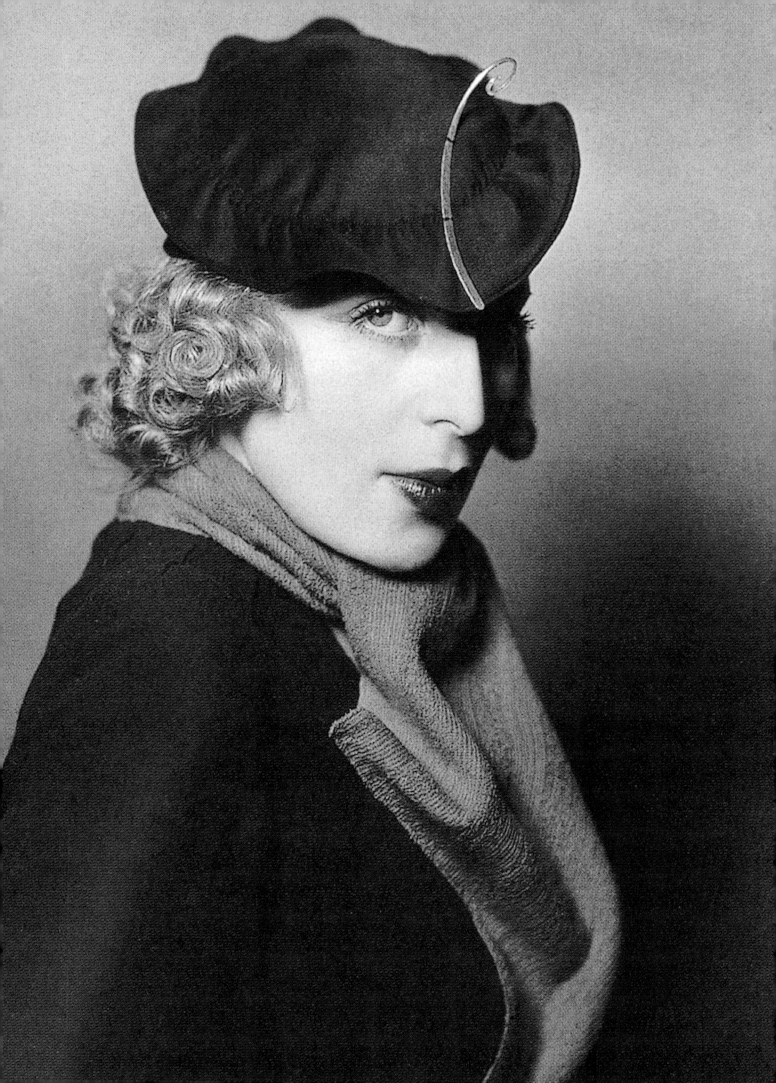

'Le Peintre installé par la femme'
Femininity and the Woman Painter

Tag Gronberg

'Tamara de Lempicka ou la femme installée par le peintre', the title of a 1950s article on De Lempicka's redecoration of her Parisian studio apartment,[1] is difficult to translate. 'The woman set up, or produced by, the painter' sounds clumsy when compared with the French, whose allusive wording draws attention both to gender and to the artist's living and working environment. Given the crucial role that femininity played in De Lempicka's construction of her public persona as a painter, it could be argued that the reverse formulation, 'le peintre installé par la femme', describes even more effectively her professional identity at the peak of her career in Paris during the 1920s and 1930s. During these decades, De Lempicka was well-known as a painter of female nudes and portraits. Although she produced some of the period's most iconic images of the modern woman – women portrayed as either fashionably boyish, *à la garçonne*, or more powerfully masculinised, as the *amazone*[2] – she promoted, in terms of her own appearance, a highly feminised image. Throughout her life she cultivated a chic appearance and posed for many glamorous portrait photographs (fig. 28), encouraging comparisons between herself and film stars, such as Greta Garbo.[3] But it is important to recognise that De Lempicka's cultivation of feminine celebrity involved more than individual self-preoccupation. Indeed, her career provides valuable insights into the artistic self-display and urban spectacle that formed an intrinsic aspect of Parisian modernity at this time.

De Lempicka's arrival in Paris in 1918/19 coincided with a period in which many émigré artists were forging careers in the French capital.[4] Women too found opportunities in the Parisian art world, as models (the traditional occupation) but also increasingly as artists and dealers.[5] Numerous opportunities existed for women to study and practise art, particularly in Montparnasse, which was well-known as an artistic quarter of the city. In certain, albeit frequently circumscribed, terms a woman artist's femininity was positively validated as an artistic virtue. For example, the painter Marie Laurencin was praised for embodying a quintessential Frenchness, while the work of others, including the Russian Sonia Delaunay, was identified with the exotic. Thérèse Bonney, one of the first women to receive a doctorate from the Sorbonne, went on to enjoy a successful career as a photographer in Paris (she was to produce work for De Lempicka, as well as for many other artists and designers). Bonney was American, and America's affiliation with modernity often worked to her advantage in securing photographic commissions.[6] Women in Paris could deploy being both foreign and female as professional assets in a variety of ways. Like De Lempicka, Bonney made strategic use of photographic portraits of herself for publicity purposes. A photograph of about 1925 that she used frequently shows her wearing a silk *crêpe-de-Chine* dress made from a Stehli Silks printed fabric entitled 'My Trip Abroad' (fig. 29). The fabric reproduced a detailed map of Paris with its streets and monuments. Another photograph (also 1925) shows Bonney at the wheel of a car in front of the Eiffel Tower (fig. 30). Not merely autobiographical images, such depictions can be seen as a witty update on and a feminine appropriation of the concept of the artistic *Bildungsreise*.

These photographs of Bonney define modernity in terms of women's mobility and freedom, with implications of self-determination and the ability to make one's own way in the modern world. Crucial too of course was the identification with Paris, still widely perceived as *the* artistic capital. The dynamic composition of De Lempicka's *My Portrait* (1929; cat. 34), showing the artist driving a green car and painted at around the same time as Bonney had had herself photographed, conveys something of the same exhilaration. De Lempicka was equally aware of the strategic role of the fashionably dressed female body in defining modernity. Whereas Bonney staged

Fig. 28
Photographic portrait
of Tamara de Lempicka
by Madame d'Ora, *c.* 1929

Fig. 29
Thérèse Bonney
wearing a silk *crêpe-de-Chine* dress made
of a Stehli Silks print
known as 'My Trip
Abroad', *c.* 1925

Fig. 30
Thérèse Bonney at the
Eiffel Tower, *c.* 1925

herself wearing a map of Paris, De Lempicka is shown driving a car that is colour-co-ordinated with her stylish outfit.[7] By contrast with a painting such as Fernand Léger's *Mécanicien* (1918), which embodies a 'machine aesthetic' through its heroic figure of the mechanic, the dynamism of De Lempicka's green car is presented as an extension of the woman artist's fashionable ensemble. In a similar way, at the 1925 Paris Exposition Internationale des Arts Décoratifs Industriels Modernes, Sonia Delaunay's designs for abstractly patterned motoring outfits and matching car paintwork were photographed outside the architect Robert Mallet-Stevens's Pavilion of Tourism (fig. 31).[8] De Lempicka's account tells how she painted her self-portrait on the French Riviera in Monte Carlo, the centre of glamorous high life. Like Delaunay's, her image of feminine motorised mobility was thus associated less with the dynamism of power and speed than with the glamour of exclusive tourism. Representations of a French-based feminine modernity by women such as De Lempicka, Bonney and Delaunay were marketed to international audiences: De Lempicka's self-portrait had been commissioned as the cover of the Berlin women's magazine *Die Dame*; Bonney was extensively involved in writing articles on France for American magazines and newspapers; and the photograph of Delaunay's geometrically patterned car appeared in journals in Germany and Australia. Modernity is often defined in terms of city life, through reference to crowded urban streets, shops and sites of entertainment, the result of new technologies, industrialisation and mass-production. Its attributes are characterised as novelty, movement and speed, and in these terms the car functioned as one of its most powerful emblems.

There were other, in some ways more significant, ways in which women practitioners could represent their engagement with modernity and with the contemporary art world, among them the design of their homes and workplaces. In 1927, for example, Bonney had the architect Gabriel Guévrékian design the interior of her small Parisian studio flat at 82 Rue des Petits Champs.[9] Here again, her status as an American working in Paris provided the main theme for the decor. The rooftop terrace was designed as a ship's bridge, the wall was covered with a Stehli Silks 'Manhattan' print and there was a glass-enclosed 'American bar'. In an essay of this period, Bonney celebrated the modernity of Parisian interiors: 'Paris has not its skyscrapers, but has, on the other hand, an ever-increasing number of ultra-modern homes…The Parisienne…is becoming used to the new lines of the modernistic school, she instinctively demands that the same spirit repeat itself in the furniture and accessories of her interior. Fortunately, there is a new and vigorous movement in Paris, that of the decorative arts, in which the best artists and artisans of France are employing their talents in modernising the accessories of the house.'[10]

Although Bonney stressed the role of the Parisienne in promoting 'modernistic' interiors, there were (as in Bonney's own case) a number of foreign women artists based in Paris who commissioned homes from architects well-known for the modernity of their designs. These

Fig. 31
Sonia Delaunay's designs
for motoring outfits and
matching car paintwork
at the Paris Exposition,
1925

included the sculptors Chana Orloff and Dora Gordine who employed Auguste Perret to design their studio-houses.[11] Such houses represented not only suitable domestic and professional accommodation for the artist-practitioner, but also desirable new architectural forms for modern urban living more generally.

In 1929, De Lempicka bought a duplex apartment designed by the architect Robert Mallet-Stevens at 29 Rue Méchain in Montparnasse. By this date, Mallet-Stevens was well-known, both as an architect of stylish urban villas and for his pavilions at the 1925 Paris Exposition. Following his success at the Exposition, he had further consolidated his reputation with the opening in 1927 of the Rue Mallet-Stevens in Auteuil, in the 16th *arrondissement* of Paris.[12] Like André Lurçat's 1924–26 group of studios and houses in the Rue Villa Seurat (Montparnasse), Mallet-Stevens's 'street' (in fact a cul-de-sac) created a virtually self-contained artistic environment. His sequence of five studio-houses was an important manifestation of the home redefined through the practice of art. In addition to Mallet-Stevens himself, the street numbered a pianist (Mme Reifenberg), two sculptors (the brothers Jan and Joel Martel) and a film-maker (Allatini) among its residents. As is signalled by the fact that it was named after its designer, the street was a dramatic means of asserting and displaying artistic identity and reputation. Although these *maisons-studios* included spaces for artistic production (the Allatini villa, for example, had a 150-seater cinema), they were intended to convey the status of their inhabitants as successful professionals working in the arts through the display of their modern design (inside as well as out). The inauguration of the street was a high-profile event, attended by public officials and recorded as a documentary film. De Lempicka's purchase of a Mallet-Stevens apartment in 1929 was indicative both of her success as a painter and of her ambition to deploy modern architecture and design to extend her public self-representation as an artist.

However, De Lempicka's concern with the promotion of her image as a successful woman artist predated the acquisition of her new apartment. Throughout her career, she mixed with well-known photographers whose many photographs of her and her homes are undoubtedly as much the product of her careful stagings as they are of the photographers' compositions. A photograph by J.-H. Lartigue from 1928 shows a room in De Lempicka's apartment on the Rue Guy de Maupassant (Montparnasse) (fig. 32). Clearly showing the residence of an artist, the photograph reveals two large-scale portraits: a full-scale charcoal sketch of Dr Pierre Boucard (one of her principal patrons) propped on an easel, and the *Portrait of the Duchess de La Salle* (1925; cat. 17) hanging on the wall. The sketch, prominently positioned in the foreground, suggests work in progress, and yet it is displayed in what appears to be the artist's bedroom. Here the public realm of work and the intimacy of the feminine boudoir coincide. Boucard's portrait suggests the idea of the professional at work at two levels: De Lempicka as portraitist,

Fig. 32
Photograph by J.-H.
Lartigue of the bedroom
in De Lempicka's Rue
Guy de Maupassant
apartment, 1928

Fig. 33
Lacquer headboard
design by De Lempicka
for her bedroom
in the Rue Guy de
Maupassant apartment
c. 1925
Crayon on paper
13.3 × 20 cm
Private collection

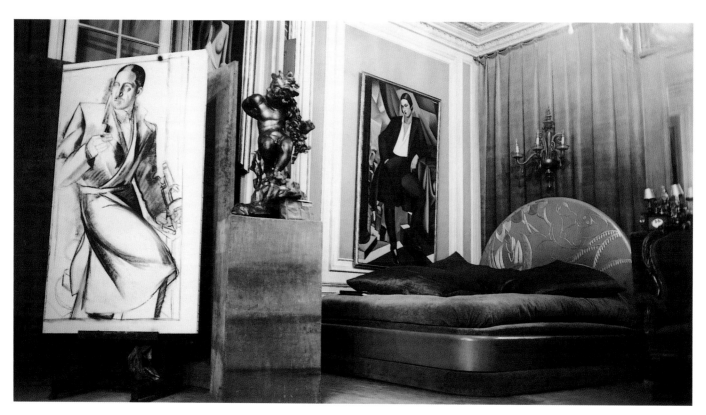

and Boucard as scientist, wearing a laboratory coat, holding a test-tube and standing next to a microscope. The 'return' to figurative painting during the interwar years in France involved a renewed preoccupation with portraiture, and this included the portrayal of the modern professional.[13] Edouard Vuillard painted a number of large-scale portraits showing his sitters surrounded by the accoutrements of their profession, for example the fashion designer Jeanne Lanvin at her desk (1933; Musée d'Orsay, Paris) and Dr Louis Viau standing next to his dental apparatus (1936–37; Musée d'Orsay, Paris, on deposit with the Musée de Prieuré, Saint-Germain-en-Laye).[14] Lartigue's photograph of De Lempicka's bedroom functions both as a depiction of such portraiture and (despite the fact that she does not actually appear) as a portrait of the painter. The femininity of the woman artist is strongly, albeit indirectly, conveyed, the lush setting of the bedroom a counterpoint to the dashing attire of the duchess, portrayed *en amazone*.[15] Juxtaposed with this portrait is the bed's headboard, a motif in lacquer designed by De Lempicka showing two intertwined female nudes in a landscape (fig. 33). In this *mise en scène*, intimations of female sexuality and professional artistry are presented to suggest a symbiotic interrelationship.

As someone highly attuned to the promotional potential of photography, De Lempicka was perhaps especially appreciative of Mallet-Stevens's concern with what he referred to as 'photogenic architecture'. During the second half of the 1920s he had worked

Fig. 34
Photograph by
Thérèse Bonney
of De Lempicka's
mezzanine library
at 29 Rue Méchain,
showing the artist's
intials decorating the
customised upholstery

Fig. 35
Photograph by M. Gravot
of the bedroom at 29
Rue Méchain, 1930

extensively as a set designer for the cinema, but his buildings could
also be said to evince this quality; soon after completion, the Rue
Mallet-Stevens was used for fashion shoots and also as a location
for films.[16]

The interior decor of De Lempicka's flat in the Rue Méchain was
co-ordinated by her sister, the architect Adrienne Gorska. Furniture
and fittings were procured from well-known modernist designers
such as René Herbst and Djo-Bourgeois; sculpture by the Martel
brothers was also on display. The apartment included a large, double-
height studio, perhaps as much for display as for work. As we saw in
Lartigue's photograph of the bedroom in the Rue Guy de Maupassant,
De Lempicka used her apartments to represent her personality and
lifestyle. This staging provided not only a context but also status and
meaning for her paintings. It is not surprising to discover that in the
Rue Méchain apartment De Lempicka's name appeared as part of
the decor: a photograph by Bonney shows the mezzanine library with
the initials T and L forming a geometrical motif on the furniture's
upholstery (fig. 34). Like many other architect-designed studio-houses
of the period, De Lempicka's Rue Méchain apartment constituted the
means for the performance of professional identity, a performance
that included the artist and her work as much as the carefully
contrived setting. The apartment received extensive coverage in arts
magazines, and something of its spectacle is conveyed by a Polish
journalist, who described it as 'empty, smooth; the walls are painted
grey...like in an aquarium in the half-light'.[17] Far more than simply
a home in which to work, the flat at 29 Rue Méchain, like the glass-
encased, strategically lit underwater environment of an aquarium,
was a dramatic display device.

The most astonishing design for an artist's home at this period
was based on a similar notion. In 1927, the Viennese architect Adolf
Loos designed a Parisian home for the famous American revue
performer Josephine Baker.[18] Outside, the building was to have been
embellished with bold, black-and-white stripes; inside, its most
dramatic feature was a double-height, illuminated swimming pool
with large glass windows, enabling guests to view Baker performing
in the water. Never executed (and perhaps more a homage on the
part of the architect than a realisable plan), Loos's design is notable
for the way in which it deploys architecture as a means of
representing female celebrity in terms of sexuality.

As with the design for Baker's house, a key element of the display
constituted by De Lempicka's apartment was its owner's gender.
An article published in January 1931 with extensive photographic
coverage makes this clear.[19] Vaunted as epitomising the most
advanced modern design, De Lempicka's apartment is attributed to
the art and taste of its inhabitant. There are references to its many
gleaming metal and reflective surfaces – tubular steel railings, metal
furniture – and to its colour scheme: the more intimate rooms, such as
the artist's bedroom and dressing area, were pink. The article closes
with a photograph of what seems to be De Lempicka's bedroom, light

52

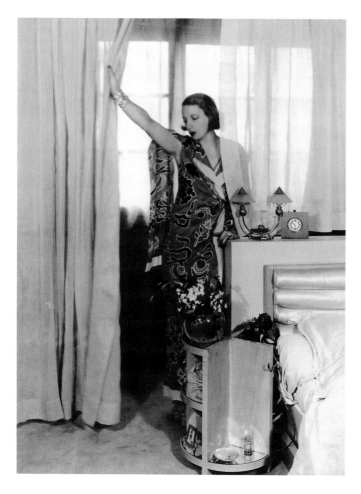

filtered through gauze curtains revealing discarded clothing draped over the bed and kicked-off shoes on the floor (fig. 35). Unlike Lartigue's photograph of the Rue Guy de Maupassant apartment, none of the images published in 1931 makes a feature of De Lempicka's paintings; instead, the interiors are filled with vases of flowers, including arum lilies, whose heady sensuality is a signature motif of so many of the artist's works. Furniture is arranged to suggest socialising rather than painting, an effect reinforced by other photographs showing the modern bar on the mezzanine floor and the telephone close to De Lempicka's bed.

More than an artist's workplace – like for example the painter Amedée Ozenfant's studio-house (1922–23) designed by Le Corbusier, with its spartan interior containing basic bentwood furniture and worktables[20] – De Lempicka's apartment resembled a set for a film depicting the glamorous lifestyle of the rich, a genre popular in French cinema and just the sort of production on which Mallet-Stevens had worked so successfully in the 1920s. The numerous articles by the journalist Jacqueline d'Hariel about De Lempicka's receptions and cocktail parties must have conjured up similarly cinematic scenes of a glittering social life in the minds of her readers.[21] Journalistic coverage undoubtedly lent cachet to De Lempicka's paintings and would have enhanced demand from certain kinds of clients. This is not to imply that De Lempicka was anything less than serious about either her work or the promotion of her career. Quite the contrary; by investing in her modern apartment and celebrity lifestyle she was able to present herself to the public in ways that successfully negotiated longstanding cultural prejudices and stereotypes. In the 1920s women artists (like other successful professionals) could still be accused of being 'defeminised' by their work; De Lempicka countered this with numerous photographs showing herself exquisitely dressed or seductively posed in her pink bedroom (fig. 36).[22] In her self-representation as well as in her other work, she appropriated a number of ideas from the contemporary film industry – the celebrity photograph, as well as the stylised facial expressions and expressively upturned eyes of its most glamorous actresses – to depict desirable, modern forms of femininity.

Given these borrowings from the cinema, it was only fitting that De Lempicka should have been filmed in her apartment. A 1932 newsreel entitled 'Un Bel Atelier moderne' depicted her at home, being waited on by her butler and sitting at her dressing table. She was also shown at work, sketching the cabaret singer and nightclub owner Suzy Solidor (1933; fig. 37).[23] This picture combined the two genres for which De Lempicka was most well-known: portraiture and nude painting. In the completed work, Solidor is depicted half-length, arm raised above her head and posed against the urban backdrop that appears in many of De Lempicka's nudes and portraits. The timelessness so often associated with the female nude is here countered not only by the cubic forms of modern architecture but also by Solidor's gleaming hair, the bobbed cut with its chunky fringe

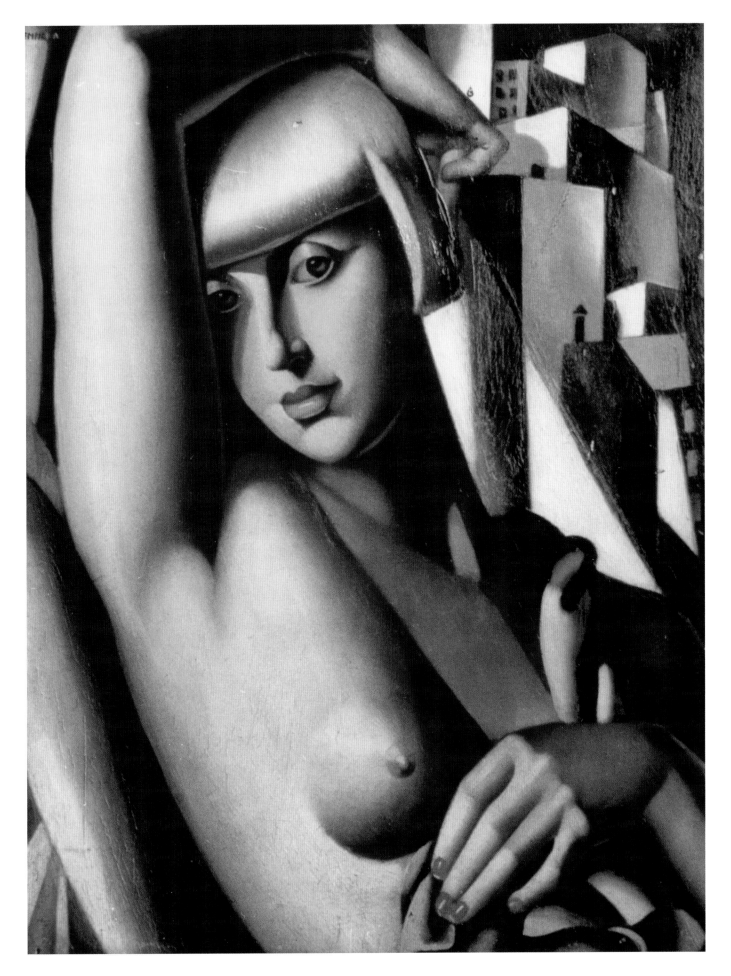

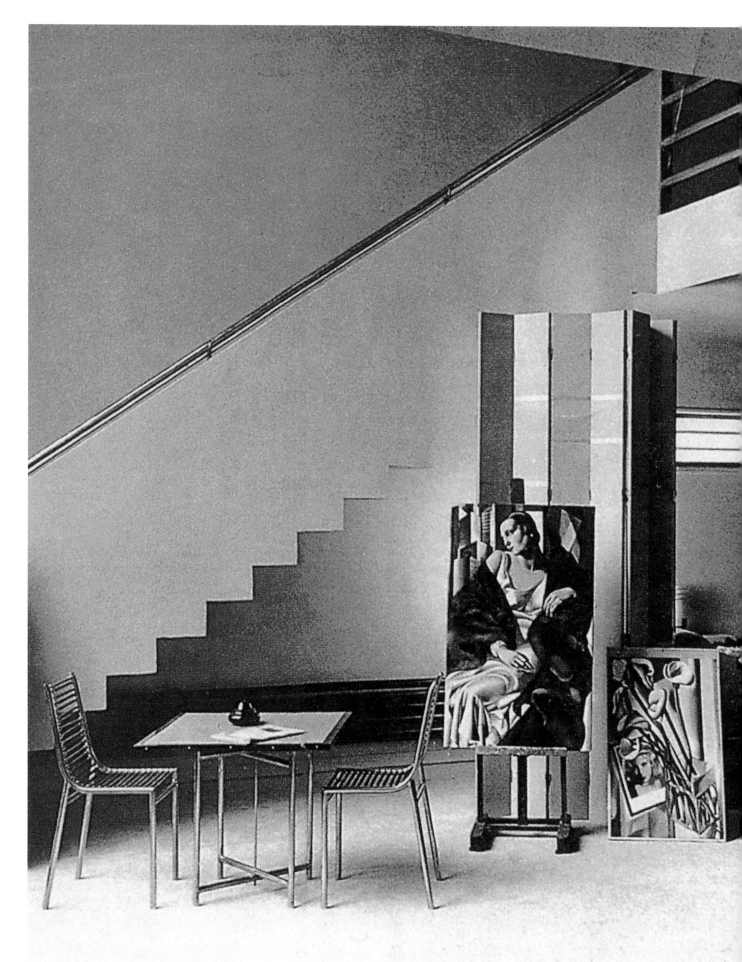

Fig. 38
Photograph by M. Gravot
of De Lempicka's studio at
29 Rue Méchain, showing
the *Portrait of Mme
Boucard* (1931; fig. 39)
and *Arlette Boucard with
Arums* (1931; cat. 43)

striking a distinctively contemporary note. The film's conjunction of
De Lempicka at her toilette and at her easel was far from fortuitous.
The claim that women artists' talent lay in their unconscious
'feminine' narcissism, that women artists worked on their *toiles*
(canvases) in much the same way as on their toilette, was by this date
a well-established truism.[24] Such condescending attitudes were to
some extent problematised by women painters' depictions of the
female nude. At one level these could be seen as the product of a kind
of narcissistic identification on the part of the artist; on the other
(more disturbingly) as the manifestation of sexual desire. The critic
Arsène Alexandre, who famously referred to De Lempicka's 'perverse
Ingrisme', claimed that De Lempicka was 'une bien étrange artiste'
whose work confounded the binary oppositions between the
voluptuous and the chaste (*volupté*/*chasteté*), the beast and the angel
(*bête*/*ange*). The 'perversity' of De Lempicka's painting, the suggestion
of fluid and unstable gendered identities, constituted an aspect of the
modernity of her work.[25] In the 1932 film, as in their lives more
generally, neither Solidor nor De Lempicka were content to play
a passive role as objects of representation. Both were intensely
preoccupied with the production and control of depictions of
themselves in order to create a public persona (Solidor was to write
Deux Cents Peintres: un modèle, an account of the many portraits
she commissioned, some of which hung in her nightclub), and both
rejected the mores of conventional female heterosexuality.

For De Lempicka, a crucial aspect of this self-staging was of
course the promotion of her painting. Not only did her stylish new
apartment show off her lavish lifestyle, but (like other artists who
lived in studio-houses at this time) she used it to display her work to
a select public. De Lempicka was successful in exhibiting her work in
public salons and with private dealers, but shows in her Rue Méchain
studio enhanced her paintings' modernity, glamour and exclusivity.
Such displays were staged both for visitors and for photographers.
An artfully composed photograph of the early 1930s (fig. 38), for
example, shows two portraits: that of Mme Boucard set on an easel
in front of a folding screen; and next to it, on the floor and propped
against the screen, a portrait of her daughter, Arlette. The
photograph's empty foreground suggests a stage, with the portraits'
sitters as the actors, a means perhaps of conjuring up the social
milieu regularly entertained by the artist in this same space. Mme
Boucard's portrait (1931; fig. 39), with its figure-clinging satin dress
and furtrimmed wrap, is typical of the movie-star glamour of De
Lempicka's female portraits. The careful delineation of the sitter's
make-up (lipstick, nail polish and thinly tweezered eyebrows) and
her elegant jewellery shares something with the conventions of
contemporary fashion photography and illustration. The shiny
surfaces of De Lempicka's flat were the perfect foil to this highly
burnished image of modern femininity. *Arlette Boucard with Arums*
(1931; cat. 43) is conceived in a rather different vein: it takes the form
of a still-life of a vase of lilies next to a portrait photograph of Arlette.

Fig. 39
*Portrait of Mme
Boucard*
1931
Oil on canvas
135 × 75 cm
Private collection

1 Boris J. Lacroix, 'Tamara de Lempicka ou la femme installée par le peintre', *Art et décoration*, December 1956, pp. 9–12.

2 On the 'modern woman', see *The Modern Woman Revisited: Paris Between the Wars*, Whitney Chadwick and Tirza True Latimer (eds), New Brunswick, N.J., and London, 2003.

3 A number of these were taken by women photographers, such as the Austrian Dora Kallmus (known as Madame d'Ora); see *Madame d'Ora Wien–Paris. Vienna and Paris 1907–1957: The Photography of Dora Kallmus*, exh. cat., Vassar College Art Gallery, Poughkeepsie, N.Y., 1987.

4 See, for example, Kenneth Silver, *The Circle of Montparnasse: Jewish Artists in Paris, 1905–1945*, New York, 1985; and *Paris: Capital of the Arts 1900–1968*, Sarah Wilson (ed.), exh. cat., Royal Academy of Arts, London; Guggenheim Museum, Bilbao, 2002.

5 The growing literature on this subject includes Bridget Elliott and Jo-Ann Wallace, *Women Artists and Writers: Modernist (Im)positionings*, London and New York, 1994; Gill Perry, *Women Artists and the Parisian Avant-Garde: Modernism and 'Feminine' Art, 1900 to the Late 1920s*, Manchester and New York, 1995; and Chadwick and Latimer, 2003. See also the exhibition brochure, *'Elles de Montparnasse': artistes, modèles, inspiratrices, inspirées*, Musée du Montparnasse, 2002; and on women writers, Shari Benstock, *Women of the Left Bank: Paris, 1900–1940*, Austin, Tex., 1986.

6 On Bonney's interwar career, see Lisa Schlansker Kolosek, *The Invention of Chic: Thérèse Bonney and Paris Moderne*, London, 2002.

7 Kizette de Lempicka-Foxhall and Charles Phillips, *Passion by Design: The Art and Times of Tamara de Lempicka*, New York and Oxford, 1987, pp. 76–77.

8 On Delaunay's participation in the 1925 Exposition, see Tag Gronberg, *Designs on Modernity: Exhibiting the City in 1920s Paris*, Manchester and New York, 1998; and Tag Gronberg, 'Paris 1925: Consuming Modernity', in *Art Deco 1910–1939*, Charlotte Benton, Tim Benton and Ghislaine Wood (eds), exh. cat., Victoria and Albert Museum, London, 2003.

9 Elisabeth Vitou, Dominique Deshoulières and Hubert Jeanneau, *Gabriel Guévrékian 1900–1970: Une Autre Architecture moderne*, Paris, 1987.

10 Thérèse Bonney, in *Arts & Decoration*, September 1927; quoted in Kolosek, 2002, p. 154.

11 Chana Orloff's studio-house (1926) was in the Rue Villa Seurat, Montparnasse, and Dora Gordine's (1929) in the Rue du Belvédère, Boulogne. On artists' studio-houses, see Jean-Claude Delorme, *Les Villas d'artistes à Paris*, Paris, 1987; Jean-Claude Delorme and Anne-Marie Dubois, *Ateliers d'artistes à Paris*, Paris, 2002; and Louise Campbell, 'Perret and His Artist-clients: Architecture in the Age of Gold', *Architectural History*, 45, 2002, pp. 409–40. On women artists' homes at this period, see Bridget Elliott, 'Housing the Work: Women Artists, Modernism and the *maison d'artiste*: Eileen Gray, Romaine Brooks and

Gluck', in *Women Artists and the Decorative Arts 1880–1935: The Gender of Ornament*, Bridget Elliott and Janice Helland (eds), Aldershot and Burlington, Vt., 2002.

12 Richard Becherer, 'Painting Architecture Otherwise: The Voguing of the Maison Mallet-Stevens', *Art History*, 23, 4, November 2000, pp. 559–98.

13 Kenneth Silver, *Esprit de Corps: The Art of the Parisian Avant-Garde and the First World War, 1914–1925*, Princeton, N.J., and London, 1989.

14 *Vuillard*, Guy Cogeval et al. (eds), exh. cat., National Gallery of Art, Washington, D.C.; The Montreal Museum of Fine Arts; Musée d'Orsay, Paris; Royal Academy of Arts, London, 2003, cats 326 and 293.

15 On the figure of the *amazone*, see Whitney Chadwick, *Amazons in the Drawing Room: The Art of Romaine Brooks*, Berkeley, Calif., and London, 2000.

16 For more on the relationship between Mallet-Stevens's architecture and photography, film and fashion, see Becherer, 2000.

17 As quoted in Alain Blondel, *Tamara de Lempicka: Catalogue Raisonné, 1921–1979*, Lausanne, 1999, p. 39.

18 On Loos's Josephine Baker project, see Beatriz Colomina, *Privacy and Publicity: Modern Architecture as Mass Media*, Cambridge, Mass., and London, 1994, pp. 260–64.

19 Georges Remon, 'Architectures modernes: L'Atelier de Mme de Lempicka', with photographs by M. Gravot, *Mobilier et décoration*, 9, 1, January 1931, pp. 1–10.

20 These photographs are reproduced in Le Corbusier, *Almanach d'Architecture Moderne*, Paris, 1926, pp. 98–101.

21 For details of Jacqueline d'Hariel's articles, see Blondel, 1999, p. 491.

22 On debates regarding the femininity of the professional and the 'modern' woman in Paris at this time, see Mary Louise Roberts, *Civilisation Without Sexes: Reconstructing Gender in Postwar France, 1917–1927*, Chicago, Ill., and London, 1994; also Chadwick and Latimer, 2003.

23 For an account of De Lempicka's friendship with Solidor, see Laura Claridge, *Tamara de Lempicka: A Life of Deco and Decadence*, New York, 1999, pp. 186–87.

24 For example, in reviewing the work of a woman painter the critic André Salmon proclaimed, 'Mme Marval peigne un peu comme on se maquille' (*L'Art vivant*, 1920, p. 282). On the historical significance of feminine associations with the dressing table, see Penny Sparke, *As Long as It's Pink: The Sexual Politics of Taste*, London, 1995.

25 Arsène Alexandre, 'Tamara de Lempicka', *La Renaissance de l'art français et des industries de luxe*, July 1929, pp. 330–37; see also Paula Birnbaum, 'Painting the Perverse: Tamara de Lempicka and the Modern Woman Artist', in Chadwick and Latimer, 2003, pp. 95–107.

26 Tag Gronberg, 'Beware Beautiful Women: The 1920s Shop-window Mannequin and a Physiognomy of Effacement', *Art History*, 20, September 1997, pp. 375–96.

27 See Tag Gronberg, *Designs on Modernity: Exhibiting the City in 1920s Paris*, Manchester and New York, 1998.

In the photograph of the studio shown here, the painting is displayed next to a vase of flowers and the photographic portrait of Arlette, thus creating a curious sense of *mise en abîme*: a photograph of a painting depicting a photograph. This juxtaposition of painted portrait and photograph can be seen as more than merely the depiction of studio props: it suggests rather a symbiotic relationship between painting and photography.

De Lempicka did not limit photography and film to a documentary or promotional role. The modernity of her work was in part a matter of how her paintings related to mechanical reproduction and consumer culture. Her self-portrait in the green car (1929; cat. 34) and several other paintings appeared on the cover of the women's magazine *Die Dame*, and it is perhaps no coincidence that more recently De Lempicka's works have been widely reproduced in the form of posters. The characteristics of her painting, its clear lines and bold colours, lend themselves well to reproductive processes; indeed, like Mallet-Stevens's architecture, her painting might be said to be photogenic. Her work is distinctive in the way it allows the more traditional iconographies and techniques of painting to coalesce with the imagery of cinema or fashion advertising. Contemporary critics remarked, for example, on the hard, almost metallic-looking skin of her subjects; this coincided with a period in which gold or silver shop-window mannequins were much in vogue.[26] De Lempicka's paintings of women, whether portraits or nudes, convey something of the commodification of the female body that was such an important feature of interwar Parisian modernity.[27] But the fact that these paintings were executed by a woman was also crucial to the public's identification of De Lempicka's *oeuvre* as 'modern'.

These mutually reinforcing encounters between painting, architecture, design and photography were part of an urban spectacle through which some women were able to fashion not only a stylish appearance but also a successful career. The design of De Lempicka's Rue Méchain apartment, much like the photographs of it and of herself, was the means of producing an extended portrait of a woman artist. For many women of the period, of course, De Lempicka's chic outfits and lifestyle (like the mobility and self-determination embodied by the female motorist) had more to do with fantasy than reality. But it is as a manifestation of an active feminine agency that her work and representations of herself were relevant to audiences far wider than those who could afford to attend her glamorous soirées or buy her paintings.

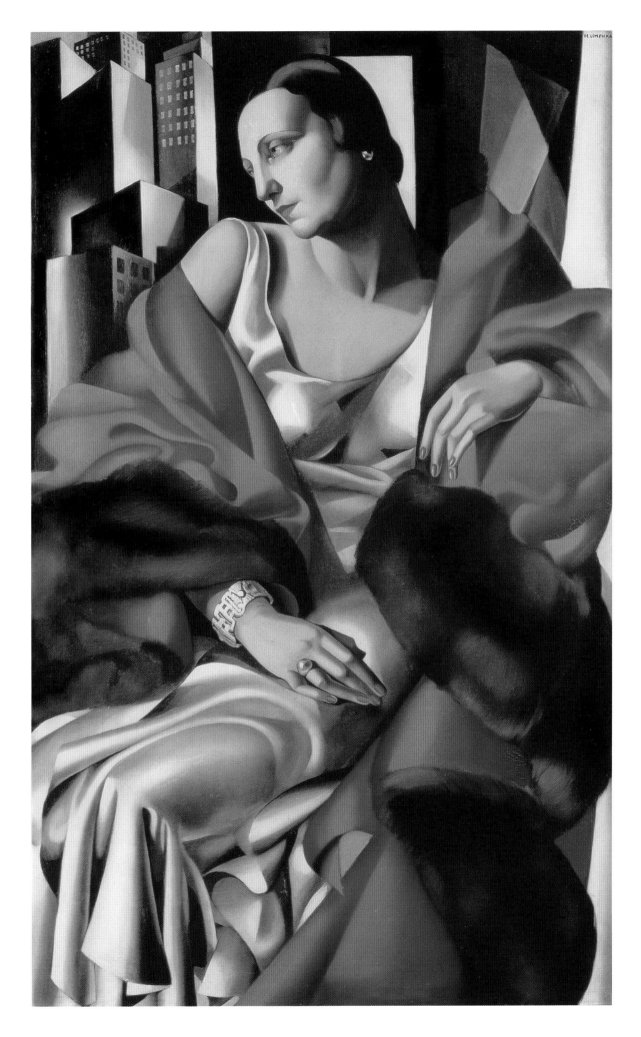

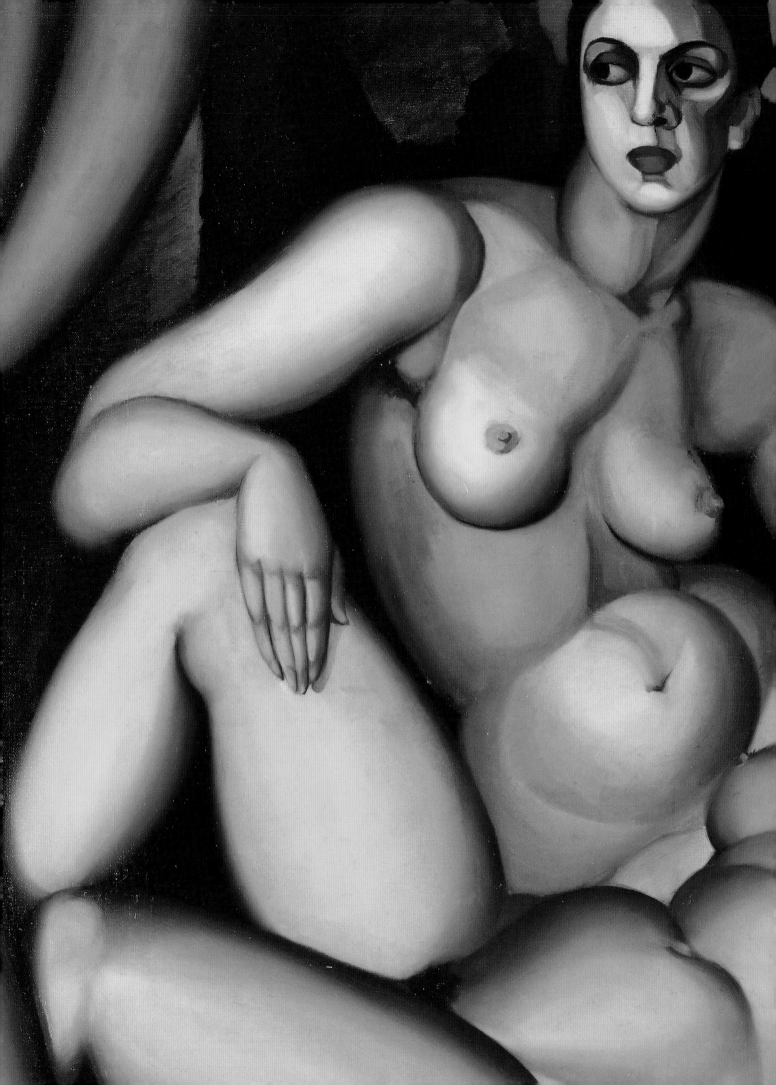

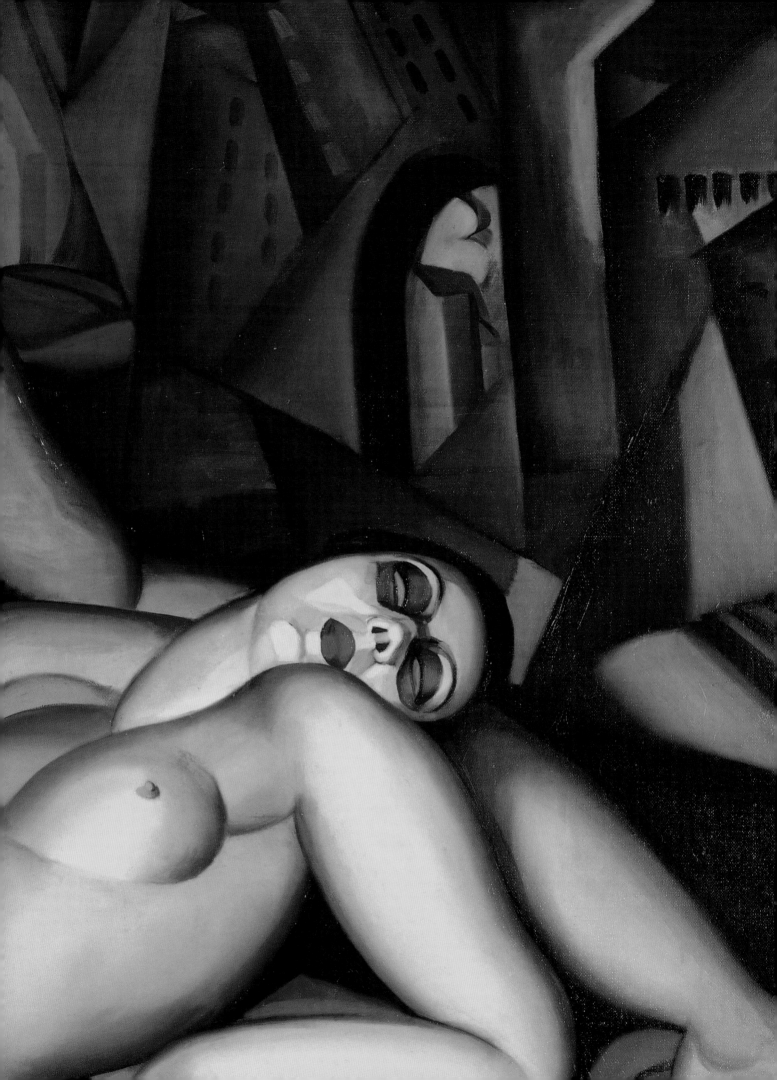

1 *Portrait of a Young
 Lady in a Blue Dress*
 1922
 Oil on canvas
 63 × 53 cm
 Private collection

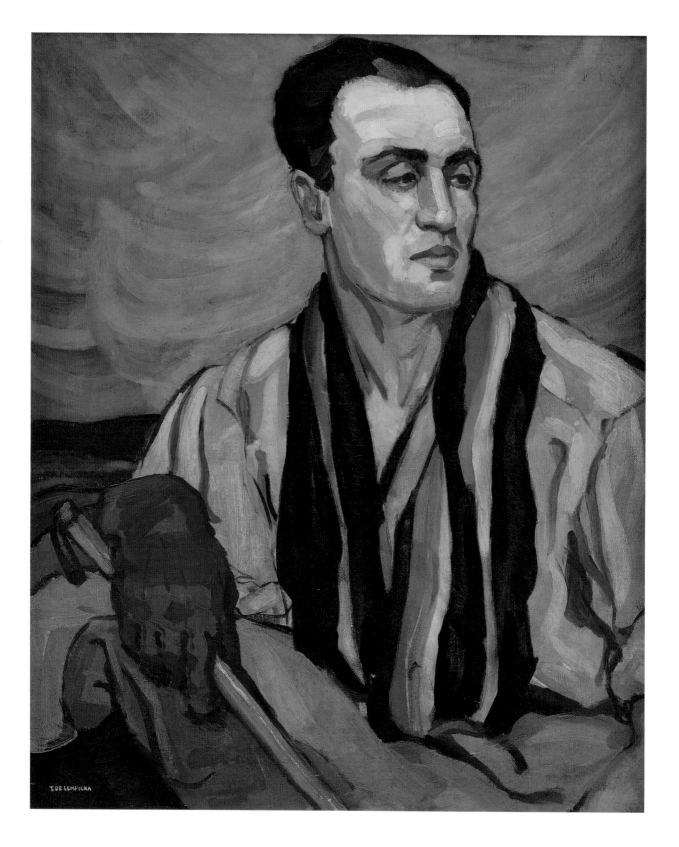

2 *Portrait of a Polo Player*
 c. 1922
 Oil on canvas
 73 × 60 cm
 From the collection
 of Daniel Fischel
 and Sylvia Neil

3 *The Kiss*
 c. 1922
 Oil on canvas
 50 × 61 cm
 Dr F. Dessau

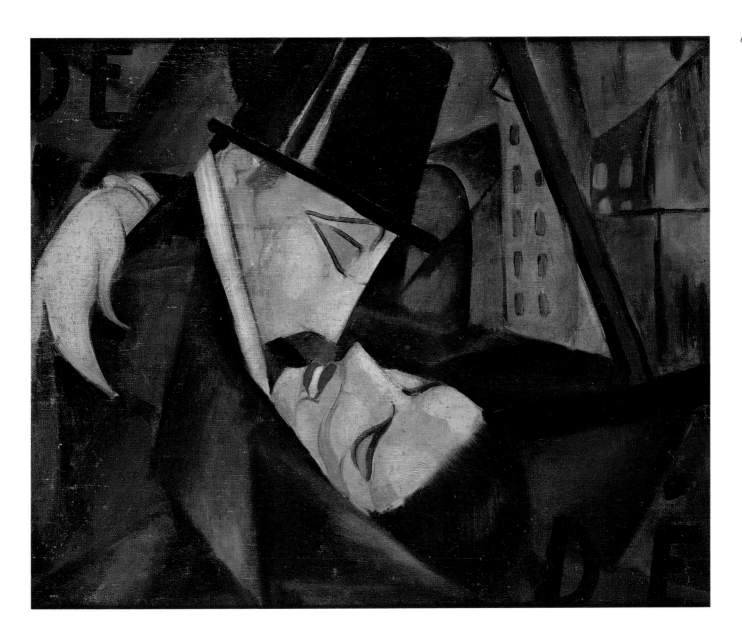

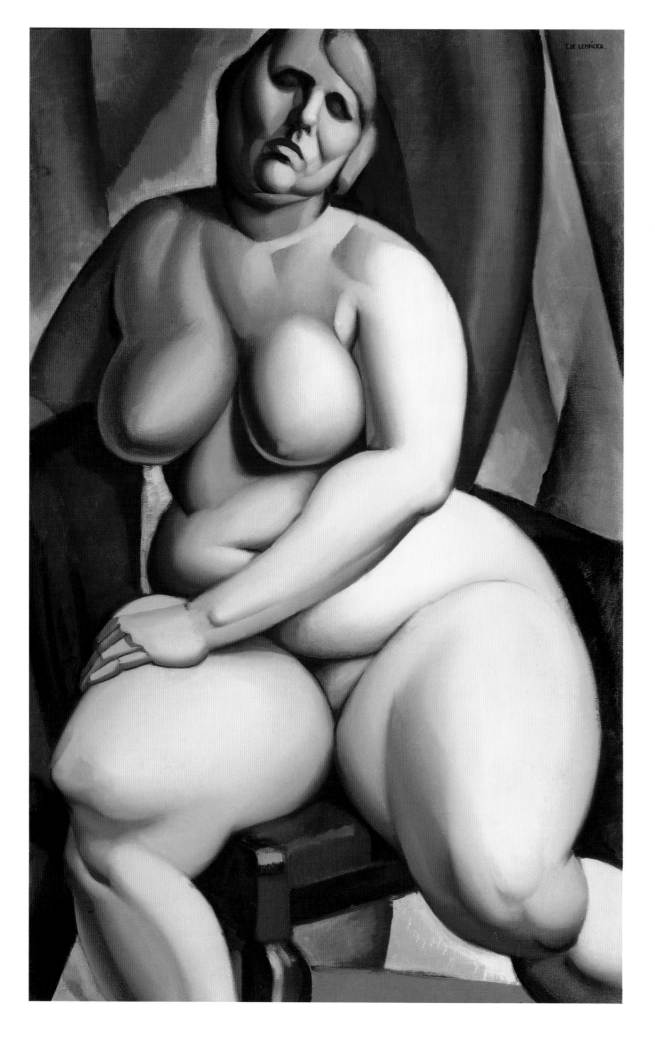

4 *Seated Nude*
 c. 1923
 Oil on canvas
 94 × 56 cm
 Private collection

5 *The Sleeping Girl*
 1923
 Oil on canvas
 89 × 146 cm
 Private collection.
 Courtesy of the
 Allan Stone Gallery,
 New York

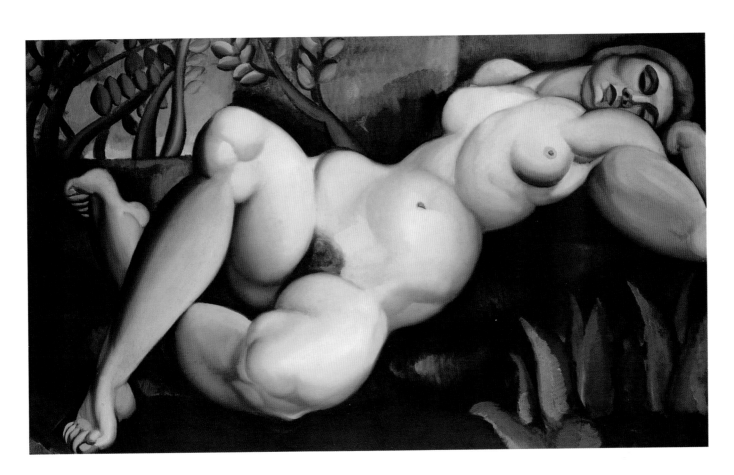

6 *Perspective*
 1923
 Oil on canvas
 130 × 162 cm
 Association des Amis
 du Petit Palais, Geneva

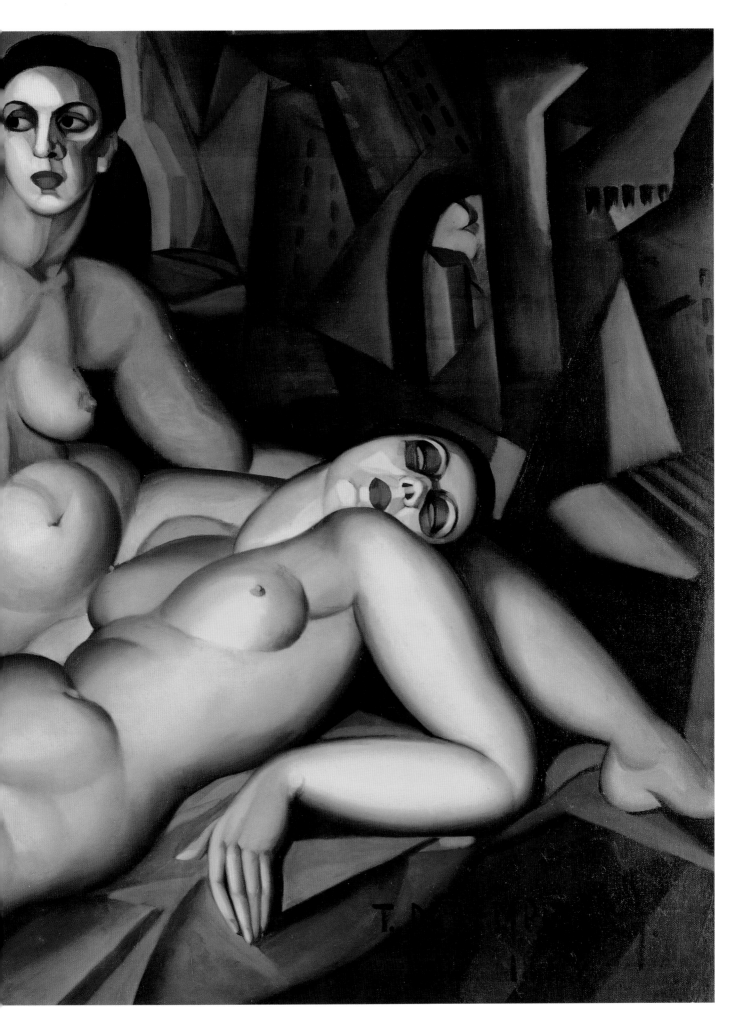

68

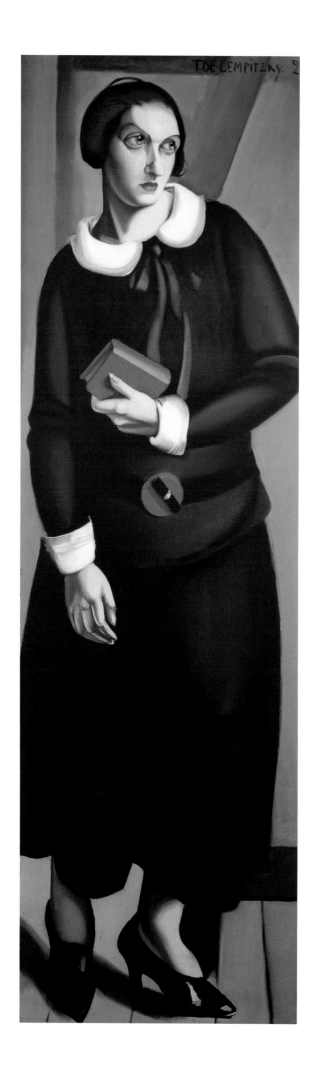

7 *Woman in a Black Dress*
 1923
 Oil on canvas
 195 × 60.5 cm
 Collection Wolfgang
 Joop

8 *Double '47'*
 c. 1924
 Oil on panel
 46 × 38 cm
 Barry Friedman Ltd,
 New York, and
 Galerie Brockstedt,
 Hamburg

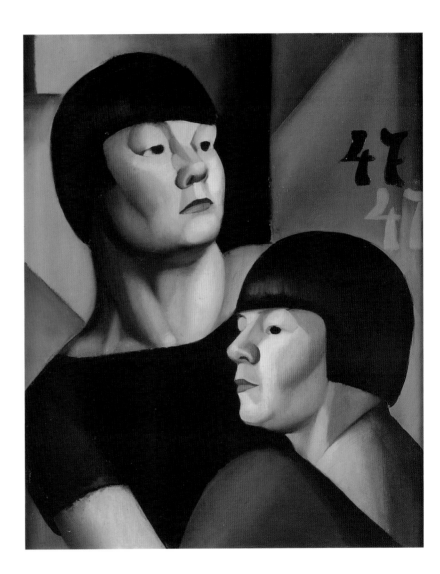

9 *The Open Book*
c. 1924
Oil on canvas, laid down
24 × 35 cm
Private collection

10 *The Red Bird*
1924
Oil on canvas, laid down
24 × 33 cm
Private collection

11 *The Green Veil*
c. 1924
Oil on canvas
46 × 33 cm
Private collection

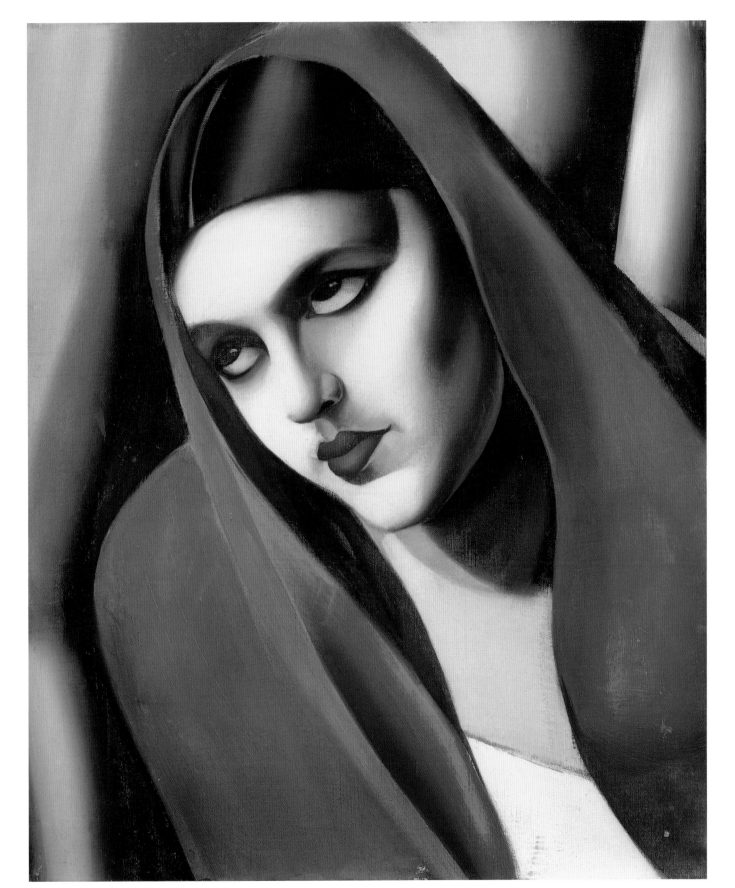

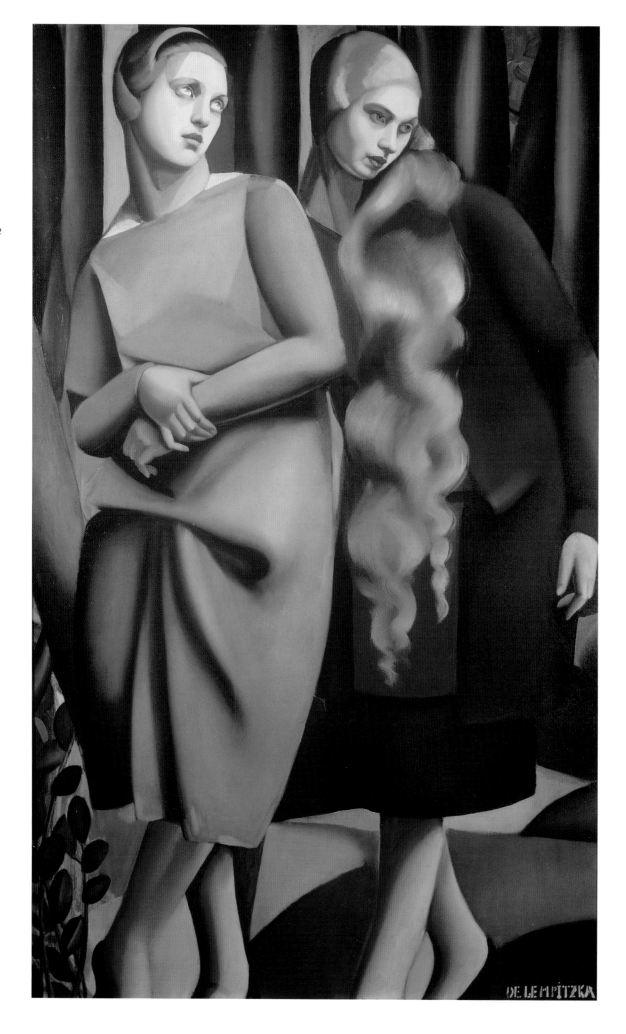

12 *Irene and Her Sister*
1925
Oil on canvas
146 × 89 cm
Private collection, USA.
Courtesy of Irena
Hochman Fine Art Ltd

13 *Two Little Girls with Ribbons*
1925
Oil on canvas
100 × 73 cm
Collection of Dr George
and Mrs Vivian Dean

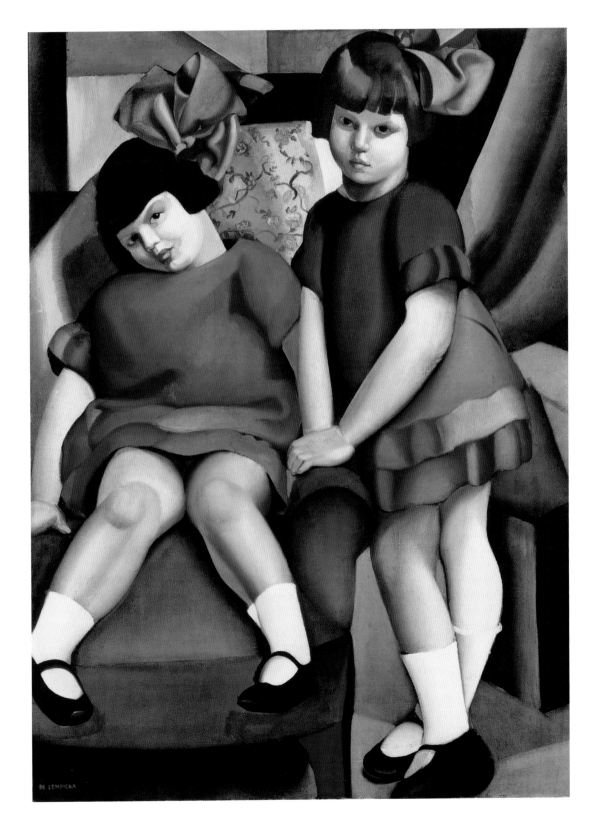

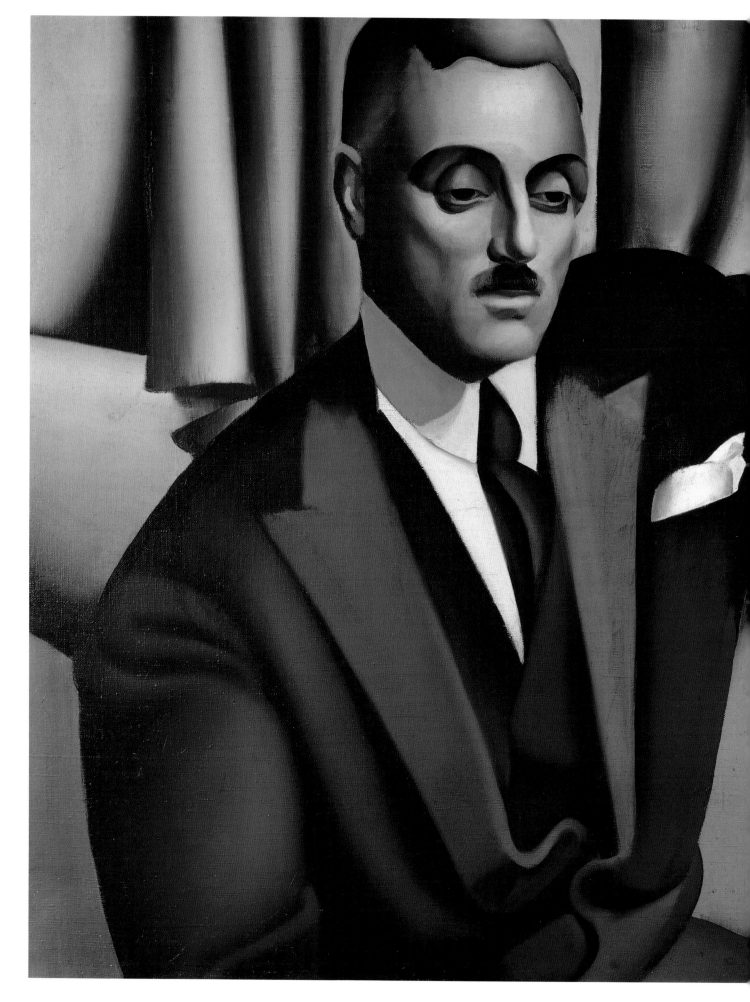

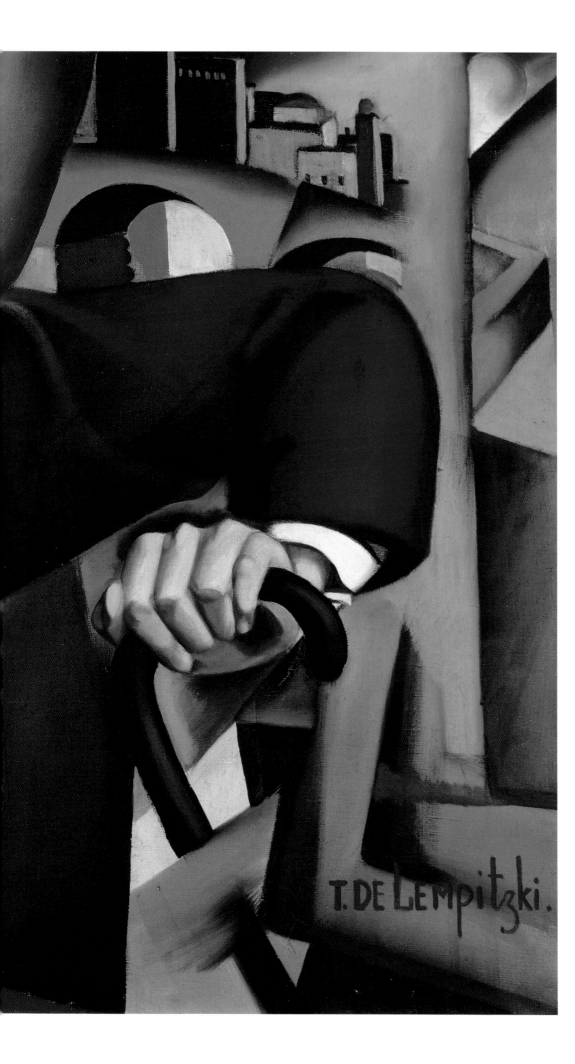

14 *Portrait of Prince Eristoff*
1925
Oil on canvas
65 × 92 cm
Private collection.
Courtesy of Barry
Friedman Ltd, New York

15 *Portrait of André Gide*
c. 1925
Oil on cardboard
50 × 35 cm
J. Nicholson, Beverly Hills,
California

16 *Portrait of Marquess Sommi*
1925
Oil on canvas
100 × 73 cm
Albert and Victoria
Benalloul

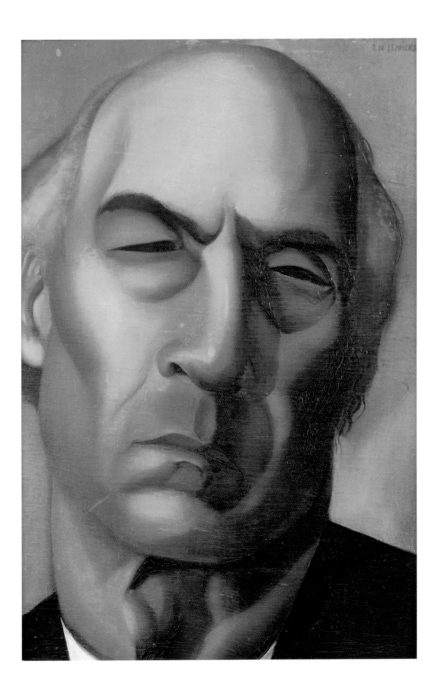

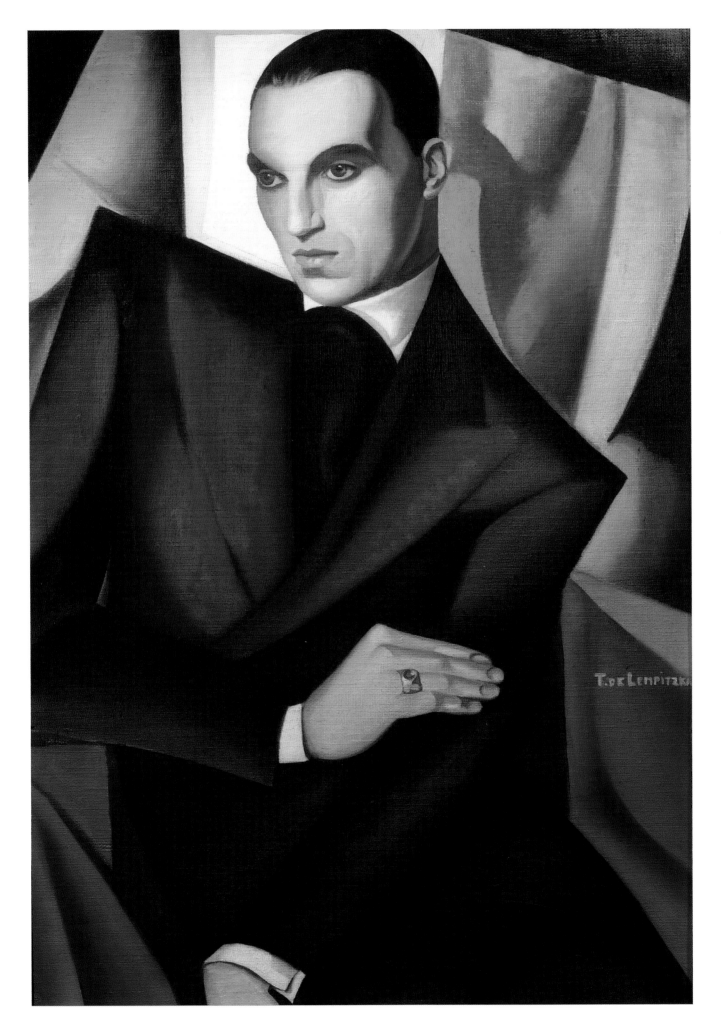

17 *Portrait of the*
Duchess de La Salle
1925
Oil on canvas
162 × 97 cm
Collection Wolfgang
Joop

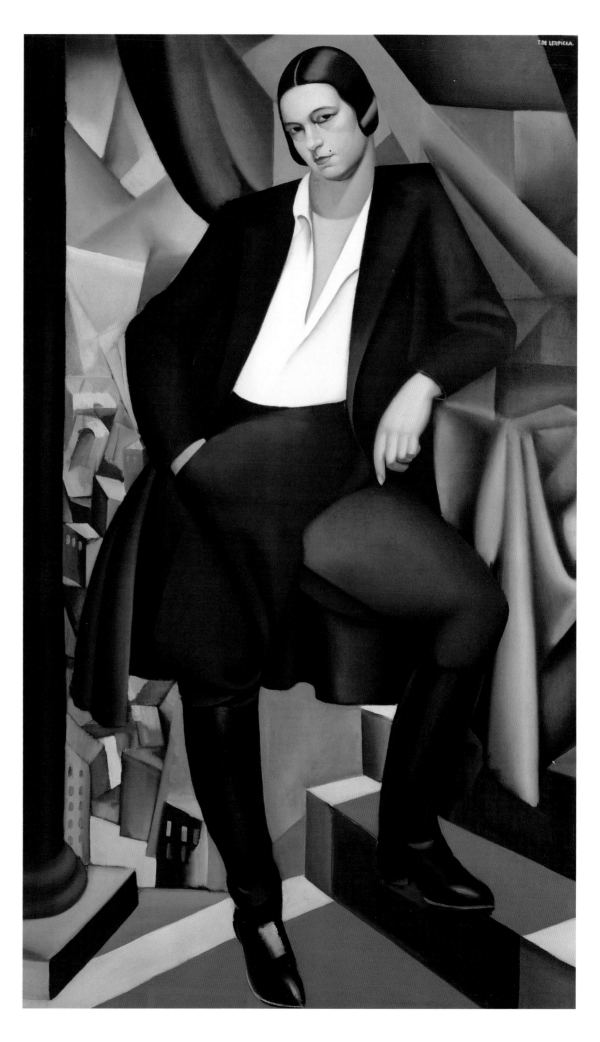

18 *Portrait of His Imperial Highness the Grand Duke Gabriel*
c. 1926
Oil on canvas
116 × 65 cm
J. Nicholson,
Beverly Hills, California

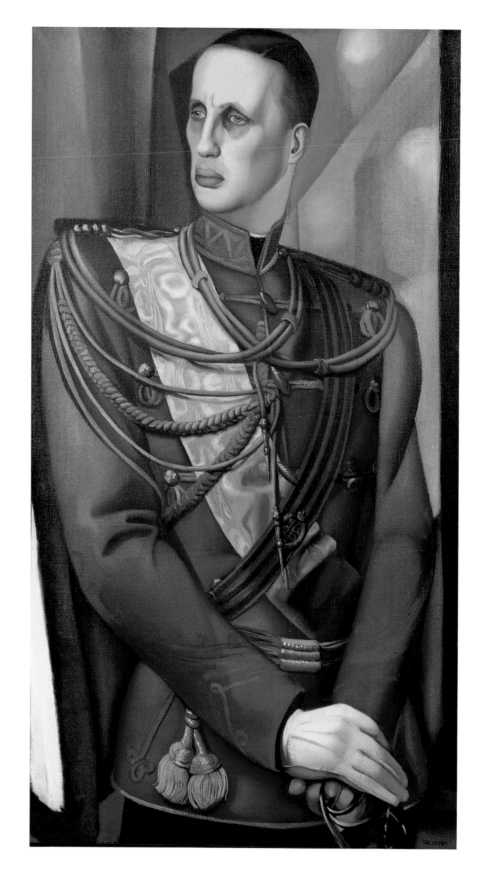

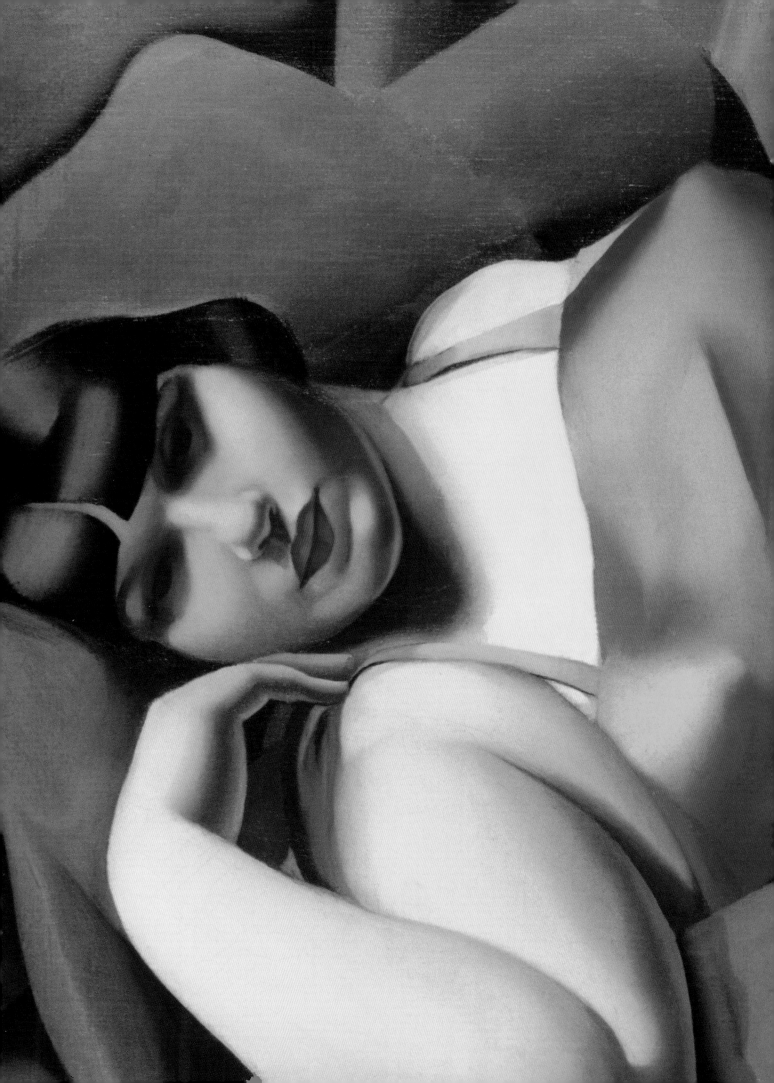

19 *The Pink Tunic*
1927
Oil on canvas
73 × 116 cm
Caroline Hirsch

20 *Kizette in Pink*
c. 1926
Oil on canvas
116 × 73 cm
Musée des Beaux-Arts
de Nantes

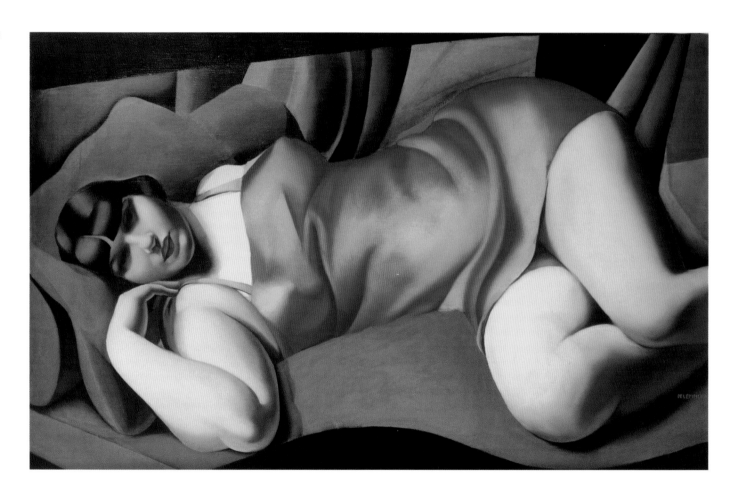

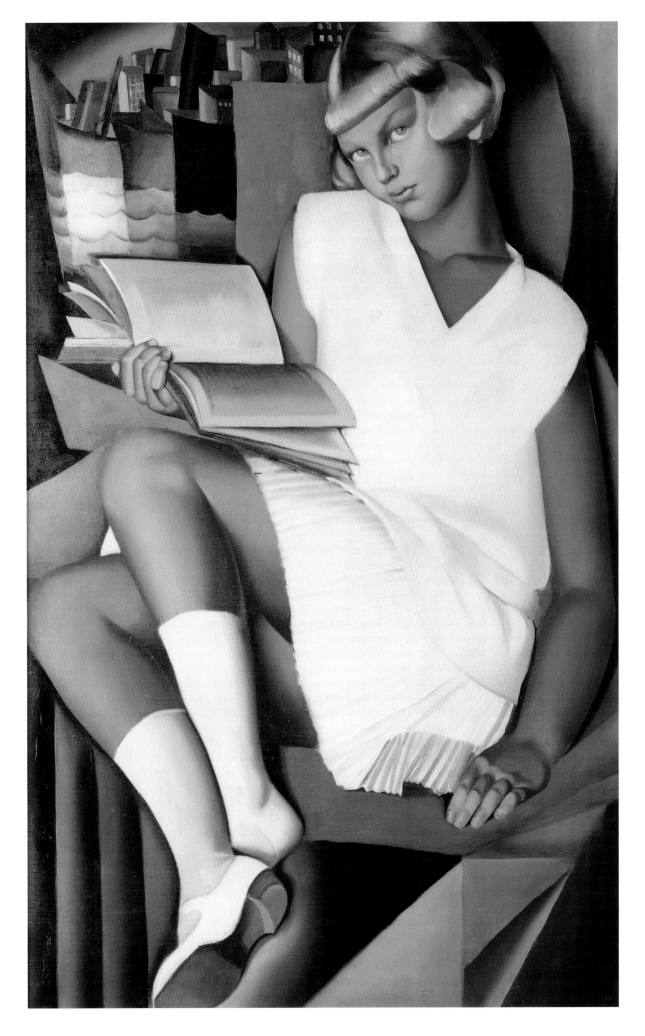

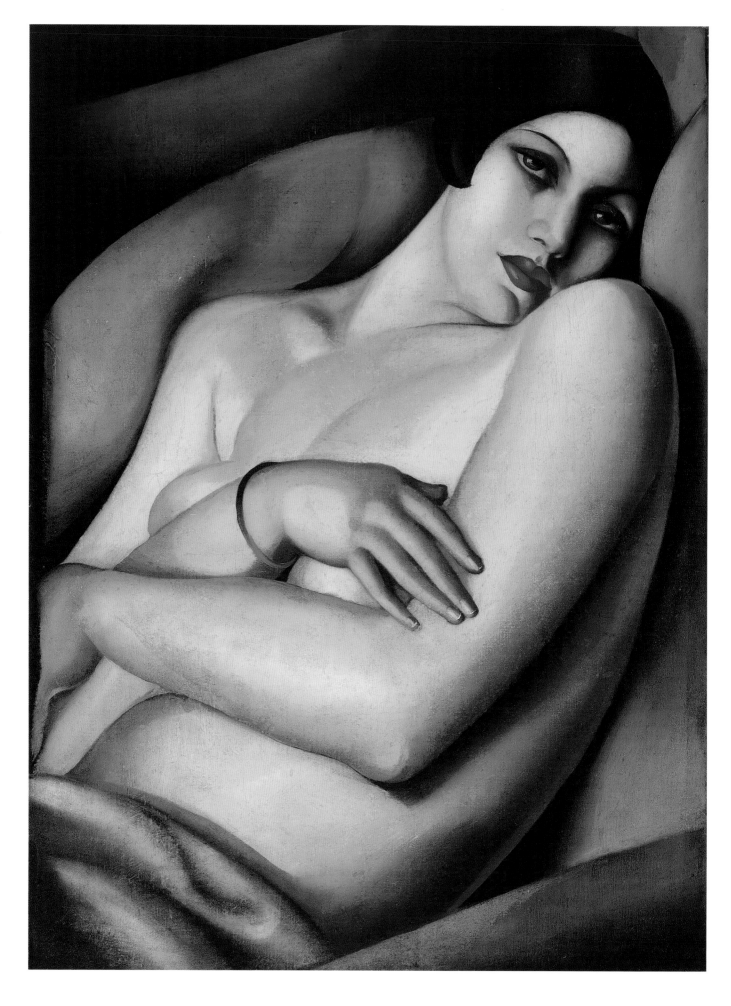

21 *The Dream*
1927
Oil on canvas
81 × 60 cm
Toni Schulman, New York

22 *La Belle Rafaëla in Green*
c. 1927
Oil on canvas
38 × 61 cm
Ms Donna Karan

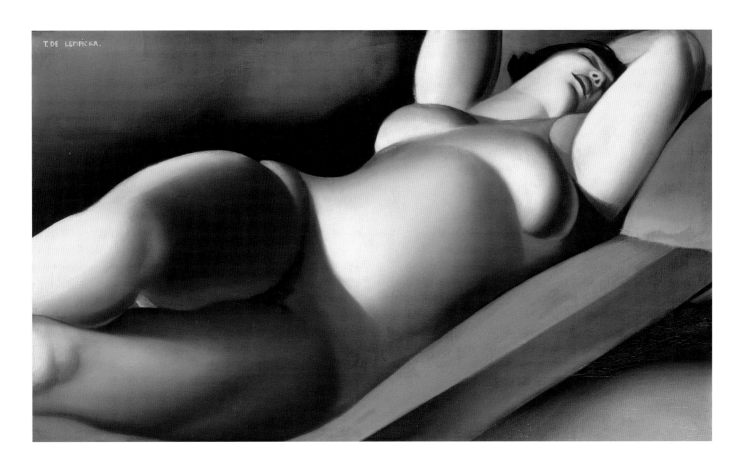

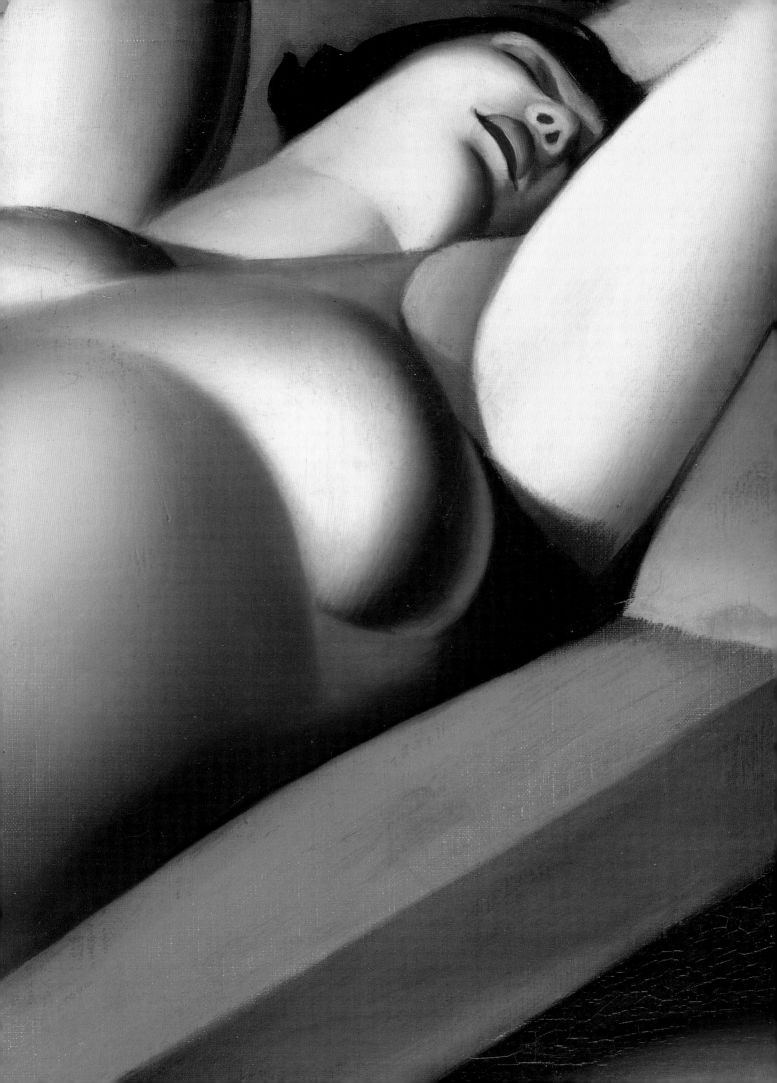

23 *The Orange Scarf*
1927
Oil on panel
41 × 33 cm
J. Nicholson, Beverly Hills,
California

24 *Reclining Nude with Book*
c. 1927
Oil on canvas
64.1 × 121.2 cm
JAPS Collection, Mexico

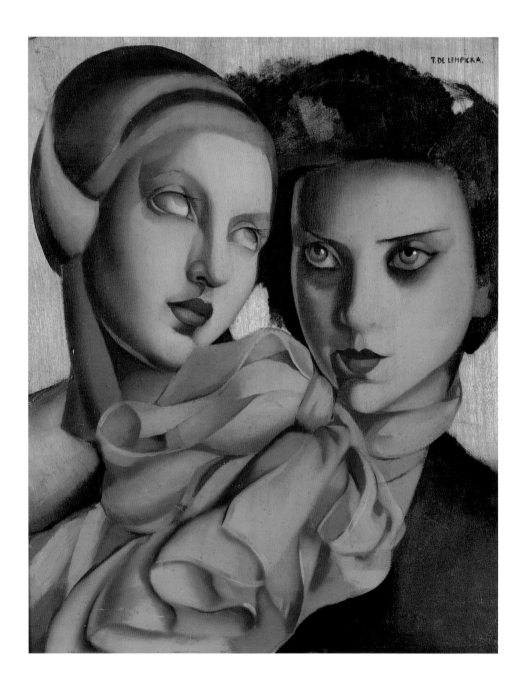

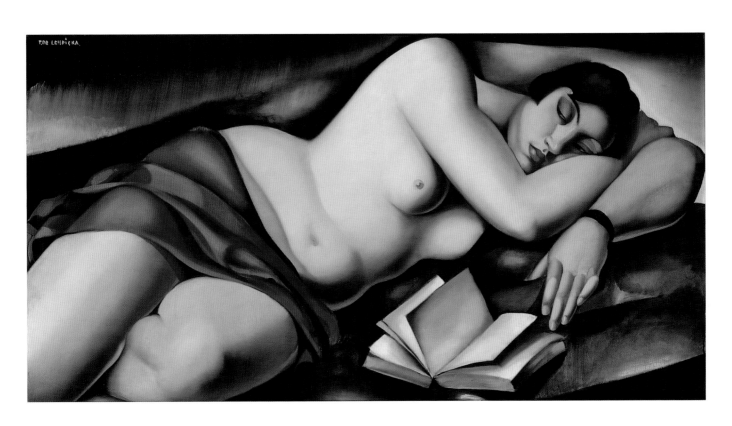

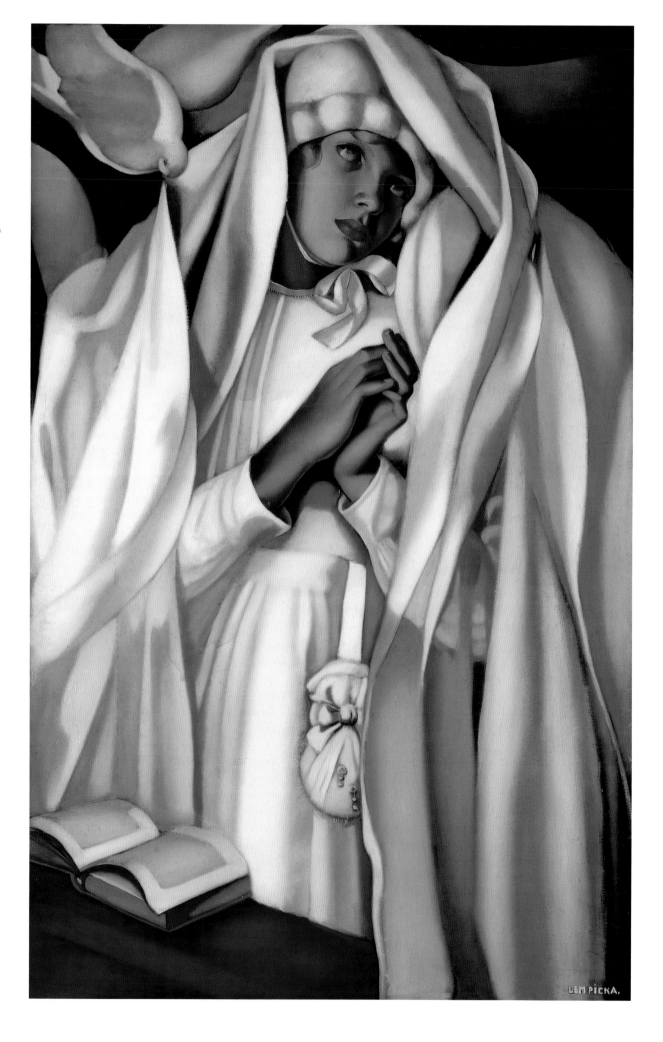

25 *The Communicant*
1928
Oil on canvas
100 × 65 cm
Centre Georges Pompidou,
Paris: Musée National
d'Art Moderne/Centre
de Création Industrielle.
Gift of the artist, 1976.
On deposit with the Musée
d'Art et d'Industrie, Roubaix

26 *Maternity*
1928
Oil on panel
35 × 27 cm
Mrs Barry Humphries

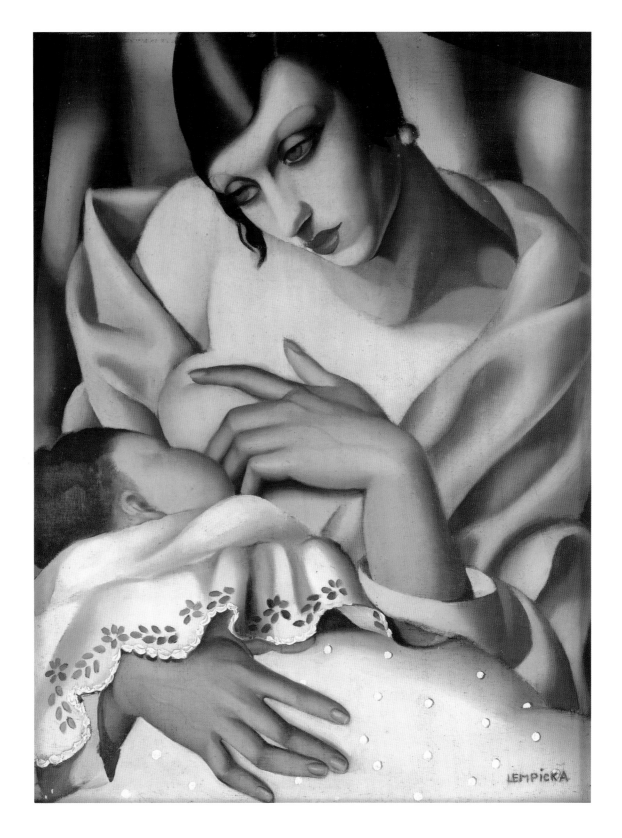

27 *Portrait of Dr Boucard*
1928
Oil on canvas
135 × 75 cm
Private collection,
Salzburg

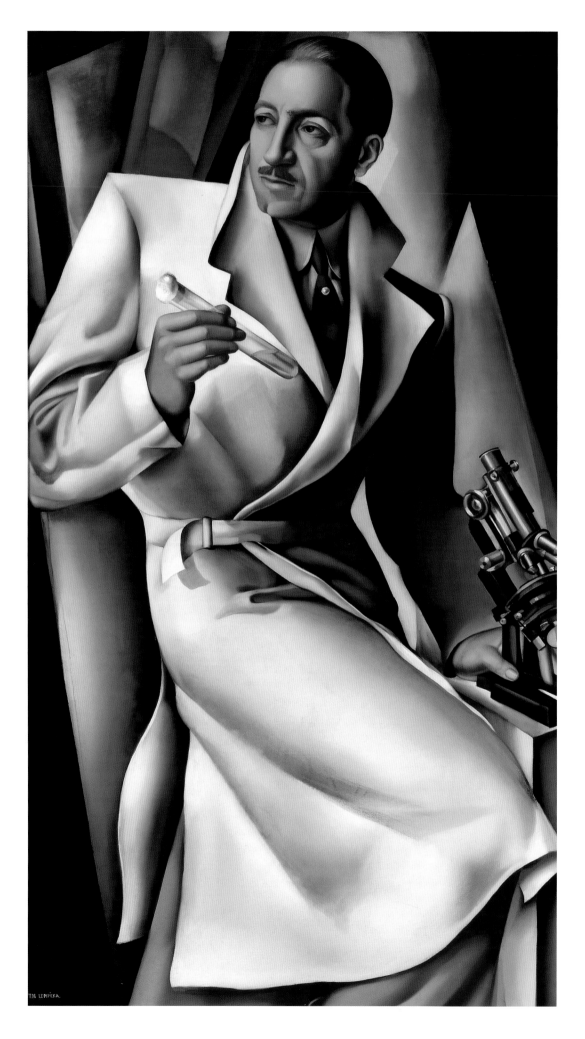

28 *Portrait of a Man*
1928
Oil on canvas
130 × 81 cm
Centre Georges
Pompidou, Paris:
Musée National
d'Art Moderne/
Centre de Création
Industrielle. Gift
of the artist, 1976.
On deposit with the
Musée des Années
30, Boulogne-
Billancourt/Espace
Landowski

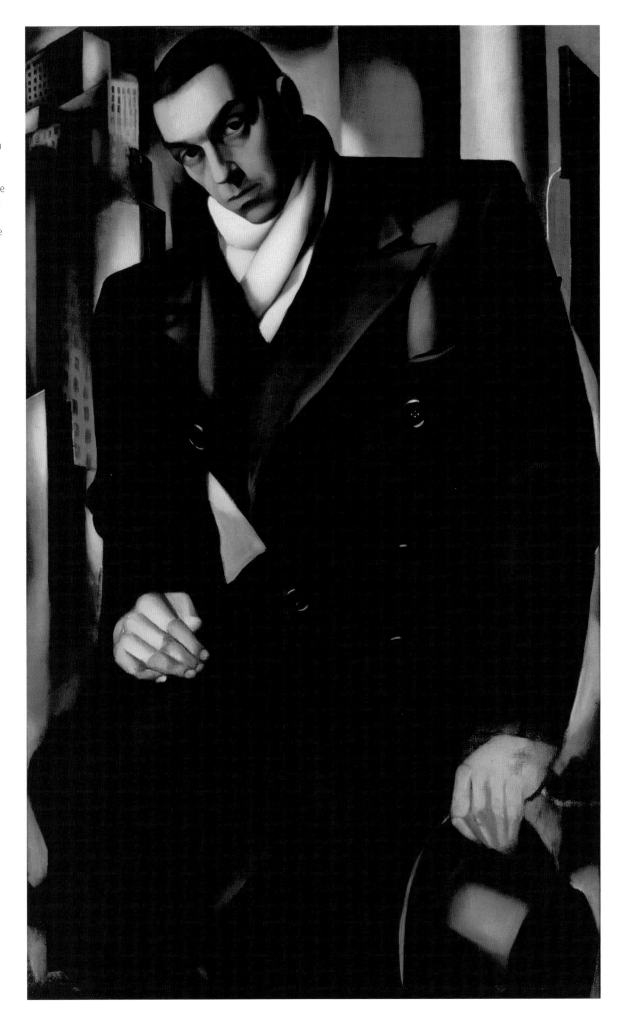

29 *Portrait of Arlette Boucard*
1928
Oil on canvas
70 × 130 cm
Private collection

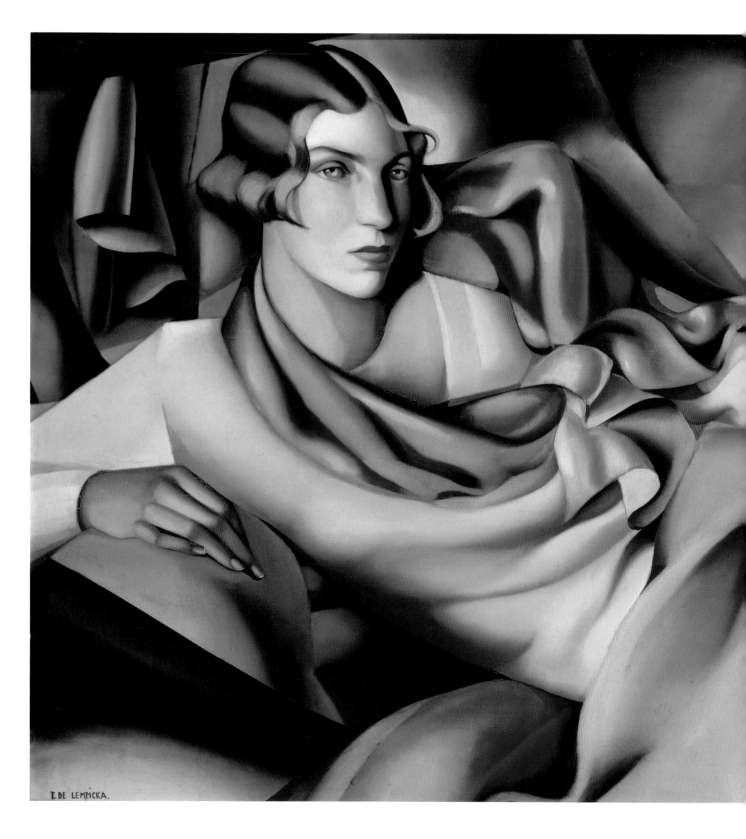

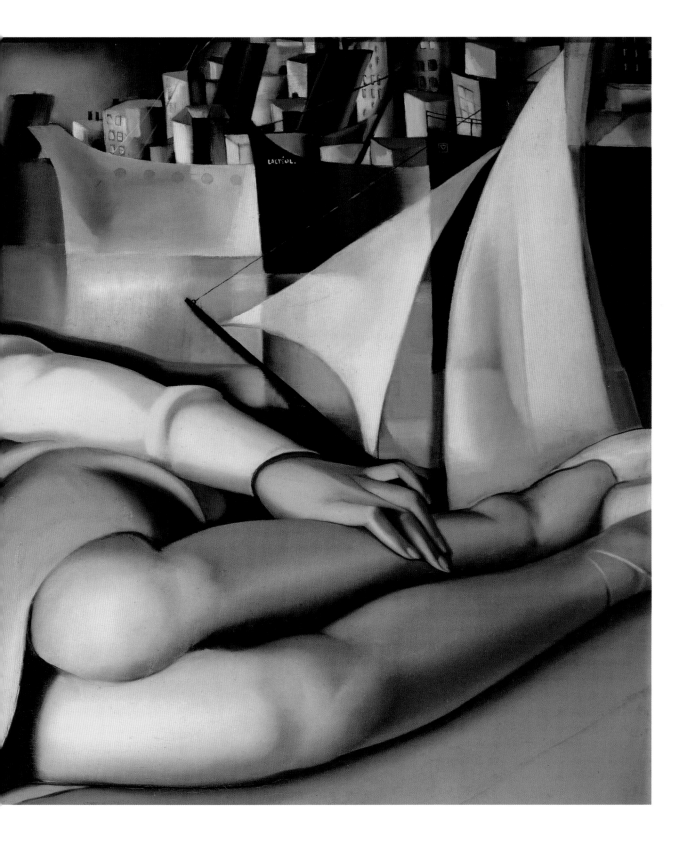

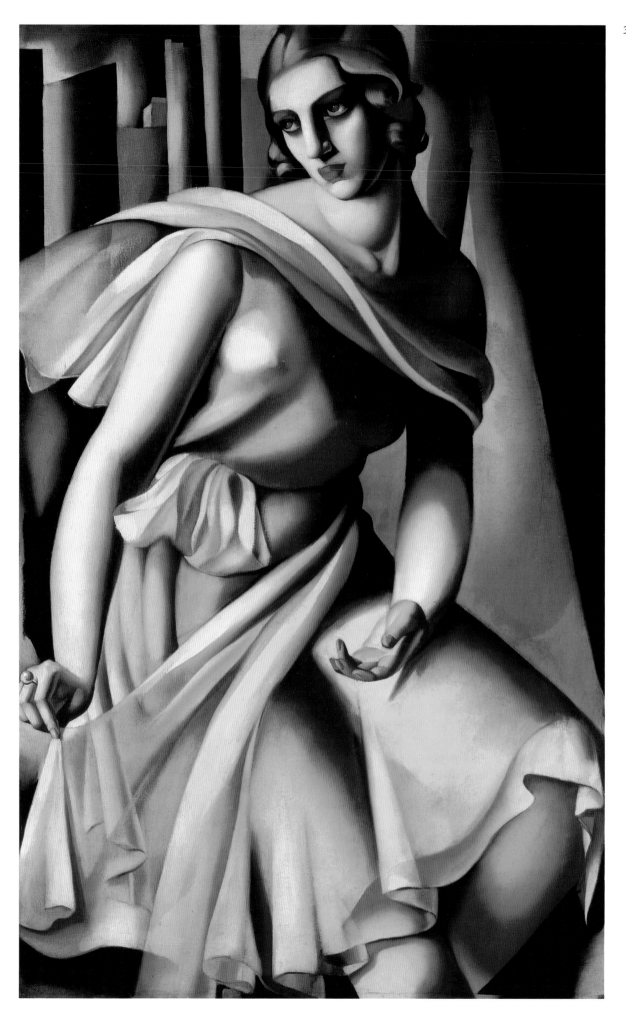

30 *Portrait of Romana*
de La Salle
1928
Oil on canvas
162 × 97 cm
Collection Wolfgang
Joop

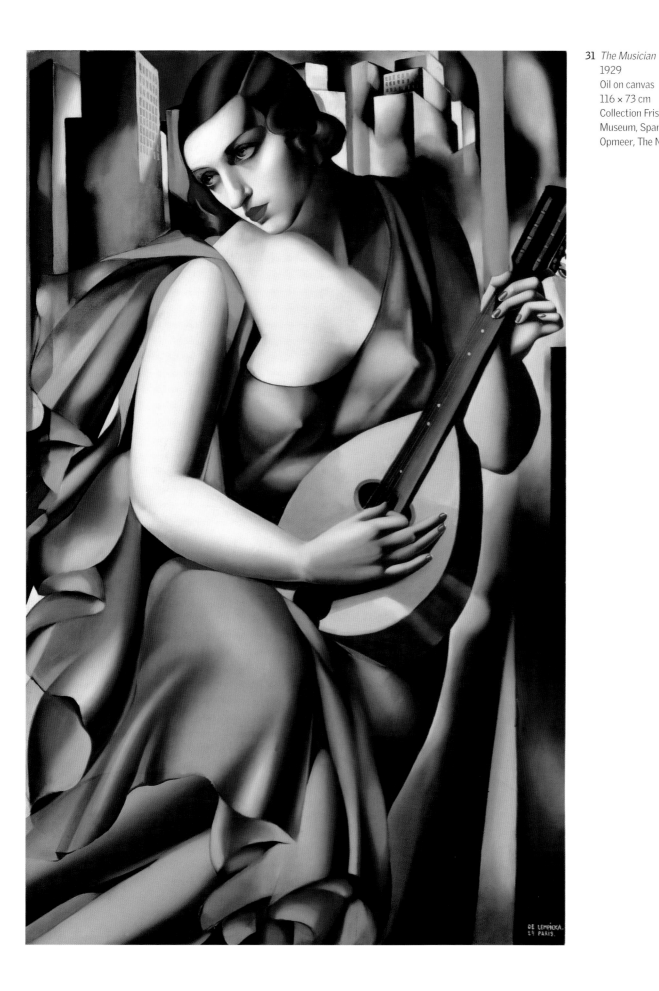

31 *The Musician*
1929
Oil on canvas
116 × 73 cm
Collection Frisia
Museum, Spanbroek/
Opmeer, The Netherlands

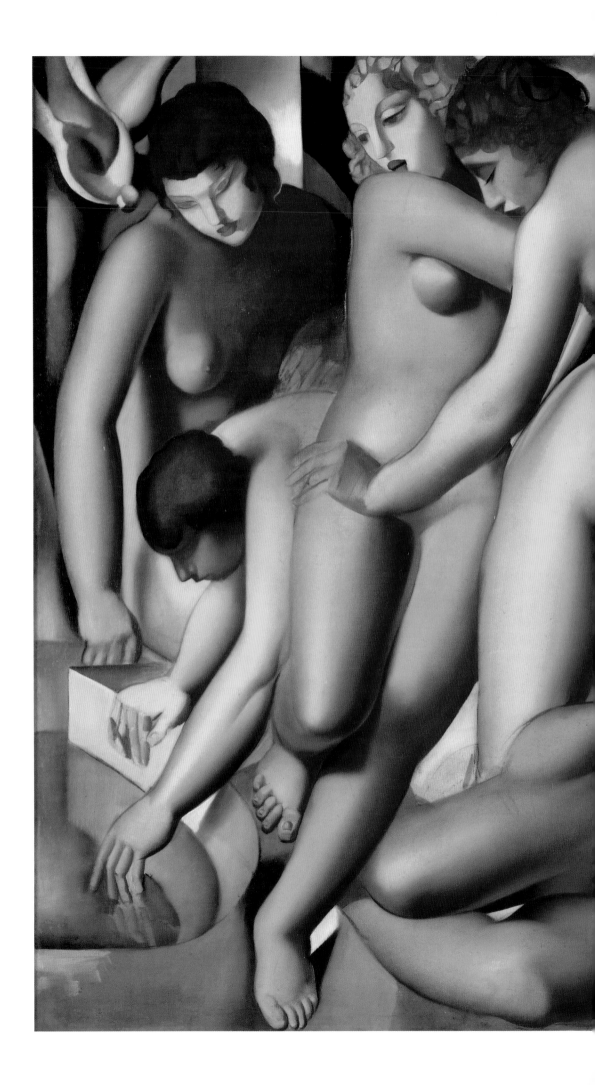

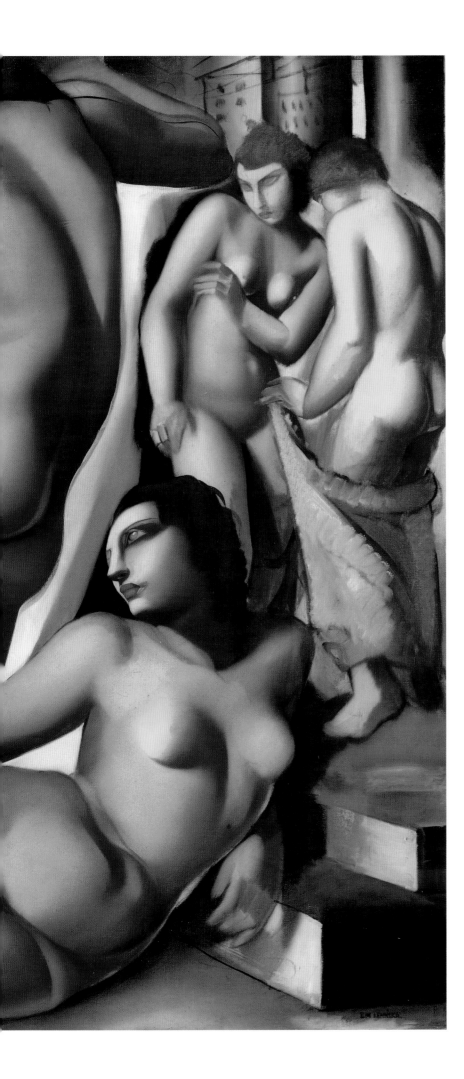

33 *St Moritz*
1929
Oil on panel
35 × 27 cm
Musée des Beaux-Arts,
Orléans

34 *My Portrait*
1929
Oil on panel
35 × 27 cm
Private collection

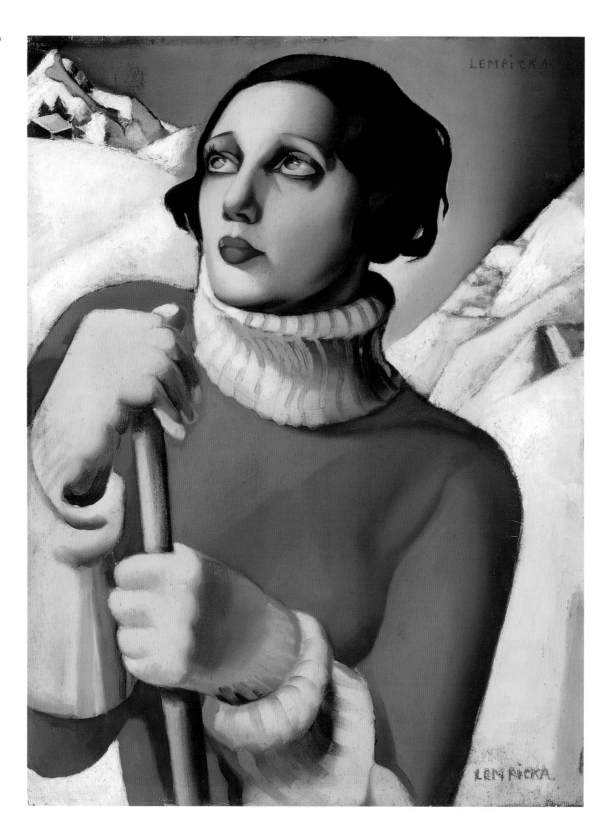

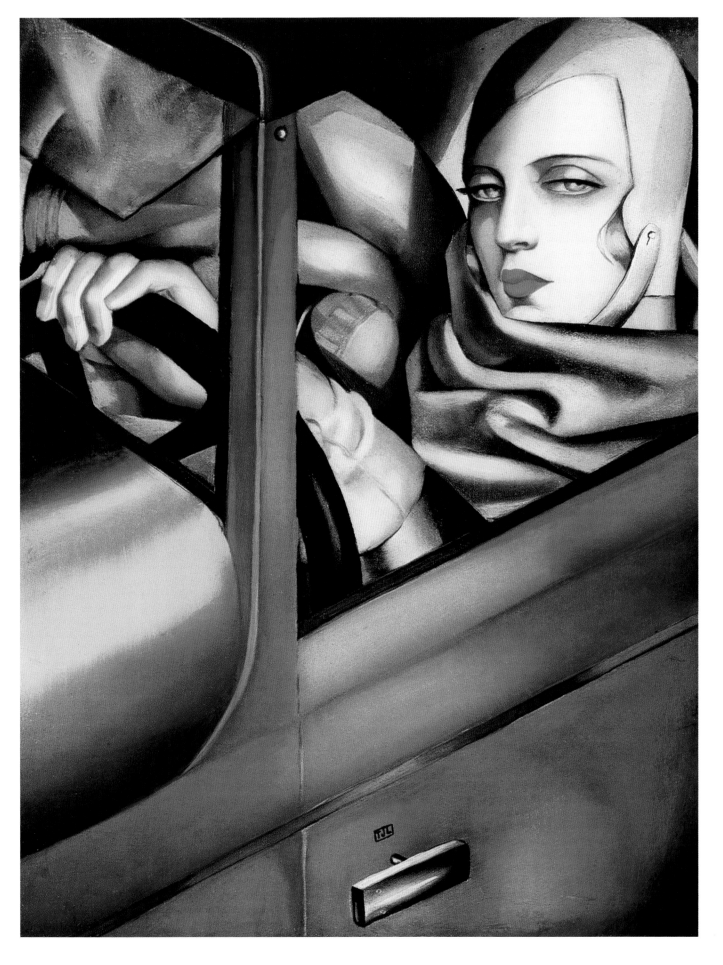

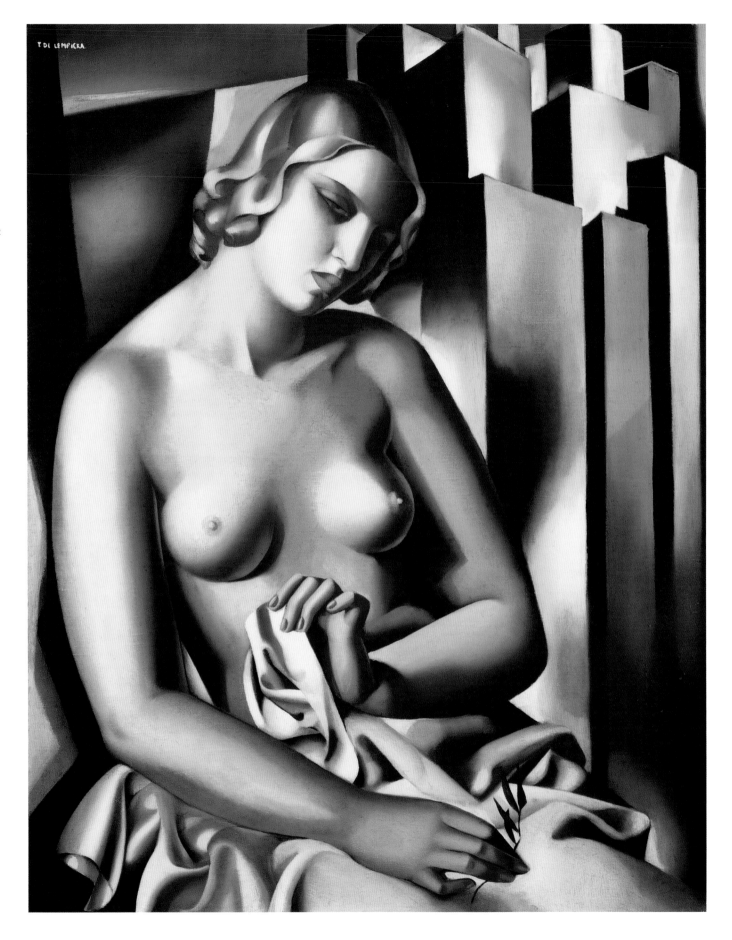

35 *Nude with Buildings*
1930
Oil on canvas
92 × 73 cm
Caroline Hirsch

36 *Sleeping Girl*
c. 1930
Oil on panel
35 × 27 cm
From the collection
of Daniel Fischel
and Sylvia Neil

103

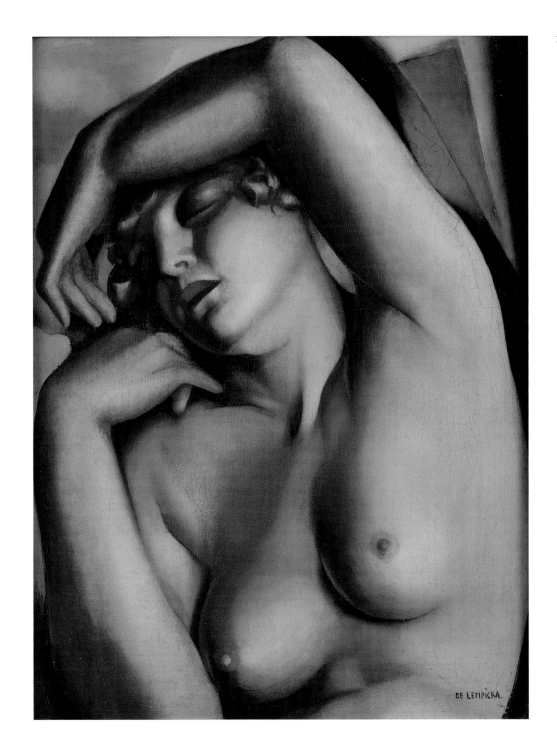

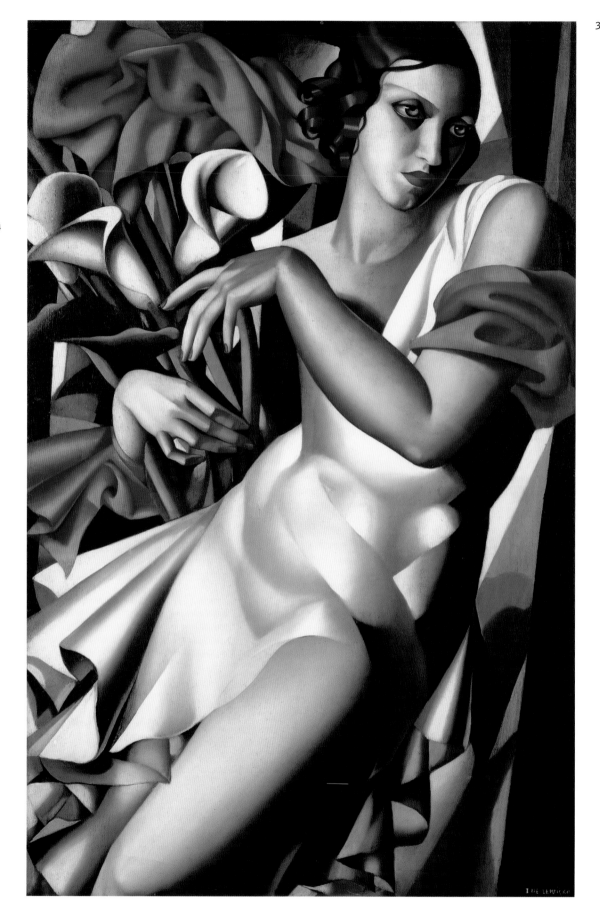

37 *Portrait of Ira P.*
1930
Oil on panel
99 × 65 cm
Private collection.
Courtesy of Christie's,
London

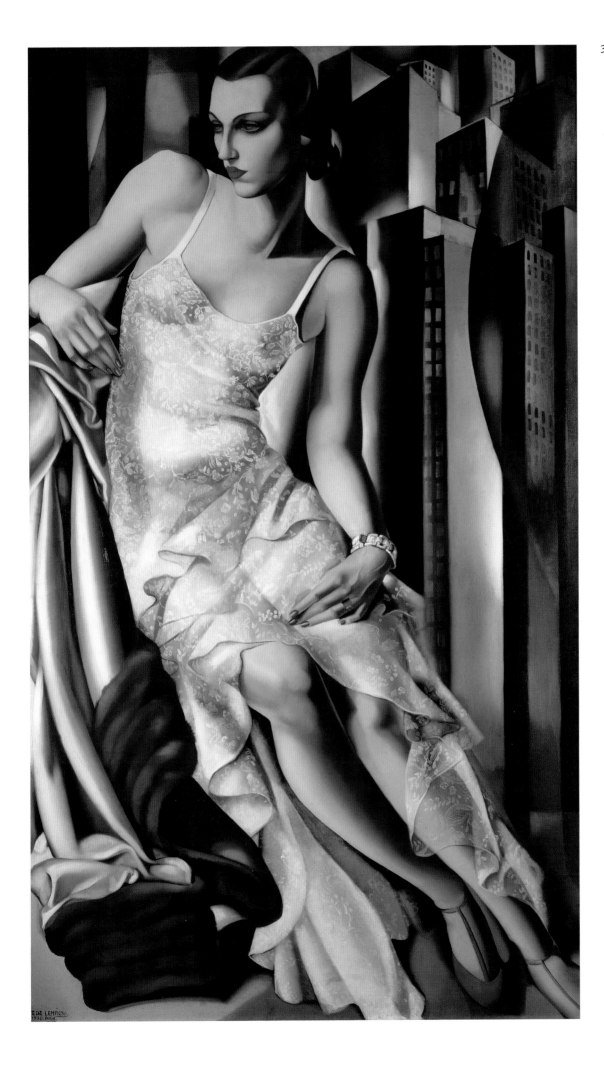

38 *Portrait of*
Mrs Allan Bott
1930
Oil on canvas
162 × 97 cm
Private collection

39 *The Telephone II*
1930
Oil on panel
35 × 27 cm
Collection Wolfgang Joop

40 *The Blue Scarf*
1930
Oil on panel
35 × 27 cm
Private collection

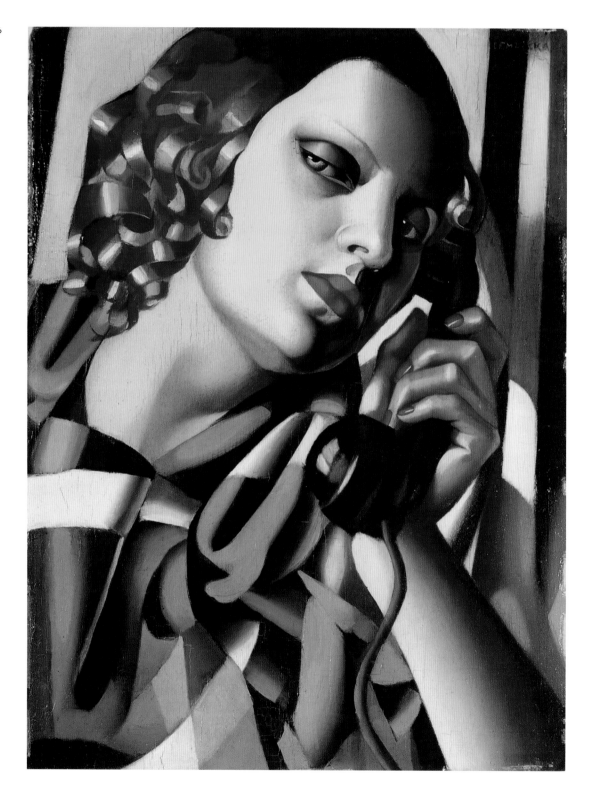

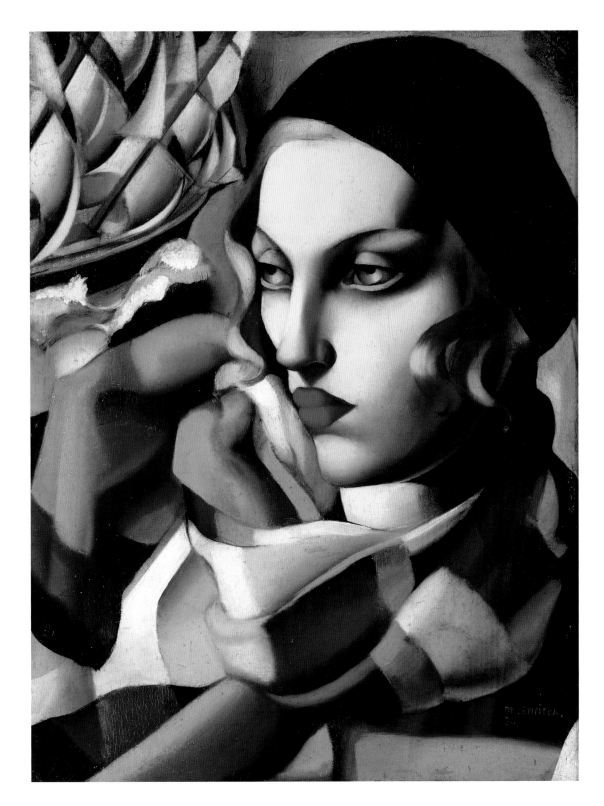

41 *Portrait of Pierre*
de Montaut
1931
Oil on panel
41 × 27 cm
Barry Friedman Ltd,
New York

42 *Adam and Eve*
1931
Oil on panel
116 × 73 cm
Private collection

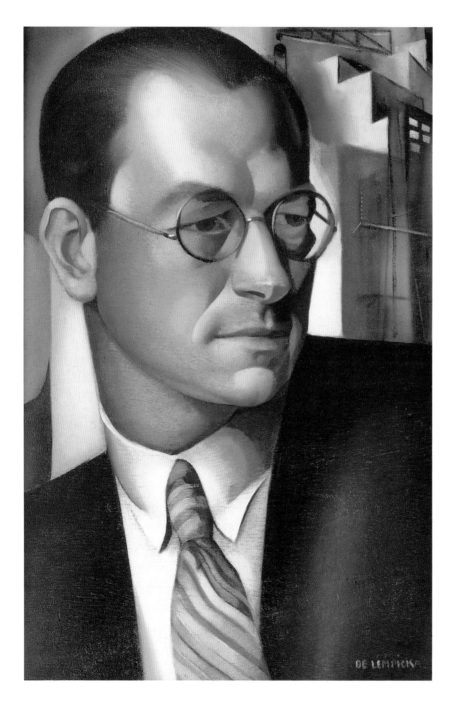

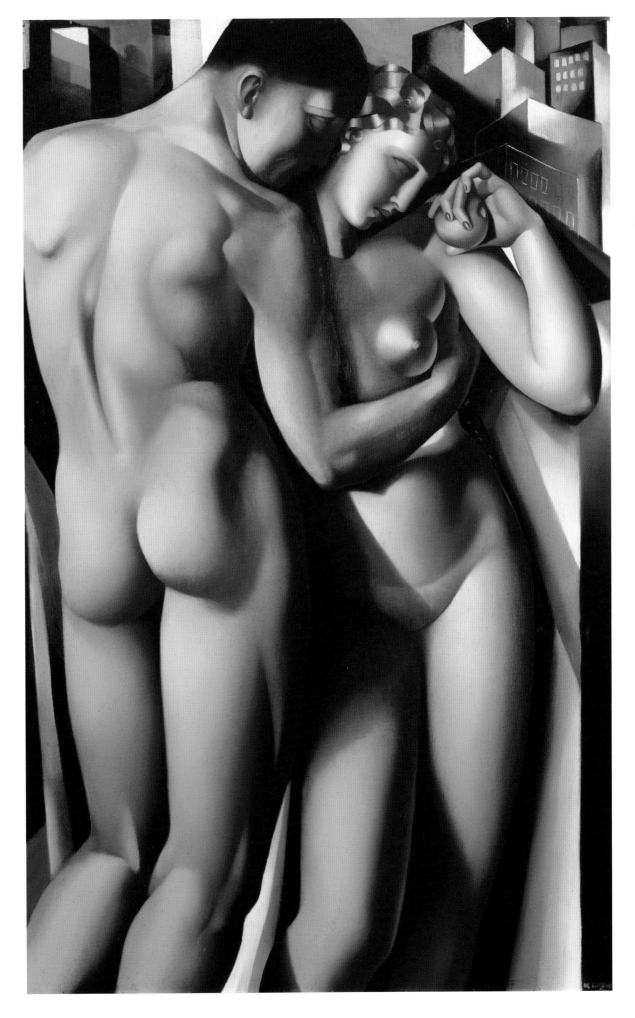

43 *Arlette Boucard with*
Arums
1931
Oil on plywood
91 × 55.5 cm
Collection Wolfgang Joop

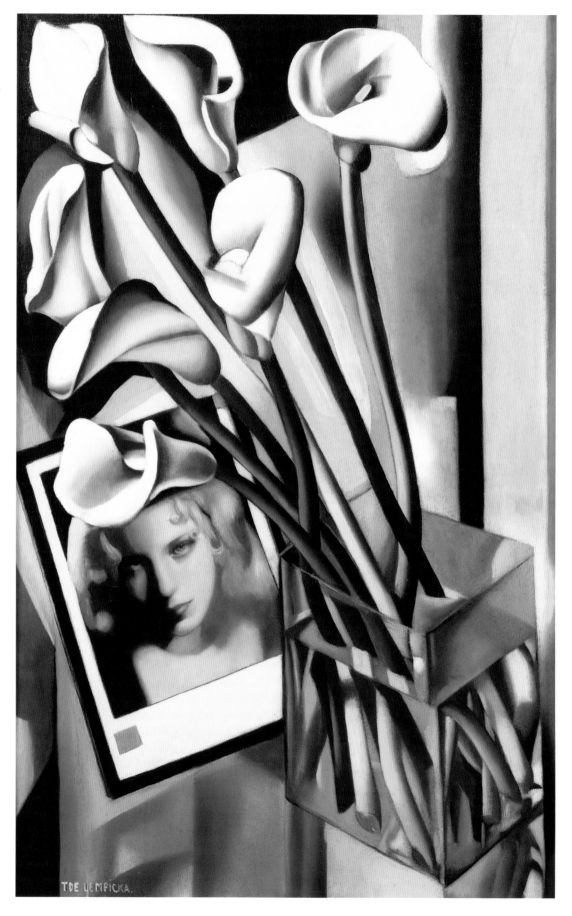

44 *Portrait of a Young Lady
and a Square Column*
c. 1931
Oil on canvas
100 × 51 cm
Private collection

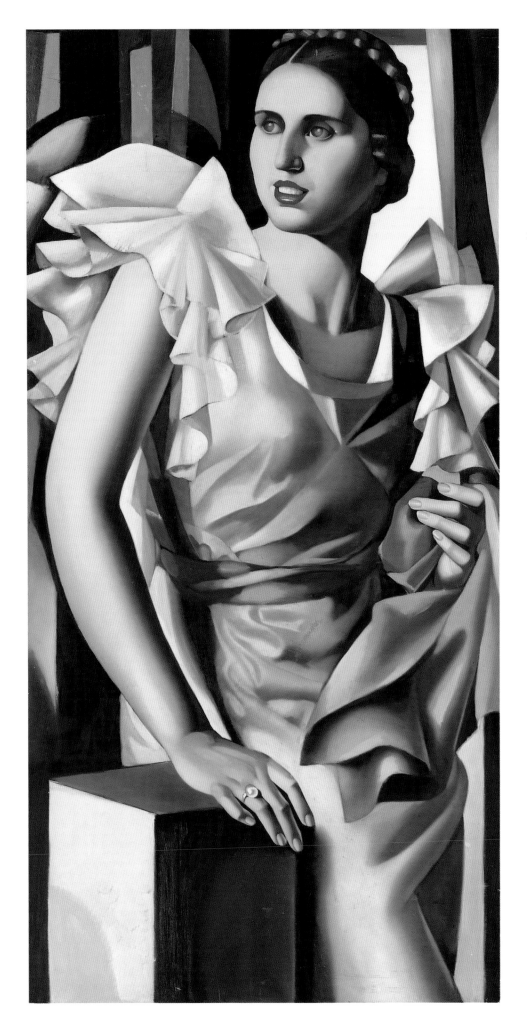

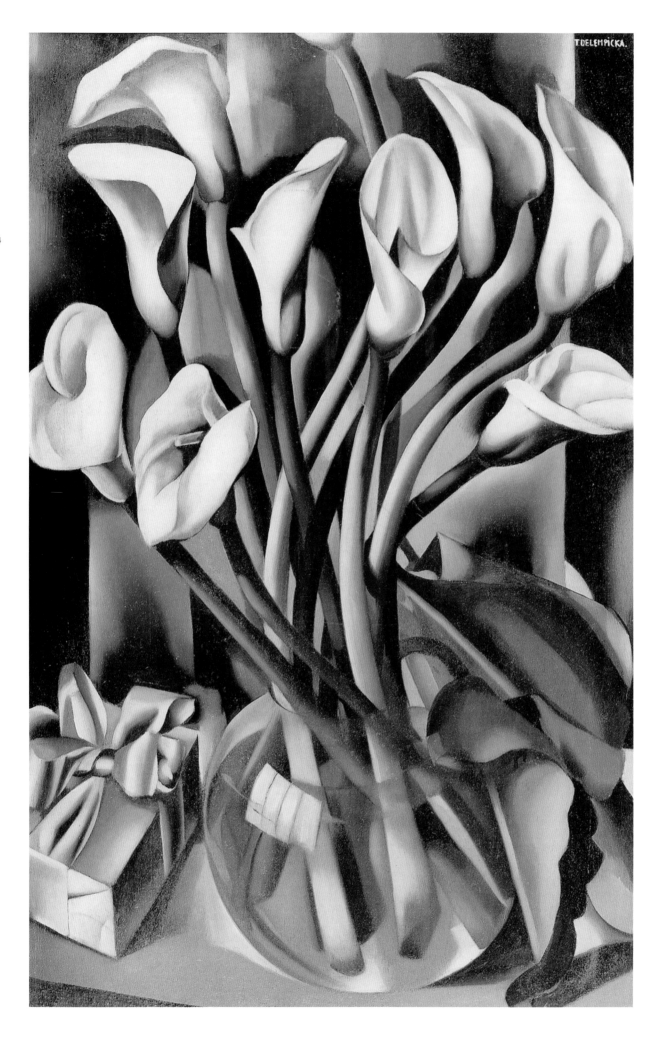

Arums
c. 1931
Oil on panel
92 × 60 cm
James and Patricia Cayne

46 *The Convalescent*
1932
Oil on panel
56 × 42 cm
Private collection

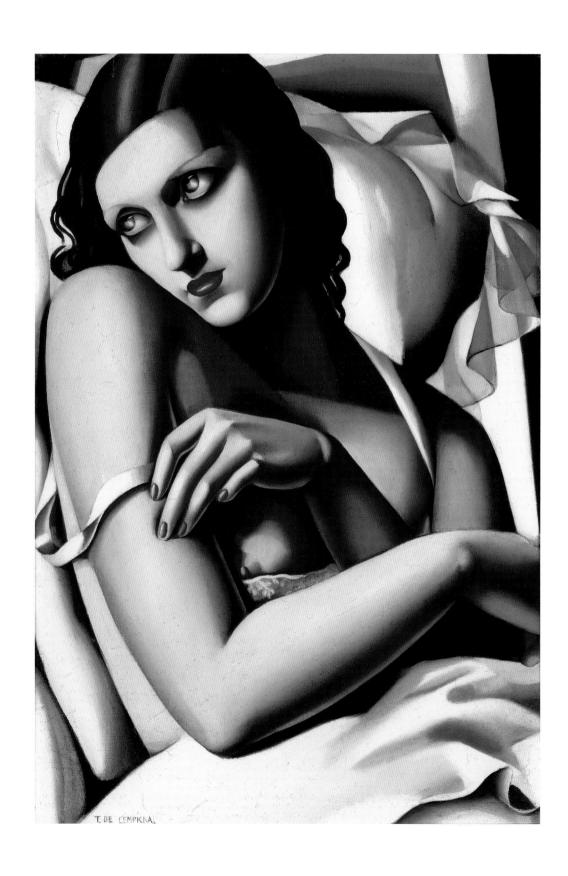

47 *Portrait of Marjorie Ferry*
1932
Oil on canvas
100 × 65 cm
Collection Wolfgang Joop

116

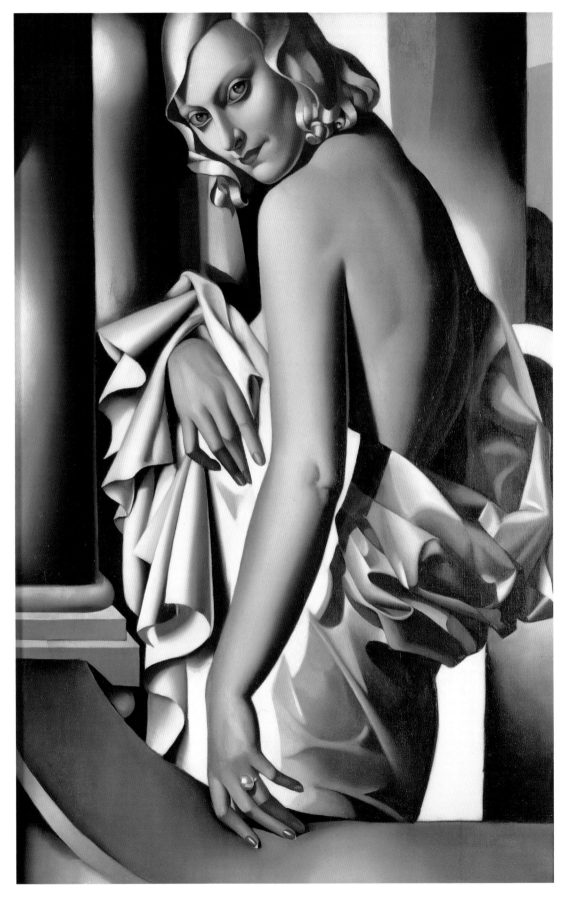

48 *Portrait of Mrs M.*
1932
Oil on canvas
100 × 65 cm
Private collection

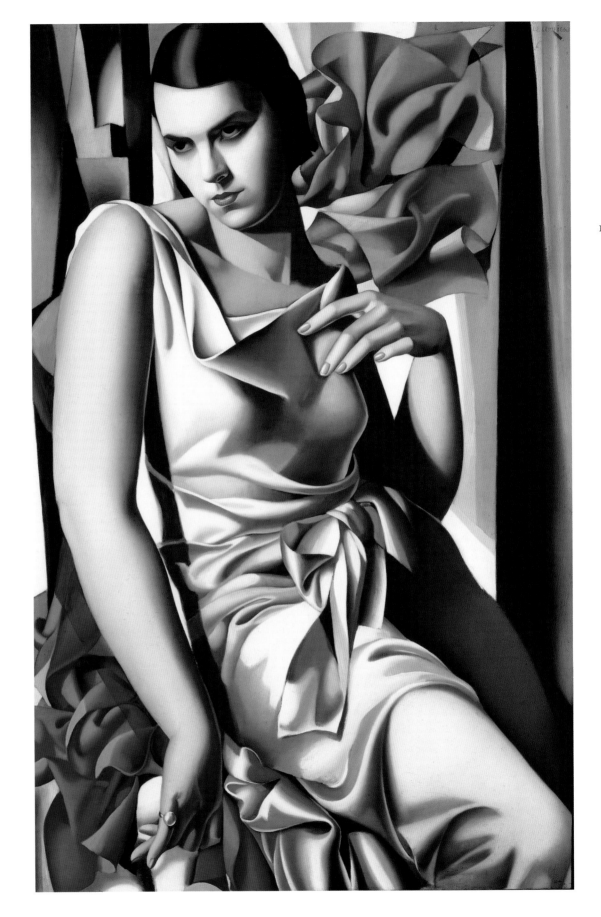

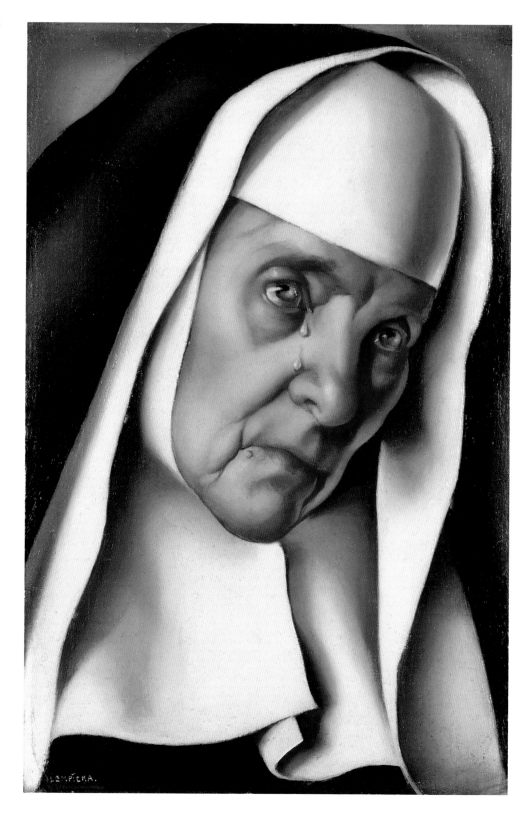

49 *The Mother Superior*
1935
Oil on canvas, laid down
30 × 20 cm
Musée des Beaux-Arts
de Nantes

50 *The Refugees*
1931
Oil on panel
53 × 51 cm
Musée d'Art et
d'Histoire, Saint-Denis

119

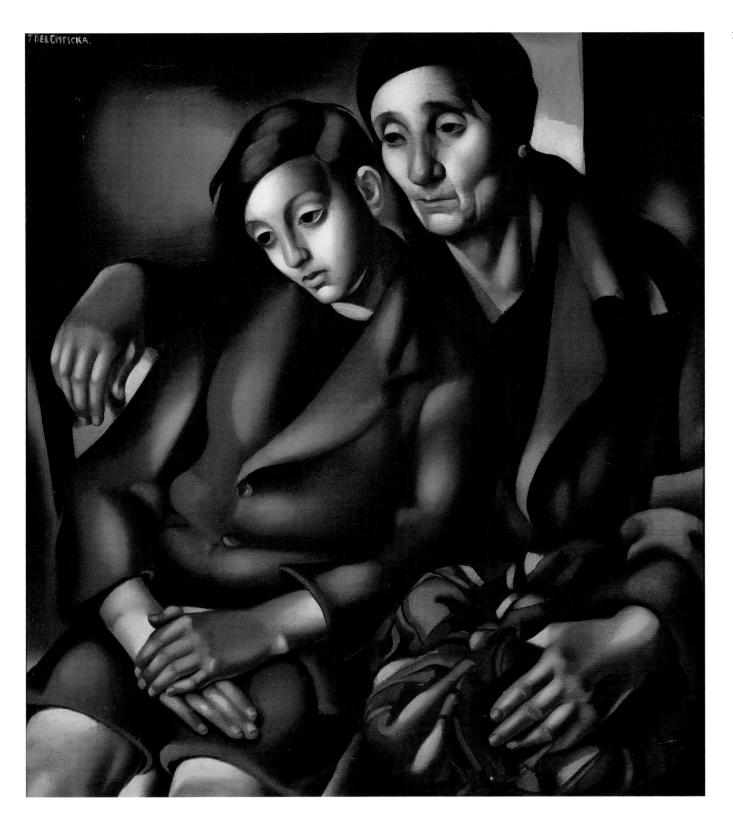

51 *Portrait of Miss*
Poum Rachou
1933
Oil on canvas
92 × 46 cm
Collection Wolfgang Joop

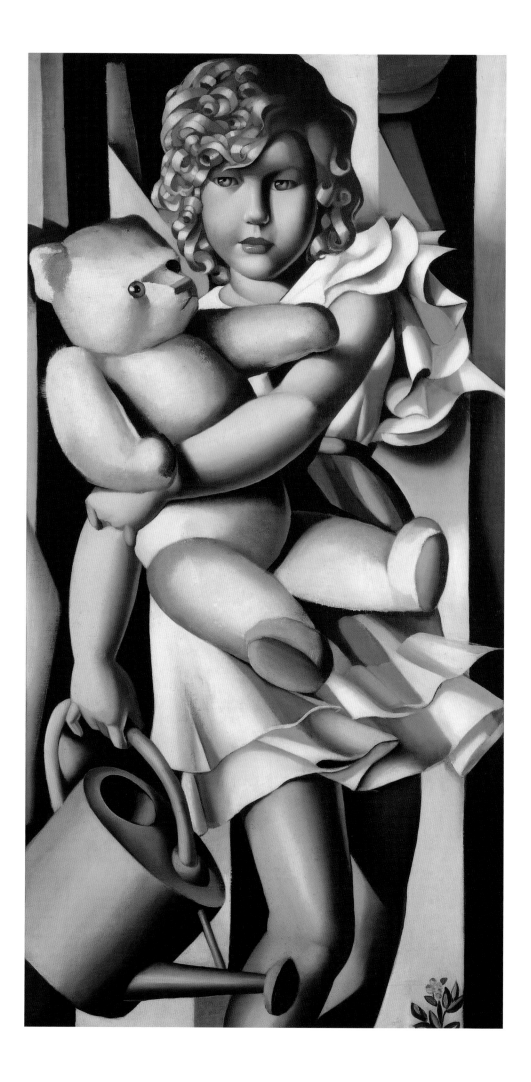

52 *Portrait of Count Vettor*
Marcello
c. 1933
Oil on panel
35 × 27 cm
Private collection

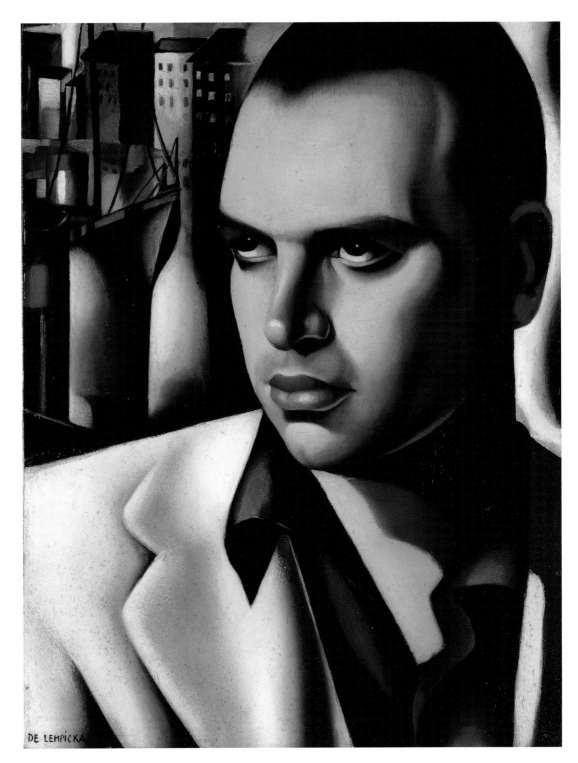

53 *Escape*
 c. 1940
 Oil on canvas
 50.8 × 40.6 cm
 Musée des Beaux-Arts
 de Nantes

54 *Wisdom*
 1940/41
 Oil on panel
 71.1 × 50.8 cm
 Private collection

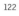

122

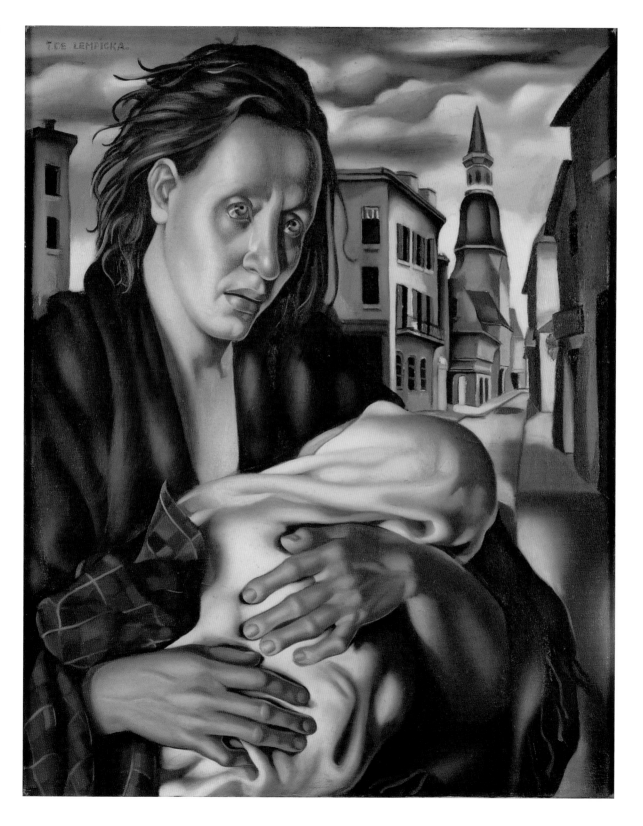

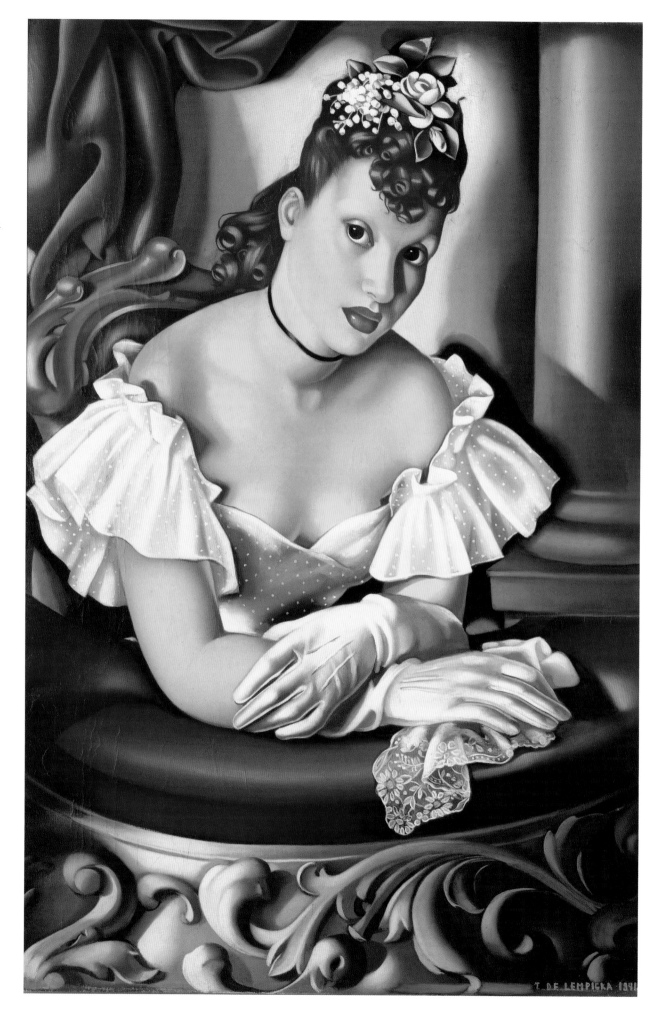

55 *At the Opera*
1941
Oil on canvas
76.2 × 50.8 cm
Collection Wolfgang Joop

56 *Succulent and Flask*
c. 1941
Oil on canvas
55.9 × 45.7 cm
The Severin Wunderman
Family Museum, Irvine,
California

57 *The Key*
c. 1946
Oil on canvas
48.3 × 35.6 cm
Collection Wolfgang
Joop

58 *The Mexican Woman*
c. 1947
Oil on plywood
50.8 × 40.5 cm
Musée des Beaux-Arts
de Nantes

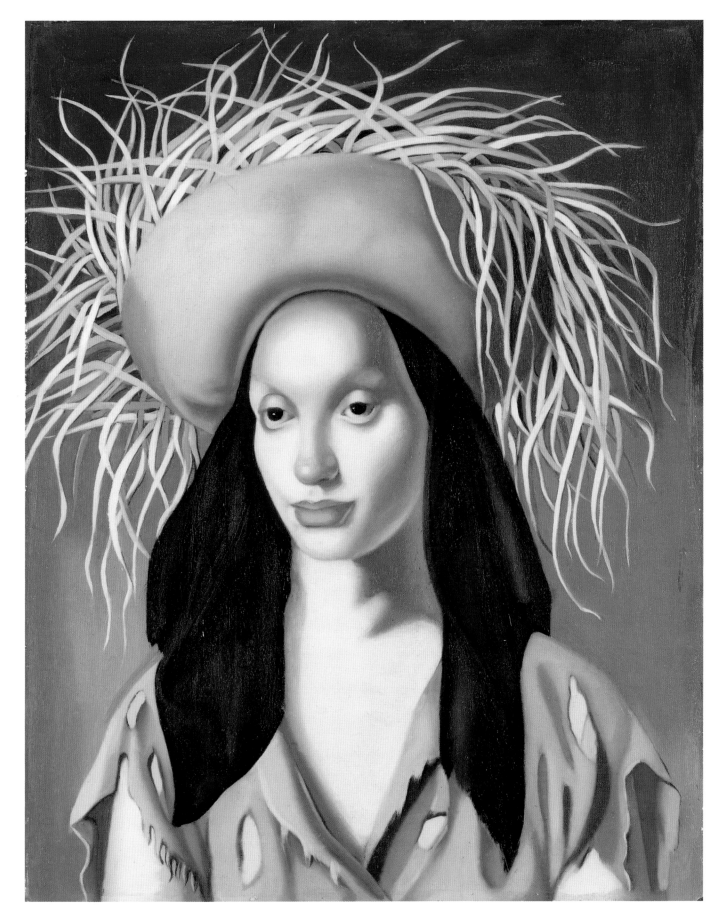

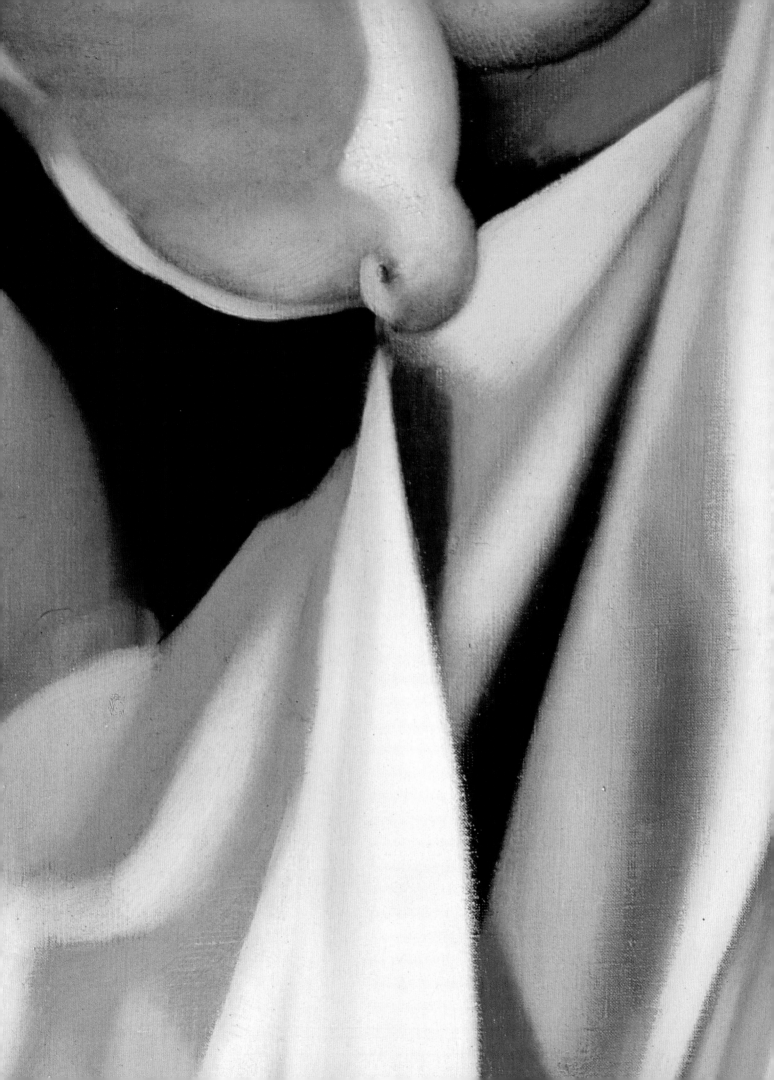

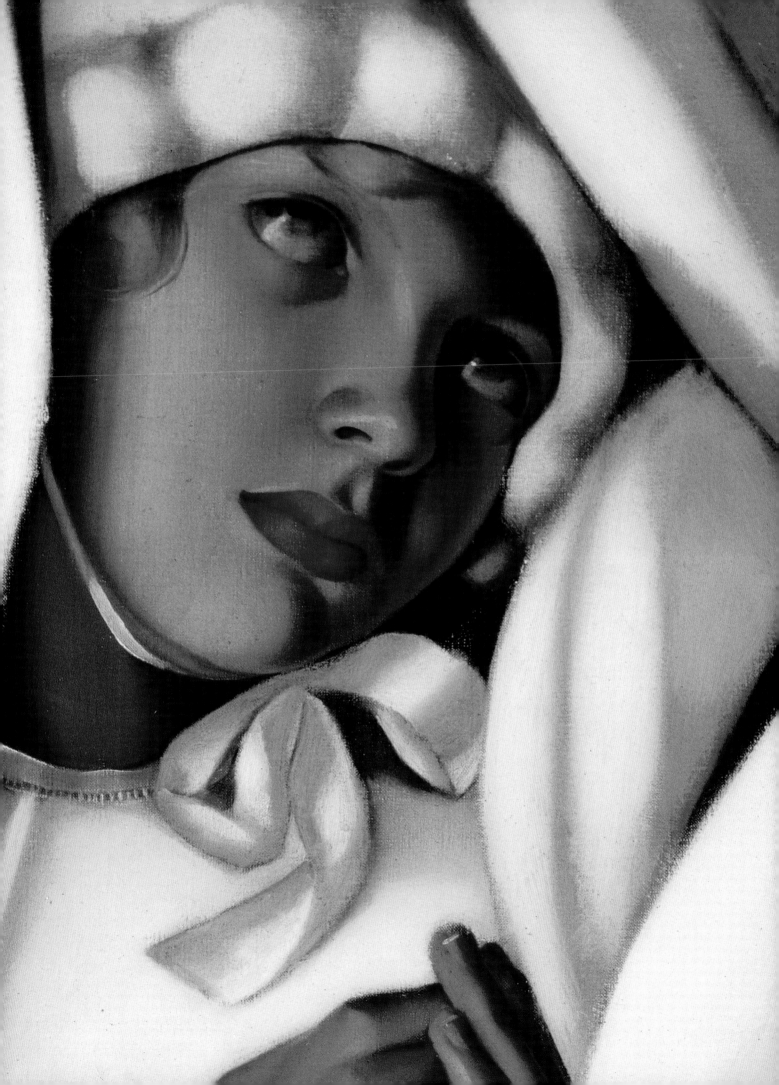

Chronology
Alain Blondel

1898

Tamara was born in Warsaw, Poland, under Russian sovereignty. Her father Boris Gorski, a lawyer, and her mother Malvina Declair both came from the educated upper classes. She had a sister, Adrienne, who followed her to Paris and enjoyed a successful career as an architect, and a brother, Stanczyk. Her childhood seems to have been happy, and she was educated in Switzerland.

1911

At the age of thirteen she was taken to Italy by her maternal grandmother, Clémentine Declair. The Renaissance masters made a powerful impression and convinced her to take up painting as a career.

1914

Tamara was living with her aunt, Stéphanie (Stefa) Stiffter, in St Petersburg when war was declared. Unable to return to Poland, she enrolled at the Academy of Art in St Petersburg, where she discovered the painting of Russian artists of her generation: Boris Grigoriev, Kouzma Petrov-Vodkin and Alexander Jacovlef.

1916

Her wedding to Count Tadeusz de Lempicki, a young lawyer, was celebrated in the Chapel of the Knights of Malta in St Petersburg.

1917

The Bolshevik revolution forced her parents and her sister to take up temporary residence in Copenhagen, so she joined them there.

The artist and her brother Stanczyk in Riga in 1900

The artist, aged thirteen, playing Diabolo in Monte Carlo

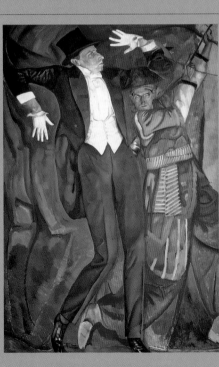

Boris Grigoriev
Portrait of the Producer V. E. Meyerhold
1916
Oil on canvas
247 × 163 cm
State Russian Museum, St Petersburg

1918

Her husband Tadeusz, who had remained in Russia to defend the family's interests, was arrested. He spent seven weeks in Communist prisons, but was rescued just in time by the Swedish consul, who managed to get him out of the country on a Swedish passport. He joined his wife in Copenhagen.

1919

By now the family had moved to Paris. De Lempicka's parents took up residence in an inexpensive hotel in Passy. Tamara, Tadeusz and their baby daughter Kizette took temporary refuge in the large apartment of Constantin Stiffter, a cousin.

1920

At the Académie Ranson, De Lempicka studied with Maurice Denis. At the Académie de la Grande Chaumière, her teacher was André Lhote. It was Lhote who exerted the stronger influence. She made a study trip to Italy.

1922

De Lempicka exhibited for the first time at the Salon d'Automne, showing her first portrait of Ira Perrot, with whom she had embarked on a relationship that was to last several years. De Lempicka set up house in an apartment in the Place Wagram where her attentive cousin Constantin Stiffter photographed her recent paintings.

1923

De Lempicka began to exhibit regularly at the Salon des Indépendants and the Salon d'Automne, continuing to do so each year until her departure for the United States. She moved into an elegant apartment in the Rue Guy de Maupassant.

The artist with her first husband, Tadeusz de Lempicki, in Paris in 1920

Ira Perrot in 1922 in front of her portrait, which De Lempicka later reworked as *Portrait of a Young Lady in a Blue Dress* (cat. 1)

1925

De Lempicka won public acclaim for her one-woman show at the Bottega di Poesia in Milan, organised by Count Emmanuele di Castelbarco. During a prolonged stay in the city she made the acquaintance of a number of Italian aristocrats with influence in the art world.

1926

She returned to Italy to fulfil a number of commissions that followed her exhibition in Milan, and began a correspondence with the poet and politician Gabriele d'Annunzio, whom she had met through Castelbarco.

1927

D'Annunzio suggested that De Lempicka paint his portrait. In order to avoid his advances she was obliged to make her escape one morning at dawn. She produced her first cover for the leading German fashion magazine *Die Dame*.

Gabriele d'Annunzio in 1916

1928

Tamara and Tadeusz were divorced (against the artist's wishes) and the portrait she had begun to paint of her husband (cat. 28) was never finished. She made the acquaintance of Dr Pierre Boucard, who commissioned several portraits. Working increasingly hard, she began to enjoy financial success, spending long periods in Cannes.

1929

Summoned by a wealthy American, Rufus Bush, to paint a portrait of his fiancée (fig. 7), De Lempicka made her first trip to New York. She produced a number of paintings while there, including some studies of skyscrapers. She held exhibitions simultaneously in Poland (winning a bronze medal at the International Exhibition in Poznan), Paris (in four Salons and at the Galerie Colette Weil) and the United States (at the Carnegie Institute, Pittsburgh).

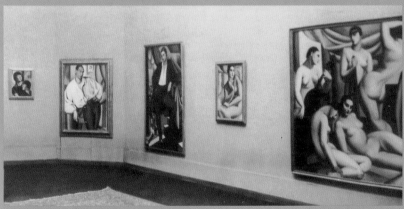

The installation of De Lempicka's 1925 exhibition at the Bottega di Poesia, Milan

De Lempicka with her daughter Kizette in Cannes in 1928

Study for 'Portrait of Mrs Bush' I
1929
Conté on paper
14.5 × 7.1 cm
Private collection

1930

Now at the height of her career, De Lempicka moved to a new studio-apartment. Probably on the advice of her architect sister Adrienne Gorska, she chose an ultra-modern block designed by Robert Mallet-Stevens and recently built near Montparnasse, the new centre of artistic life in Paris, prompting an immediate outpouring of articles in the press. Her dazzling parties caused a sensation in Parisian high society.

1931

She had a one-woman show at Galerie Colette Weil for the second year in succession. The year saw some of her best portraits. She continued her liaison with Baron Raoul Kuffner, whom she had met in 1927 when he had commissioned her to paint a portrait of his mistress, the dancer Nana de Herrera (fig. 5).

1932

The Musée du Luxembourg in Paris paid 8,000 francs for *Young Lady with Gloves* (fig. 8), which had been exhibited in the Salon des Indépendants. Her first showing with 'Femmes Artistes Modernes', a group of feminist artists, known by the initials 'FAM', who were to include her in their annual exhibition until their association was abandoned. Pathé News devoted a sequence to her, filmed in her studio.

1933

De Lempicka married Baron Raoul Kuffner, making her a wealthy woman, although economic problems were besetting Europe.

1934

She participated in an exhibition at the Galerie du Cygne in Paris, owned by her journalist friend Jacqueline d'Hariel, an ardent feminist; the mixed show was entitled 'Exhibition of the Leading Female Painters in Paris', indicating that De Lempicka was still devoted to the cause. Alfonso XIII, King of Spain, commissioned her to paint his portrait. Begun in Salsomaggiore in Italy, the painting was never finished. Her output began to diminish quite markedly, and she started to concentrate on religious subjects.

Axonometric view of the apartment at 29 Rue Méchain, *c.* 1929, a building designed by Robert Mallet-Stevens, and (right) a photograph of the smoking room

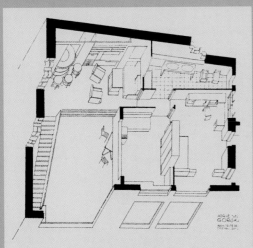

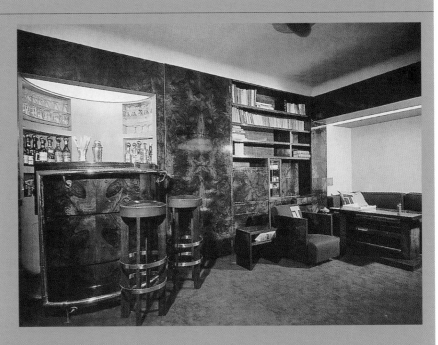

1935

De Lempicka fell into a lengthy spell of depression. During a trip to Tuscany she decided to retire to a convent, engaging the Mother Superior in long discussions. She did not put her plan into action, but painted a tragic portrait of the nun (cat. 49). She wrote sorrowful letters to her faithful confidant Gino Puglisi, a handsome Italian airman.

1936

As her mental state deteriorated De Lempicka retreated for frequent spells to a clinic in Switzerland. She managed to disguise a portrait of the psychiatrist dealing with her case as St Anthony. Her frail mental condition had no deleterious effect on her beauty and powers of seduction, as a series of portraits by the Milanese photographer Camuzzi shows.

1937

Because she painted so little during this difficult period, De Lempicka was unable to show any recent work at the Exposition Internationale in Paris. She chose *Adam and Eve* (cat. 42) for her contribution to the FAM exhibition. In her studio she concentrated on humble, rustic subjects, including *The Peasant Girl* and *Peasant Girl Praying*.

1938

De Lempicka regained her taste for living. She convinced her husband to sell his properties in Hungary, perhaps through an intuition of trouble brewing in Europe. Her plan to move to the United States encouraged her to sever all links with the old continent. In her studio she took up more ambitious subjects in preparation for the relaunch of her career in America.

1939

On 24 February the Kuffners boarded the SS *Paris*, bound for New York. The artist took a large selection of paintings with her, leaving her daughter Kizette in the care of Adrienne and her husband. In May, she held her first exhibition at the Paul Reinhardt Gallery.

Portrait of Gino Puglisi in His Youth
1935
Oil on panel
35 × 27 cm
Private collection

One of a series of photographic portraits of the artist by Camuzzi, 1936

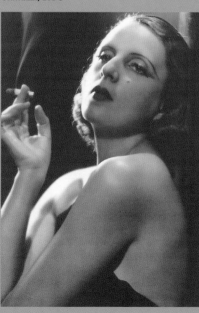

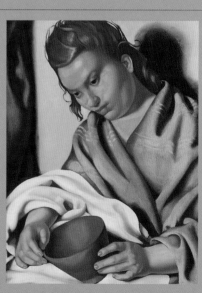

The Peasant Girl
c. 1937
Oil on canvas
40.6 × 30.5 cm
Barry Friedman Collection

1940

The Kuffners decided to live in Hollywood, buying a house belonging to the film director King Vidor. De Lempicka threw herself into charitable work in support of wartime Europe, and was given the rank of Staff Sergeant in the Women's Emergency Corps (whose uniforms she had designed). She requested American citizenship.

1941

On 7 April, an exhibition entitled 'Tamara de Lempicka (Baroness de Kuffner)' was inaugurated at the Julien Levy Gallery in New York. All De Lempicka's most recent paintings were included. A number of earlier works gave the exhibition the feeling of a retrospective.

1942

The 1941 show moved to Los Angeles, where a new gallery belonging to Julien Levy opened on Sunset Boulevard. After an exhibition at the Milwaukee Art Center, the Kuffners moved to New York, where they bought an apartment at 322 East 57th Street. Her painting at this time took its inspiration from the natural world around their country house in Connecticut, and she produced a series of still-lifes. In New York she devoted herself to her social circle, yet poor health undermined her efforts.

1949

De Lempicka's postwar style was characterised by a somewhat uncertain definition. Eager to return to Europe, in January she visited Italy and revisited the museums, returning with numerous sketches and some copies. Willy Maywald photographed her in her Paris studio in the Rue Méchain, in a décor worthy of Jean Cocteau.

1953

She began a period as an abstract painter.

The artist (right) at the opening of her 1939 exhibition at the Paul Reinhardt Gallery, New York

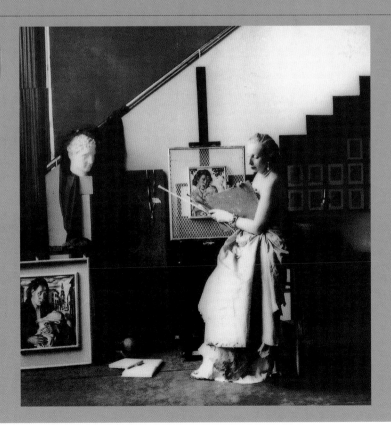

The artist at her easel in her Paris studio, photographed by Willy Maywald, c. 1949

1955

De Lempicka travelled extensively throughout the early 1950s, with long periods spent in France, Italy, Cuba and Mexico. During a visit to Paris in 1955 she held an exhibition at the Galerie André Weil that went largely unnoticed. She redecorated her studio in the Rue Méchain in the Rococo style.

1957

A small monograph by Gabriele Mandel appeared on the occasion of an exhibition organised by Princess Stefanella Barberini Colonna di Sciarra in her gallery, Sagittarius, in Milan. Only figurative work from the 1940s was included.

1961

In May, a retrospective entitled 'T. de Lempicka, Recent and Early Work, 1930–1960' was held at the Galerie Ror-Volmar in Paris. Posters in the newspapers announced: 'neo-cubism, abstract, figurative art'. The exhibition received little attention. It was repeated the following year at the Alexandre Iolas Gallery in New York with a similar lack of success. Raoul Kuffner died in November during the return voyage from Europe to America. De Lempicka moved to Houston to be near her daughter.

1963

Following the failure of her retrospective, De Lempicka decided not to exhibit again. She continued to paint, however, and her style changed radically. She abandoned firm outlines and smooth surfaces for a thicker, rougher texture. She was to paint regularly until 1964.

1967

By chance, during a visit to Paris and to her studio, De Lempicka received a visit from two young dealers who proposed that she should mount an exhibition. She willingly agreed to sell them some paintings, but categorically refused to exhibit.

Abstract Composition
1957
Oil on canvas
54 × 81 cm
Van den Abbeele
Collection, Belgium

A photograph by L. S. Jaulmes of the installation of the 1972 exhibition at the Galerie du Luxembourg, Paris

1972

On the insistence of the two young dealers, who had just set up the Galerie du Luxembourg in an 'exotic' area of Paris (Les Halles), she overcame her doubts. This exhibition marked the beginning of her rediscovery. Her new public revered her work as emblematic of the 1930s. The newspapers published copious accounts.

1976

De Lempicka gave a number of paintings to the museums of France.

1977

De Lempicka's art and her life were now viewed as bearing witness to a period that grew more fascinating the more distant it became. Once again, she was an object of curiosity to journalists and chroniclers. A highly coloured version of her failed relationship with Gabriele d'Annunzio was published in a luxurious binding. She was deeply shocked, but the book undeniably boosted her celebrity.

1978

She retired to Cuernavaca in Mexico.

1980

De Lempicka died at Tres Bambùs, her house in Cuernavaca. At her request, her ashes were scattered at the top of the volcano Popocatépetl.

A photograph by L. S. Jaulmes of the artist at the opening of the 1972 exhibition at the Galerie du Luxembourg, Paris

A corner of the artist's studio in her house in Cuernavaca, Mexico, 1980

Select Bibliography

138

Alexandre, Arsène, 'Tamara de Lempicka', *La Renaissance de l'art français et des industries de luxe*, July 1929, pp. 330–37

Bazin, Germain, and H. Itsuki, *Tamara de Lempicka*, Tokyo, 1980

Birnbaum, Paula, 'Painting the Perverse: Tamara de Lempicka and the Modern Woman Artist', in *The Modern Woman Revisited: Paris Between the Wars*, Whitney Chadwick and Tirza True Latimer (eds), New Brunswick, N.J., and London, 2003, pp. 95–107

Blondel, Alain, *Tamara de Lempicka: Catalogue Raisonné, 1921–1979*, Lausanne, 1999

Bojko, Szymon, 'Tamara de Lempicka (1898–1980)', *Pro Arte*, Winter 1987

Chiarelli, Luigi, 'Tamara de Lempicka', *La Donna*, April 1930

Claridge, Laura, *Tamara de Lempicka: A Life of Deco and Decadence*, New York, 1999

Die Dame, covers by Tamara de Lempicka for February 1927, August 1928, December 1929 and October 1930 issues

Dayot, Magdeleine A., 'Tamara de Lempicka', *L'Art et les artistes*, 156, April 1935

de Lempicka-Foxhall, Kizette, and Charles Phillips, *Passion by Design: The Art and Times of Tamara de Lempicka*, New York and Oxford, 1987

de Sceaux, Didier, 'Un Peintre: Tamara de Lempicka', *Le Forum*, 12 July 1927

Fiorini, Guido, 'Necessità di raffinatezza', *Ottobre*, 4 May 1935, p. 3

Georges-Michel, Michel, 'Une Reine du bizarre', *Aux Ecoutes*, 16 June 1961

Gilot, Françoise, 'Tamara de Lempicka, mystérieuse et connue', *Vogue*, 609, September 1980

Gilot, Françoise, 'Tamara', *Arts and Antiques*, February 1986, pp. 25–27

Harrison, Joanne, 'A Portrait of the Artist', *Houston City Magazine*, August 1978, pp. 38–49

Krisane, John, *Tamara*, stage play, Los Angeles, Calif., 1984

Lacroix, Boris J., 'Tamara de Lempicka ou la femme installée par le peintre', *Art et décoration*, December 1956, pp. 9–12

Levy, Julien, *Memoir of an Art Gallery*, New York, 1977

The Major Works of Tamara de Lempicka, 1925–1935, intro. by Giancarlo Marmori, Milan, 1978

Mandel, Gabriele, *La pittrice Tamara de Lempicka*, Milan, 1957

Marmori, Giancarlo, 'Tamara Is Forever: Portrait of a Forgotten Artist', *Viva*, May 1978, pp. 59–62

McKay, Gary, 'And the Baroness Was an Artist: The Brush Strokes of Tamara de Lempicka', *Ultra*, March 1988, pp. 26–32

Mori, Gioia, *Tamara de Lempicka, Paris 1920–1938*, Florence, 1994

Neret, Gilles, *Tamara de Lempicka, 1898–1980*, Cologne, 1993

Olmedo, Guillermina, 'Especial Tamara de Lempicka', *Casas & Gente*, Mexico, 1989

Remon, Georges, 'Architectures modernes: L'Atelier de Mme de Lempicka', with photographs by M. Gravot, *Mobilier et décoration*, 9, 1, January 1931, pp. 1–10

Tamara de Lempicka de 1925 à 1935, preface by Jean Reau, exh. cat., Galerie du Luxembourg, Paris, 1972

Tamara de Lempicka: tra eleganza e trasgressione, Maurizio Calvesi and Alessandro Borghese (eds), exh. cat., Accademia di Francia, Rome; Museum of Fine Art, Montreal, 1994

Tamara de Lempicka, with the Journal of Aélis Mazoyer, Gabriele d'Annunzio's Housekeeper, Piero Chiara and Federico Roncoroni (eds), John Shepley (trans.), Milan, 1977

Tamara de Lempitzka, preface by Jacques Reboul, exh. cat., Bottega di Poesia, Milan, 1925

Thormann, Ellen, *Tamara de Lempicka: Kunstkritik und Künsterinnen in Paris*, Berlin, 1993

Torriano, Pietro, 'Tamara de Lempicka', *Emporium*, 62, 372, December 1925, pp. 402–03

Warnod, André, 'Les Expositions: quelques oeuvres de Tamara de Lempicka', *Comoedia*, 21 May 1930, p. 3

Warnod, André, 'L'Intéressante Exposition de Tamara de Lempicka', *Comoedia*, 17 May 1931, p. 3

Woroniecki, E., 'Tamara de Lempicka', *La Pologne*, 1 January 1928

Zaslawsaka, I., 'Tamara de Lempicka', *Kobieta Wspolczesna (The Modern Woman)*, 20 July 1932

List of Works

1 *Portrait of a Young Lady in a Blue Dress* (B. 7), 1922. Oil on canvas, 63 × 53 cm. Private collection

2 *Portrait of a Polo Player* (B. 8), *c.* 1922. Oil on canvas, 73 × 60 cm. From the collection of Daniel Fischel and Sylvia Neil. London only

3 *The Kiss* (B. 13), *c.* 1922. Oil on canvas, 50 × 61 cm. Dr F. Dessau

4 *Seated Nude* (B. 21), *c.* 1923. Oil on canvas, 94 × 56 cm. Private collection

5 *The Sleeping Girl* (B. 22), 1923. Oil on canvas, 89 × 146 cm. Private collection. Courtesy of the Allan Stone Gallery, New York

6 *Perspective* (B. 23), 1923. Oil on canvas, 130 × 162 cm. Association des Amis du Petit Palais, Geneva. London only

7 *Woman in a Black Dress* (B. 31), 1923. Oil on canvas, 195 × 60.5 cm. Collection Wolfgang Joop

8 *Double '47'* (B. 33), *c.* 1924. Oil on panel, 46 × 38 cm. Barry Friedman Ltd, New York, and Galerie Brockstedt, Hamburg

9 *The Open Book*, *c.* 1924. Oil on canvas, laid down, 24 × 35 cm. Private collection

10 *The Red Bird* (B. 40), 1924. Oil on canvas, laid down, 24 × 33 cm. Private collection

11 *The Green Veil* (B. 37), *c.* 1924. Oil on canvas, 46 × 33 cm. Private collection

12 *Irene and Her Sister* (B. 57), 1925. Oil on canvas, 146 × 89 cm. Private collection, USA. Courtesy of Irena Hochman Fine Art Ltd

13 *Two Little Girls with Ribbons* (B. 66), 1925. Oil on canvas, 100 × 73 cm. Collection of Dr George and Mrs Vivian Dean

14 *Portrait of Prince Eristoff* (B. 70), 1925. Oil on canvas, 65 × 92 cm. Private collection. Courtesy of Barry Friedman Ltd, New York

15 *Portrait of André Gide* (B. 69), *c.* 1925. Oil on cardboard, 50 × 35 cm. J. Nicholson, Beverly Hills, California

16 *Portrait of Marquess Sommi* (B. 55), 1925. Oil on canvas, 100 × 73 cm. Albert and Victoria Benalloul

17 *Portrait of the Duchess de La Salle* (B. 72), 1925. Oil on canvas, 162 × 97 cm. Collection Wolfgang Joop

18 *Portrait of His Imperial Highness the Grand Duke Gabriel* (B. 77), *c.* 1926. Oil on canvas, 116 × 65 cm. J. Nicholson, Beverly Hills, California

19 *The Pink Tunic* (B. 84), 1927. Oil on canvas, 73 × 116 cm. Caroline Hirsch

20 *Kizette in Pink* (B. 81), *c.* 1926. Oil on canvas, 116 × 73 cm. Musée des Beaux-Arts de Nantes

21 *The Dream* (B. 85), 1927. Oil on canvas, 81 × 60 cm. Toni Schulman, New York

22 *La Belle Rafaëla in Green* (B. 86), *c.* 1927. Oil on canvas, 38 × 61 cm. Ms Donna Karan

23 *The Orange Scarf* (B. 89), 1927. Oil on panel, 41 × 33 cm. J. Nicholson, Beverly Hills, California

24 *Reclining Nude with Book* (B. 88), *c.* 1927. Oil on canvas, 64.1 × 121.2 cm. JAPS Collection, Mexico

25 *The Communicant* (B. 102), 1928. Oil on canvas, 100 × 65 cm. Centre Georges Pompidou, Paris: Musée National d'Art Moderne/Centre de Création Industrielle. Gift of the artist, 1976.

On deposit with the Musée d'Art et d'Industrie, Roubaix

26 *Maternity* (B. 106), 1928. Oil on panel, 35 × 27 cm. Mrs Barry Humphries

27 *Portrait of Dr Boucard* (B. 108), 1928. Oil on canvas, 135 × 75 cm. Private collection, Salzburg

28 *Portrait of a Man* (B. 107), 1928. Oil on canvas, 130 × 81 cm. Centre Georges Pompidou, Paris: Musée National d'Art Moderne/Centre de Création Industrielle. Gift of the artist, 1976. On deposit with the Musée des Années 30, Boulogne-Billancourt/Espace Landowski

29 *Portrait of Arlette Boucard* (B. 95), 1928. Oil on canvas, 70 × 130 cm. Private collection

30 *Portrait of Romana de La Salle* (B. 100), 1928. Oil on canvas, 162 × 97 cm. Collection Wolfgang Joop

31 *The Musician* (B. 117), 1929. Oil on canvas, 116 × 73 cm. Collection Frisia Museum, Spanbroek/Opmeer, The Netherlands. London only

32 *Women Bathing* (B. 120), 1929. Oil on canvas, 89 × 99 cm. Private collection, New York

33 *St Moritz* (B. 116), 1929. Oil on panel, 35 × 27 cm. Musée des Beaux-Arts, Orléans. Vienna only

34 *My Portrait* (B. 115), 1929. Oil on panel, 35 × 27 cm. Private collection. Vienna only

35 *Nude with Buildings* (B. 129), 1930. Oil on canvas, 92 × 73 cm. Caroline Hirsch

36 *Sleeping Girl* (B. 135), *c.* 1930. Oil on panel, 35 × 27 cm. From the collection of Daniel Fischel and Sylvia Neil. London only

37 *Portrait of Ira P.* (B. 143), 1930. Oil on panel, 99 × 65 cm. Private collection. Courtesy of Christie's, London. London only

38 *Portrait of Mrs Allan Bott* (B. 132), 1930. Oil on canvas, 162 × 97 cm. Private collection

39 *The Telephone II* (B. 134), 1930. Oil on panel, 35 × 27 cm. Collection Wolfgang Joop

40 *The Blue Scarf* (B. 131), 1930. Oil on panel, 35 × 27 cm. Private collection

41 *Portrait of Pierre de Montaut* (B. 149), 1931. Oil on panel, 41 × 27 cm. Barry Friedman Ltd, New York

42 *Adam and Eve* (B. 147), 1931. Oil on panel, 116 × 73 cm. Private collection. London only

43 *Arlette Boucard with Arums* (B. 154), 1931. Oil on plywood, 91 × 55.5 cm. Collection Wolfgang Joop

44 *Portrait of a Young Lady and a Square Column* (B. 145), *c.* 1931. Oil on canvas, 100 × 51 cm. Private collection

45 *Arums* (B. 155), *c.* 1931. Oil on panel, 92 × 60 cm. James and Patricia Cayne

46 *The Convalescent* (B. 160), 1932. Oil on panel, 56 × 42 cm. Private collection

47 *Portrait of Marjorie Ferry* (B. 166), 1932. Oil on canvas, 100 × 65 cm. Collection Wolfgang Joop

48 *Portrait of Mrs M.* (B. 161), 1932. Oil on canvas, 100 × 65 cm. Private collection

49 *The Mother Superior* (B. 191), 1935. Oil on canvas, laid down, 30 × 20 cm. Musée des Beaux-Arts de Nantes

50 *The Refugees* (B. 158), 1931. Oil on panel, 53 × 51 cm. Musée d'Art et d'Histoire, Saint-Denis

51 *Portrait of Miss Poum Rachou* (B. 175), 1933. Oil on canvas, 92 × 46 cm. Collection Wolfgang Joop

52 *Portrait of Count Vettor Marcello* (B. 177), *c.* 1933. Oil on panel, 35 × 27 cm. Private collection

53 *Escape* (B. 220), *c.* 1940. Oil on canvas, 50.8 × 40.6 cm. Musée des Beaux-Arts de Nantes

54 *Wisdom* (B. 221), 1940/41. Oil on panel, 71.1 × 50.8 cm. Private collection

55 *At the Opera* (B. 222), 1941. Oil on canvas, 76.2 × 50.8 cm. Collection Wolfgang Joop

56 *Succulent and Flask* (B. 227), *c.* 1941. Oil on canvas, 55.9 × 45.7 cm. The Severin Wunderman Family Museum, Irvine, California

57 *The Key* (B. 273), *c.* 1946. Oil on canvas, 48.3 × 35.6 cm. Collection Wolfgang Joop

58 *The Mexican Woman* (B. 278), *c.* 1947. Oil on plywood, 50.8 × 40.5 cm. Musée des Beaux-Arts de Nantes

List of Lenders

Albert and Victoria Benalloul
James and Patricia Cayne
Dr George and Mrs Vivian
 Dean
Dr F. Dessau
Daniel Fischel and Sylvia Neil
Barry Friedman Ltd,
 New York
Barry Friedman Ltd,
 New York, and Galerie
 Brockstedt, Hamburg
Geneva: Association des Amis
 du Petit Palais
Caroline Hirsch
Mrs Barry Humphries
Wolfgang Joop
Ms Donna Karan
Mexico: JAPS Collection
Nantes: Musée des Beaux-Arts
 de Nantes
J. Nicholson, Beverly Hills,
 California
Orléans: Musée des Beaux-Arts
Paris: Centre Georges
 Pompidou: Musée National
 d'Art Moderne/Centre
 de Création Industrielle.
 On deposit with the Musée
 d'Art et d'Industrie,
 Roubaix
Paris: Centre Georges
 Pompidou: Musée National
 d'Art Moderne/Centre
 de Création Industrielle.
 On deposit with the Musée
 des Années 30, Boulogne-
 Billancourt/Espace
 Landowski
Private collection. Courtesy
 of Christie's, London
Private collection. Courtesy
 of Barry Friedman Ltd,
 New York
Private collection. Courtesy
 of the Allan Stone Gallery,
 New York
Private collection, New York
Private collection, Salzburg
Private collection, USA.
 Courtesy of Irena
 Hochman Fine Art Ltd

Saint-Denis: Musée d'Art
 et d'Histoire
Toni Schulman, New York
The Severin Wunderman
 Family Museum, Irvine,
 California
Spanbroek/Opmeer,
 The Netherlands:
 Frisia Museum
*and others who wish
to remain anonymous*

Photographic Acknowledgements

All works of art are
reproduced by kind
permission of the owners.
Specific acknowledgements
are as follows:

I. Andréani, cat. 50
Beauvais: Musée de Beauvais,
 fig. 10
Matt Flynn, figs 29, 30, 34
Roy Fox, cat. 38
Geneva: Studio Monique
 Bernaz, cat. 6
M. Gravot, figs 11, 35, 38
Laurent Sully Jaulmes, figs 6,
 16, 19, 39
Jacques-Henri Lartigue,
 fig. 32
London: Giraudon/Bridgeman
 Art Library, fig. 26, p. 130
 (bottom right)
London: Prudence Cuming
 Associates Ltd, cat. 26
Milan: Foto Saporetti, cat. 10
André Morin, cat. 3
Nantes: Ville de Nantes,
 Musée des Beaux-Arts,
 cats 49, 53, 58; B. Voisin,
 cat. 20
New York: Ali Elai-Camerarts,
 cats 7, 19, 57
New York: courtesy Barry
 Friedman Ltd, cats 1, 2,
 4, 5, 8, 11, 13, 14, 16, 17,
 21, 32, 36, 39, 40, 41, 43,
 46, 51, 52, 54, 55, 56;
 figs 3, 13, 25
New York: Phillips, fig. 33
New York: © Sotheby's, Inc.
 2004, cats 30, 47
Madame d'Ora, fig. 28
Paris: Centre Georges
 Pompidou, Musée National
 d'Art Moderne/Centre de
 Création Industrielle, fig. 8
Paris: © CNAC/MNAM Dist.
 RMN, cat. 28; Jacqueline
 Hyde, cat. 25
Pau: Musée des Beaux–Arts,
 fig. 14
Arturo Piera, cat. 24
Pruskin, fig 17
ScanParcoBazin, fig. 15
Evan Schneider, cat. 45
Studio Piaz, fig. 36
Marc Vaux, figs 5, 9, 27
Joshua White, cats 15, 18, 23
James Young, fig. 22

**Copyright of works
illustrated**
All works illustrated
by Tamara de Lempicka
© ADAGP, Paris and DACS,
London 2004, and as listed
below:

© André Lhote/ADAGP,
 Paris and DACS,
 London 2004, fig. 14
© Association Willy
 Maywald/ADAGP, Paris
 and DACS, London 2004,
 p. 135 (bottom right)
© Ministère de la Culture,
 France/AAJHL, fig. 32
© Succession Picasso/ADAGP,
 Paris and DACS, London
 2004, fig. 18
Thérèse Bonney Collection,
 Cooper-Hewitt, National
 Design Museum,
 Smithsonian Institution,
 fig. 34

Index

All references are to page numbers.
Those in **bold** type indicate
catalogue plates, and those in *italic*
type indicate other illustrations

Benefactors of the Royal Academy of Arts

ROYAL ACADEMY TRUST

Major Benefactors

The Trustees of the Royal Academy
Trust would like to thank all
those who have been exceedingly
generous over a number of years
in support of the galleries, the
exhibitions, the conservation of the
Collections, the Library, the Royal
Academy Schools and the education
programme:

HM The Queen
The 29th May 1961 Charitable
 Trust
Barclays Bank
B.A.T. Industries plc
The late Tom Bendhem
The late Brenda M Benwell-Lejeune
John Frye Bourne
British Telecom
Mr Raymond M Burton CBE
Sir Trevor and Lady Chinn
The Trustees of the Clore
 Foundation
The John S Cohen Foundation
Sir Harry and Lady Djanogly
The Dulverton Trust
Alfred Dunhill Limited
The John Ellerman Foundation
The Eranda Foundation
Ernst and Young
Esso UK plc
Esmée Fairbairn Charitable Trust
The Foundation for Sport and
 the Arts
Friends of the Royal Academy
Jacqueline and Michael Gee
Glaxo Holdings plc
Diane and Guilford Glazer
Mr and Mrs Jack Goldhill
Maurice and Laurence Goldman
Mr and Mrs Jocelin Harris
The Philip and Pauline Harris
 Charitable Trust
The Charles Hayward Foundation
Heritage Lottery Fund
IBM United Kingdom Limited
The Idlewild Trust
The JP Jacobs Charitable Trust
Lord and Lady Jacobs
The Japan Foundation
Gabrielle Jungels-Winkler
 Foundation
Mr and Mrs Donald P Kahn
The Kresge Foundation
The Kress Foundation
The Kirby Laing Foundation
The Lankelly Foundation
The late John S Latsis
The Leverhulme Trust
Lex Service plc
The Linbury Trust
Sir Sydney Lipworth QC
 and Lady Lipworth
John Lyon's Charity
John Madejski
Her Majesty's Government
The Manifold Trust
Marks and Spencer
Ronald and Rita McAulay
McKinsey and Company Inc
The Mercers' Company
Mr and Mrs Minoru Mori
The Monument Trust
The Henry Moore Foundation
The Moorgate Trust Fund
Robin Heller Moss
Museums and Galleries
 Improvement Fund
National Westminster Bank
New Opportunities Fund
Stavros S Niarchos
The Peacock Trust
The Pennycress Trust
PF Charitable Trust
The Pilgrim Trust
The Edith and Ferdinand
 Porjes Trust
John Porter Charitable Trust
The Porter Foundation
Rio Tinto plc
Mr John A Roberts FRIBA
Virginia and Simon Robertson
The Ronson Foundation
The Rose Foundation
Rothmans International plc
Mrs Jean Sainsbury
The Saison Foundation
The Basil Samuel Charitable Trust

Mrs Coral Samuel CBE
Sea Containers Ltd
Shell UK Limited
Miss Dasha Shenkman
William and Maureen Shenkman
The Archie Sherman Charitable
 Trust
Sir Hugh Sykes DL
Sir Anthony and Lady Tennant
Ware and Edythe Travelstead
The Trusthouse Charitable
 Foundation
The Douglas Turner Trust
Unilever plc
The Weldon UK Charitable Trust
The Welton Foundation
The Weston Family
The Malcolm Hewitt Wiener
 Foundation
The Maurice Wohl Charitable
 Foundation
The Wolfson Foundation
and others who wish to remain
anonymous

Benefactors

The Trustees of the Royal Academy
Trust would like to thank all those
who have recently supported
the galleries, the exhibitions, the
conservation of the Collections, the
library, the Royal Academy
Schools or the education
programme:

Benjamin West Group Donors
Chairman
Lady Judge

Gold Donors
Mrs Deborah L Brice
Jack and Linda Keenan
Riggs Bank Europe
Mr and Mrs Joshua Swidler

Silver Donors
Lady Mimi Adamson
Susan Ansley Johnson
Megan Barnett
Mrs Adrian Bowden
Mr Jeffrey Brummette
 and Mrs Donna Lancia
Mr Ed Cohen
Abel G Halpern and Helen
 Chung-Halpern
Lady Judge
Sir Paul Judge
Mr Scott Lanphere
Sir William and Lady Purves
Mr and Mrs Nicolas Rohatyn
Mrs Anne Sixt
Ms Tara Stack
Frederick and Kathryn Uhde
Miss Christine Vanden
 Beukel

Bronze Donors
Sir Rudolph and Lady Agnew
Mrs Alan Artus
Tom and Diane Berger
Mr and Mrs Mark Booth
Mr and Mrs Robert Bowman
Mrs M E Brocklebank
Wendy M Brooks and Tim Medland
Mrs Susanne Childs
Mr and Mrs Paolo Cicchiné
Mr and Mrs Paul Collins
Mrs Joan Curci
Linda and Ronald F Daitz
Mr and Mrs C R Dammers
Mr and Mrs Peter Dicks
Virginia H Drabbe-Seeman
Eversheds
Arthur Fabricant
Mr Joseph A Field
Mr and Mrs Robert L Forbes
Cyril and Christine Freedman
Mr and Mrs John C Gore
Mr and Mrs Edward Greene
Mr Andrew Hawkins
Madeleine Hodgkin
Mr and Mrs Richard Kaufman
Mr and Mrs Robert Kiley
Mr and Mrs Peter Klimt
L A Tanner & Co, Inc
Tom and Lori Larsen
Mr Charles G Lubar
Mr and Mrs Michael Mackenzie
Mr and Mrs Bruce McLaren
Mr and Mrs Philip Mengel
Mike and Martha Pedersen

Carole Turner Record
Mr and Mrs K M Rubie
Mrs Sylvia B Scheuer
Mr and Mrs Thomas Schoch
Ellen and Dan Shapiro
John and Sheila Stoller
Mr and Mrs Julian Treger
Michael and Yvonne Uva
Mr and Mrs Santo Volpe
Mr and Mrs Nicholas Watkins
Mr and Mrs Jeffrey Weingarten
Mr and Mrs John D Winter
and others who wish to remain
anonymous

Collection Patrons Group
Gold Patrons
Mrs Helena Frost
The Leche Trust
The Leverhulme Trust
The Paul Mellon Centre for
 Studies in British Art

Silver Patrons
Heritage of London Trust Ltd

Bronze Patrons
Clothworkers' Foundation
Joseph Strong Frazer Trust
Richard and Odile Grogan
Mr and Mrs Graham Reddish
Mr and Mrs Marcus Setchell
Brian D Smith
and others who wish to remain
anonymous

Education Patrons Group
Gold Patrons
John Lyon's Charity
J P Morgan Fleming Foundation
The Mercer's Company
The Merrell Foundation
Robin Heller Moss
Pidem Fund
The Steel Charitable Trust

Silver Patrons
Austin & Hope Pilkington Trust
The Goldsmiths' Company Charities
The Kobler Trust
The Mulberry Trust
Mrs Jean Sainsbury

Bronze Patrons
Mrs Flavia de Grey
Sir Ewan and Lady Harper
The Millichope Foundation
The Peter Storrs Trust
and others who wish to remain
anonymous

Exhibitions Patrons Group
Chairman
Mrs John Burns

Gold Patrons
The 29th May 1961 Charitable
 Trust
Mrs B A Battersby
Mr and Mrs W E Bollinger
Alain and Marie Boublil
Ivor Braka
Mr and Mrs William Brake
Dr Christopher Brown
Lady Brown
Mr and Mrs John Burns
Mr Raymond M Burton CBE
Sir James and Lady Butler
C H K Charities Limited
Mr Lynn Chadwick CBE RA
David J and Jennifer A Cooke
The Dudley Dodd Charitable Trust
Mr and Mrs Patrick Doherty
Giuseppe Eskenazi
Mrs Eliana de Faria
Lawton Fitt
Mr and Mrs Robin Fleming
The Robert Gavron Charitable Trust
Jacqueline and Michael Gee
David and Maggi Gordon
Lady Gosling
Charles and Kaaren Hale
Mrs Sue Hammerson
Mrs Olivia Harrison
Lady E Hebdige
Mrs Gabrielle Jungels-Winkler
Mr and Mrs S Kahan
Mr and Mrs Donald P Kahn
Lady Kalms MBE
Mr and Mrs Joseph Karaviotis
The Kreitman Foundation

The Kirby Laing Foundation
EFG Private Bank Limited
Mr and Mrs Ronald Lubner
Fiona Mactaggart MP
John Madejski
Sir Denis Mahon CH CBE FBA
Professor and Mrs Anthony
 Mellows
Mr and Mrs Tom Montague Meyer
Paul and Alison Myners CBE
Mr Frederick Paulsen
P F Charitable Trust
The Rayne Foundation
Mr and Mrs Anthony Reeves
Mr John A Roberts FRIBA
Mrs Coral Samuel CBE
Mr and Mrs David Shalit
Mr and Mrs Clive Sherling
Mrs Roama Spears
Sir Anthony and Lady Tennant
Jane and Anthony Weldon
Roger and Jennifer Wingate
Mr and Mrs Ronald W Zeghibe
Mr and Mrs Michael Zilkha

Silver Patrons
Mr and Mrs Paul Baines
The Peter Boizot Foundation
Mrs Elie Brihi
Mr and Mrs Charles Brown
Mr and Mrs P G H Cadbury
Sir Charles and Lady Chadwyck-
 Healey
Sir Trevor and Lady Chinn
John C L Cox CBE
Stephen and Marion Cox
The de Laszlo Foundation
John and Tawna Farmer
Mr and Mrs Gerald Fogel
Mr and Mrs Jocelin Harris
Mrs Susan Hayden
The Headley Trust
Michael and Morven Heller
Mr and Mrs Alan Hobart
Mr and Mrs Jon Hunt
Mr and Mrs Fred Johnston
Sir Christopher and Lady Lewinton
Mr Jonathon E Lyons
R C Martin
Pamela and Jack Maxwell
Mr and Mrs D J Peacock
Mrs Jean Redman-Brown
Mrs Estefania Renaud
The Audrey Sacher Charitable Trust
Mrs Stella Shawzin
Mr and Mrs Richard Simmons
Sir James and Lady Spooner
Mrs Jonathan Todhunter
Mrs Linda M Williams
Mr and Dr Pierre Winkler

Bronze Patrons
Mr and Mrs Gerald Acher
Mrs Denise Adeane
Dr and Mrs M Alali
Mr Derrill Allatt
Mr Peter Allinson
Mrs Elizabeth Alston
The Rt Hon the Lord Ancram
Mr and Mrs Z Aram
Mrs Mashi Azmudeh
Jane Barker
Mrs Yvonne Barlow
Mrs Jill Barrington
Mr Stephen Barry
James M Bartos
The Duke of Beaufort
Mr and Mrs Simon Bentley
Mrs Sue Besser
Mrs Frederick Bienstock
Mr Mark Birley
Dame Elizabeth Blackadder
 OBE RSA RA
Sir Victor and Lady Blank
Mr Peter Bowring CBE
Mr and Mrs Michael Bradley
The Britto Foundation
Mr Jeremy Brown
Mrs Richard Burton
Mrs Alan Campbell-Johnson
Mr F A A Carnwath CBE
Jean and Eric Cass
The Marquise de Cérenville
Mrs Sue Hammerson
Mrs George Coelho
Carole and Neville Conrad
David J and Jennifer A Cooke
Mr and Mrs Sidney Corob
Tom Corrigan
Julian Darley and Helga
 Sands
The Countess of Dartmouth

Mr Keith Day and Mr Peter
 Sheppard
Mr and Mrs Hans de Gier
Peter and Kate De Haan
Anne Dell Provost
Lady de Rothschild
Dr Anne Dornhorst
Sir Philip Dowson PPRA
 and Lady Dowson
John Drummond FCSD Hon
 DES RCA
Mr and Mrs Maurice Dwek
Mr and Mrs D Dymond
Professor Dyson and Dr Anne
 Naylor
Mr and Mrs Nicholas Earles
Lord and Lady Egremont
Mr and Mrs Peter Ellis
Mr and Mrs John and Fausta
 Eskenazi
The Family Rich Charities Trust
Mary Fedden RA
Mr Bryan Ferry
Mrs Donatella Flick
Flying Colours Gallery
Mr and Mrs George Fokschaner
Lord and Lady Foley
Mr and Mrs Edwin H Fox
Mrs R M Fox
Mr Monty Freedman
Michael and Clara Freeman
A Fulton Company Limited
The Baron and Baroness of Fulwood
Jacqueline and Jonathan Gestetner
The David Gill Memorial Fund
Mr and Mrs Simon Gillespie
Patricia Glasswell
Michael Godbee
Mrs Alexia Goethe
Sir Nicholas and Lady Goodison's
 Charitable Settlement
Ms Angela Graham
Sir Ronald Grierson
Mr Roger Hatchell and Mrs Ira
 Kettner
David and Lesley Haynes
Sir Denys and Lady Henderson
Mrs Margarita Hernandez
Mr and Mrs Alan Hill
Russell and Gundula Hoban
Anne Holmes-Drewry
Sir Joseph Hotung
Mrs Sue Howes and Mr Greg
 Dyke
Mr and Mrs Allan Hughes
Mrs Pauline Hyde
Simone Hyman
Mr S Isern-Feliu
Ian and Barbara Jackson
Sir Martin and Lady Jacomb
Mr and Mrs Ian Jay
Harold and Valerie Joels
Mr D H Killick
Mr and Mrs James Kirkman
Joan H Lavender
Mr and Mrs Peter Leaver
Mr George Lengvari
The Lady Lever of Manchester
Colette and Peter Levy
Mrs Rosemarie Lieberman
Susan Linaker
Sir Sidney Lipworth QC and
 Lady Lipworth
Mrs Livingstone
Miss R Lomax-Simpson
Mr and Mrs Mark Loveday
Richard and Rose Luce
Mr and Mrs Henry Lumley
Mrs Marilyn Maklouf
Mr and Mrs Eskandar Maleki
Mr and Mrs Michael (RA) and
 José Manser
Mr Curt Marcus
Mr Marcus Margulies
Mr David Marks and Ms Nada
 Chelhot
The Lord Marks of Broughton
Marsh Christian Trust
Mr and Mrs Stephen Mather
Mr Brian Mayou and Dr Susan
 Mayou
Miss Jane McAusland
Mrs M C W McCann
Gillian McIntosh
Mr and Mrs Andrew McKinna
The Mercers' Company
Mrs Kathryn Michael
Mr Roy Miles
Mrs Alan Morgan
Mr and Mrs Carl Anton
 Muller

N Peal Cashmere
Mr and Mrs Nordby
Mr and Mrs Simon Oliver
Mrs Lale Orge
Mr Michael Palin
Mr Gerald Parkes
Mr Vasily Pasetchnik
John H Pattisson
Mrs Wendy Becker Payton
The Pennycress Trust
Mr Andrew S Perloff
Philip S Perry
John and Scheherazade
 Pesaute-Mullis
Mr David Pike
Mr Godfrey Pilkington
Mr and Mrs A Pitt-Rivers
Mr and Mrs William A Plapinger
John Porter Charitable Trust
Mr Ian M Poynton
Miss Victoria Provis
The Quercus Trust
John and Anne Raisman
Sir David and Lady Ramsbotham
Mr T H Reitman
The Roland Group of Companies
 Plc
Mr and Mrs Ian Rosenberg
Paul and Jill Ruddock
Lady (Robert) Sainsbury
Mr and Mrs Bryan Sanderson
Mr and Mrs Hugh Sassoon
Mr S Schaefer and Ms O Ma
The Schneer Foundation, Inc
Carol Sellars
Dr and Mrs Agustin Sevilla
Dr Lewis Sevitt
The Countess of Shaftesbury
Lord and Lady Colin Sharman
Mr and Mrs William Sieghart
P Simon
Alan and Marianna Simpson
Mr and Mrs Mark Franklin
 Slaughter
Mr and Mrs R W Strang
Mrs D Susman
The Swan Trust
Mr and Mrs David Swift
Mr John Tackaberry
Group Captain James B Tait
 and Irene Bridgmont
Mrs Mark Tapley
Mr and Mrs John D Taylor
Miss M L Ulfane
Valentino-Liliana Abboud
Visa Lloyds Bank Monte Carlo
Mrs Catherine Vlasto
Mrs Claire Vyner
Mr and Mrs Ludovic de Walden
John B Watton
The Hon Mrs Simon Weinstock
Edna and Willard Weiss
Mrs Hazel Westbury
Rachel and Anthony Williams
Mr Jeremy Willoughby OBE
The Rt Hon Lord and Lady Young
 of Graffham
and others who wish to remain
anonymous

Schools Patrons Group
Gold Patrons
Arts and Humanities Research
 Board
The Brown Foundation, Inc.,
 Houston
The Gilbert & Eileen Edgar
 Foundation
The Eranda Foundation
Mr and Mrs Jack Goldhill
The Headley Trust
Fiona Johnstone
The David Lean Foundation
The Leverhulme Trust
The Henry Moore Foundation
Newby Trust Limited
Edith and Ferdinand Porjes
 Charitable Trust
Paul Smith and Pauline Denyer
 Smith
The South Square Trust
The Starr Foundation
Sir Siegmund Warburg's Voluntary
 Settlement
The Harold Hyam Wingate
 Foundation

Silver Patrons
The Stanley Picker Trust
The Radcliffe Trust
The Celia Walker Art Foundation

Bronze Patrons
The Lord Aldington
The Candide Charitable Trust
The Charlotte Bonham-Carter
 Charitable Trust
Mr and Mrs Stephen Boyd
The Selina Chenevière Foundation
Denise Cohen Charitable Trust
Mr Simon Copsey
May Cristea Award
Keith and Pam Dawson
The Delfont Foundation
The Marchioness of Dufferin and
 Ava
Mr Alexander Duma
Mr Hani Farsi
Hirsh London
Ken and Dora Howard
The Lark Trust
Mrs Lore Lehmann
Mr John Martin
Claus and Susan Moehlmann
Miranda Page-Wood
N Peal Cashmere
The Worshipful Company of
 Painter-Stainers
Pickett
Peter Rice Esq
Mr and Mrs Anthony Salz
Mr and Mrs Robert Lee Sterling Jr
The Peter Storrs Trust
Mr and Mrs Denis Tinsley
and others who wish to remain
anonymous

General Benefactors
Gold
Mr and Mrs John Coombe
The Douglas Turner Trust
The Ingram Trust

Silver
Mrs Gary Brass
Mr and Mrs Eric Franck
Mrs S M Shrager

Bronze
Mrs Lily Cantor
Miss Jayne Edwardes
Sarah and Alastair Ross Goobey
Piers and Rosie Gough
Sally and Donald Main
Mr and Mrs Vincenzo Palladino
P H Holt Charitable Trust
and others who wish to remain
anonymous

**AMERICAN ASSOCIATES OF
THE ROYAL ACADEMY TRUST**

Major Benefactors
The Annenberg Foundation
Mr and Mrs Sid R Bass
The Brown Foundation Inc, Houston
The Drue Heinz Trust
Mr Edwin L Cox
Mr and Mrs Eugene V Fife
Mr Francis Finlay
Mrs Henry Ford II
The Horace W Goldsmith
 Foundation
Mr and Mrs Martin D Gruss
Ms Frances S Hayward
Mr and Mrs Donald P Kahn
Mrs Katherine K Lawrence
The Henry Luce Foundation
Mr and Mrs John L Marion
Mr and Mrs Jack C Massey
Mr Hamish Maxwell
Mr and Mrs George McFadden
The Estate of Paul Mellon KBE
Ms Diane A Nixon
Leon B Polsky and Cynthia Hazen
 Polsky
Mrs Arthur M Sackler
Mrs Louisa S Sarofim
Ms Kathleen D Smith
The Starr Foundation
Mr and Mrs Robert Lee Sterling Jr
Alfred Taubman
Mr and Mrs Vernon Taylor Jr
The Thaw Charitable Trust
The Honourable John C Whitehead
Mr and Mrs Frederick B
 Whittemore

Benefactors
Mr and Mrs Herbert S Adler
The Blackstone Group
Citigroup
Mr William Finneran

Mrs Melville Wakeman Hall
The Hon and Mrs William A Nitze
Ms Sandra Payson
Mr Thomas C Quick
Mr and Mrs William P Rayner
Mr and Mrs John R Robinson
Mrs Edmond J Safra
Sony Corporation of America
Dr and Mrs Robert D Wickham

Sponsors

Mrs George Abbott
Mrs Deborah Brice
Mrs Mildred C Brinn
Mrs Jan Cowles
Mr and Mrs Marvin Davidson
Lady Fairfax
Mr and Mrs Jonathan Farkas
Mrs Katherine D W Findlay
Mrs Eva G de Garza Laguera
Mr David Hockney RA
Mr James M Kemper Jr
Mr and Mrs William H Mann
Mrs John P McGrath
Mr David McKee
Mr and Mrs William Rayner
Arthur Ochs Sulzberger and
 Allison Stacey Cowles
Virgin Atlantic

Patrons

Ms Helen Harting Abell
Mr and Mrs Steven Ausnit
Mr and Mrs E William Aylward
Mr and Mrs Raphael Bernstein
Mr Donald A Best
Mr and Mrs Henry W Breyer III
Jane and Robert Carroll
Mr and Mrs Benjamin Coates
Ms Anne S Davidson
Ms Zita Davisson
Ambassador Enriquillo and
 Mrs Audrey Z del Rosario
Mrs Charles H Dyson
Mrs A Barlow Ferguson
Mrs Robert Ferst
Mr Richard E Ford
Mrs Raymond C Foster
The William Fox Jr Foundation
Mr and Mrs Lawrence S
 Friedland
Eleanor and Eugene Goldberg
Mrs Betty Gordon
Mrs David Granger
Mrs Rachel K Grody
Mrs Richard L Harris
Gurnee and Marjorie Hart
Mr Edward H Harte
Mr and Mrs Gustave M Hauser
Dr Bruce C Horten
Mr Robert J A Irwin
The Honorable and Mrs W Eugene
 Johnston
Mr William W Karatz
Mr and Mrs Stephen M Kellen
Mr and Mrs Gary A Kraut
Ambassador and Mrs Philip
 Lader
Mrs Kay Lawrence
Mr and Mrs William D Lese
William M and Sarah T Lese
 Family Fund
Mr Arthur L Loeb
Mrs Barbara T Missett
Mr Allen Model
Mrs Garett Moran
Mr and Mrs Paul S Morgan
Mr Paul D Myers
Mr and Mrs Wilson Nolen
Mrs Richard D O'Connor
Mr and Mrs Jeffrey Pettit
Mr Robert S Pirie
Dr and Mrs James S Reibel
Mrs Frances G Scaife
Ms Jan Scholes
Mr and Mrs Stanley DeForest
 Scott
Ms Georgia Shreve
Mr and Mrs Morton Sosland
Mrs Frederick M Stafford
Mr and Mrs Stephen Stamas
Mr Richard Steinwurtzel
Ms Brenda Neubauer Straus
Mrs Matilda Gray Stream
Elizabeth F Stribling
Mr Martin J Sullivan
Mrs Royce Deane Tate
Mrs Britt Tidelius
Mrs Richard Barclay Tullis
Ms Sue Erpf Van de Bovenkamp
Mrs William M Weaver Jr

Ms Deborah White
Mr and Mrs George White
Mrs Sara E White
Mr and Mrs Robert G Wilmers
Mr Robert W Wilson
*and others who wish to remain
anonymous*

**CORPORATE MEMBERSHIP OF
THE ROYAL ACADEMY OF ARTS**

Launched in 1988, the Royal
Academy's Corporate Membership
Scheme has proved highly
successful. Corporate membership
offers company benefits to staff
and clients and access to the
Academy's facilities and resources.
Each member pays an annual
subscription to be a Member
(£7,000) or Patron (£20,000).
Participating companies recognise
the importance of promoting the
visual arts. Their support is vital
to the continuing success of the
Academy.

**CORPORATE MEMBERSHIP
SCHEME**

Corporate Patrons

Ashurst Morris Crisp
Bloomberg LP
BNP Paribas
Deutsche Bank AG
Ernst and Young
GlaxoSmithKline plc
Granada plc
John Lewis Partnership
JPMorgan
Radisson Edwardian Hotels
Standard Chartered Bank

Corporate Members

Apax Partners Holding Ltd
Atos KPMG Consulting
Bear, Stearns International Ltd
The Boston Consulting Group
Bovis Lend Lease Limited
The British Land Company PLC
Bunzl plc
Cantor Fitzgerald
Capital International
CB Richard Ellis
Cedar Communications
Christie's
Chubb Insurance Company
 of Europe
Citigroup
CJA (Management Recruitment
 Consultants) Limited
Clifford Chance
Colefax and Fowler
Credit Agricole Indosuez
De Beers
Diageo plc
Eversheds
F&C Management plc
Fleming Family & Partners
GAM
Goldman Sachs International
Hay Group
Herdez Europa
Hewitt, Bacon and Woodrow
H J Heinz Company Limited
HSBC plc
King Sturge
KPMG
LECG
Man Group plc
Marks and Spencer
Mizuho International
Morgan Stanley
MoMart Ltd
Pearson plc
The Peninsular and Oriental Steam
 Navigation Company
Pentland Group plc
Raytheon Systems Limited
Reed Elsevier Group plc
The Royal Bank of Scotland
Schroders & Co
Sea Containers Ltd.
SG
Six Continents PLC
Skanska Construction Group
 Limited
Slaughter and May
The Royal Society of Chemistry
The Smith & Williamson Group
Trowers & Hamlins

Unilever UK Limited
Veolia Water
Watson Wyatt
Weil Gotschal & Manges
Yakult UK Limited
Zurich Financial Services

Honorary Corporate Patrons
ABN AMRO
DaimlerChrysler

Honorary Corporate Members
All Nippon Airways Co. Ltd
American Express
A.T. Kearney Limited
Epson (UK) Limited
London First
UBS Wealth Management

**SUPPORTERS OF PAST
EXHIBITIONS**

The President and Council of the
Royal Academy would like to thank
the following sponsors and
benefactors for their generous
support of major exhibitions during
the last ten years:

ABN AMRO
 *Masterpieces from Dresden,
 2003*
American Associates of the Royal
 Academy Trust
 *Illuminating the Renaissance:
 The Triumph of Flemish
 Manuscript Painting in Europe,
 2003
 The Art of Philip Guston
 (1913–1980), 2004*
American Express
 *Giorgio Armani: A
 Retrospective, 2003*
Allied Trust Bank
 *Africa: The Art of a Continent,
 1995**
Anglo American Corporation of
 South Africa
 *Africa: The Art of a Continent,
 1995**
A.T. Kearney
 *231st Summer Exhibition, 1999
 232nd Summer Exhibition,
 2000
 233rd Summer Exhibition, 2001
 234th Summer Exhibition, 2002
 235th Summer Exhibition, 2003*
The Banque Indosuez Group
 *Pissarro: The Impressionist
 and the City, 1993*
Barclays
 *Ingres to Matisse: Masterpieces
 of French Painting, 2001*
BBC Radio 3
 *Paris: Capital of the Arts
 1900–1968, 2001*
BMW (GB) Limited
 *Georges Rouault: The Early
 Years, 1903–1920, 1993
 David Hockney: A Drawing
 Retrospective, 1995**
British Airways Plc
 *Africa: The Art of a Continent,
 1995*
British American Tobacco
 Aztecs, 2002
Cantor Fitzgerald
 *From Manet to Gauguin:
 Masterpieces from Swiss
 Private Collections, 1995
 1900: Art at the Crossroads,
 2000*
The Capital Group Companies
 *Drawings from the J Paul Getty
 Museum, 1993*
Chase Fleming Asset Management
 *The Scottish Colourists
 1900–1930, 2000*
Chilstone Garden Ornaments
 *The Palladian Revival: Lord
 Burlington and His House and
 Garden at Chiswick, 1995*
Christie's
 *Frederic Leighton 1830–1896,
 1996
 Sensation: Young British Artists
 from The Saatchi Collection,
 1997
 Pre-Raphaelite and Other
 Masters: The Andrew Lloyd
 Webber Collection, 2003*

Classic FM
 *Goya: Truth and Fantasy,
 The Small Paintings, 1994
 The Glory of Venice: Art in
 the Eighteenth Century, 1994
 Masters of Colour: Derain to
 Kandinsky. Masterpieces from
 The Merzbacher Collection,
 2002
 Masterpieces from Dresden,
 2003
 Pre-Raphaelite and Other
 Masters: The Andrew Lloyd
 Webber Collection, 2003*
Corporation of London
 Living Bridges, 1996
Country Life
 *John Soane, Architect: Master
 of Space and Light, 1999*
Credit Suisse First Boston
 *The Genius of Rome 1592–1623,
 2000*
The Daily Telegraph
 *American Art in the 20th
 Century, 1993
 1900: Art at the Crossroads,
 2000*
De Beers
 *Africa: The Art of a Continent,
 1995*
Debenhams Retail plc
 *Premiums and RA Schools
 Show, 1999
 Premiums and RA Schools
 Show, 2000
 Premiums and RA Schools
 Show, 2001
 Premiums and RA Schools
 Show, 2002*
Deutsche Morgan Grenfell
 *Africa: The Art of a Continent,
 1995*
Diageo plc
 230th Summer Exhibition, 1998
The Drue Heinz Trust
 *The Palladian Revival: Lord
 Burlington and His House and
 Garden at Chiswick, 1995
 Denys Lasdun, 1997
 Tadao Ando: Master
 of Minimalism, 1998*
The Dupont Company
 *American Art in the 20th
 Century, 1993*
Ernst & Young
 Monet in the 20th Century, 1999
Eyestorm
 *Apocalypse: Beauty and Horror
 in Contemporary Art, 2000*
Fidelity Foundation
 *The Dawn of the Floating World
 (1650–1765). Early Ukiyo-e
 Treasures from the Museum
 of Fine Arts, Boston, 2001*
Friends of the Royal Academy
 Victorian Fairy Painting, 1997
Game International Limited
 *Forty Years in Print: The Curwen
 Studio and Royal Academicians,
 2001*
The Jacqueline and Michael Gee
 Charitable Trust
 *LIFE? or THEATRE? The Work
 of Charlotte Salomon, 1999*
Générale des Eaux Group
 Living Bridges, 1996
Glaxo Wellcome plc
 *The Unknown Modigliani,
 1994*
Goldman Sachs International
 *Alberto Giacometti, 1901–1966,
 1996
 Picasso: Painter and Sculptor
 in Clay, 1998*
The Guardian
 The Unknown Modigliani, 1994
Guinness PLC (see Diageo plc)
 *225th Summer Exhibition, 1993
 226th Summer Exhibition, 1994
 227th Summer Exhibition, 1995
 228th Summer Exhibition, 1996
 229th Summer Exhibition, 1997*
Harpers & Queen
 *Georges Rouault: The Early
 Years, 1903–1920, 1993
 Sandra Blow, 1994
 David Hockney: A Drawing
 Retrospective, 1995**
 Roger de Grey, 1996*
The Headley Trust
 Denys Lasdun, 1997

The Henry Moore Foundation
 *Africa: The Art of a Continent,
 1995*
Ibstock Building Products Ltd
 *John Soane, Architect: Master
 of Space and Light, 1999*
The Independent
 *Living Bridges, 1996
 Apocalypse: Beauty and Horror
 in Contemporary Art, 2000*
International Asset Management
 *Frank Auerbach, Paintings and
 Drawings 1954–2001, 2001*
Donald and Jeanne Kahn
 John Hoyland, 1999
Land Securities PLC
 Denys Lasdun, 1997
The Mail on Sunday
 *Royal Academy Summer
 Season, 1993*
Marks & Spencer
 *Royal Academy Schools
 Premiums, 1994
 Royal Academy Schools
 Final Year Show, 1994**
Martini & Rossi Ltd
 *The Great Age of British
 Watercolours, 1750–1880,
 1993*
Paul Mellon KBE
 *The Great Age of British
 Watercolours, 1750–1880,
 1993*
Mercedes-Benz
 *Giorgio Armani:
 A Retrospective, 2003*
Merrill Lynch
 *American Art in the 20th
 Century, 1993**
 *Paris: Capital of the Arts
 1900–1968, 2001*
Mexico Tourism Board
 Aztecs, 2002
Midland Bank plc
 *RA Outreach Programme,
 1993–1996
 Lessons in Life, 1994*
Minorco
 *Africa: The Art of a Continent,
 1995*
Natwest Group
 *Nicolas Poussin 1594–1665,
 1995*
The Nippon Foundation
 *Hiroshige: Images of Mist, Rain,
 Moon and Snow, 1997*
Peterborough United Football Club
 *Art Treasures of England:
 The Regional Collections, 1997*
Pemex
 Aztecs, 2002
Premiercare (National Westminster
 Insurance Services)
 *Roger de Grey, 1996**
RA Exhibition Patrons Group
 *Chagall: Love and the Stage,
 1998
 Kandinsky, 1999
 Chardin 1699–1779, 2000
 Botticelli's Dante: The Drawings
 for Dante's Divine Comedy, 2001
 Return of the Buddha: The
 Qingzhou Discoveries, 2002
 Ernst Ludwig Kirchner: The
 Dresden and Berlin Years, 2003
 Vuillard: From Post-
 Impressionist to Modern
 Master, 2004*
Reed Elsevier plc
 *Van Dyck 1599–1641, 1999
 Rembrandt's Women, 2001*
The Royal Bank of Scotland
 *Braque: The Late Works, 1997**
 *Premiums, 1997
 Premiums, 1998
 Premiums, 1999
 Royal Academy Schools
 Final Year Show, 1996
 Royal Academy Schools
 Final Year Show, 1997
 Royal Academy Schools
 Final Year Show, 1998*
Virginia and Simon Robertson
 *Aztecs, 2002
 Illuminating the Renaissance:
 The Triumph of Flemish
 Manuscript Painting in Europe,
 2003*
The Sara Lee Foundation
 *Odilon Redon: Dreams and
 Visions, 1995*

Sea Containers Ltd
 *The Glory of Venice: Art in the
 Eighteenth Century, 1994*
Silhouette Eyewear
 *Sandra Blow, 1994
 Africa: The Art of a Continent,
 1995*
Société Générale, UK
 *Gustave Caillebotte: The
 Unknown Impressionist, 1996**
Société Générale de Belgique
 *Impressionism to Symbolism:
 The Belgian Avant-garde
 1880–1900, 1994*
Thames Water Plc
 *Thames Water Habitable Bridge
 Competition, 1996*
The Times
 *Drawings from the J Paul Getty
 Museum, 1993
 Goya: Truth and Fantasy,
 The Small Paintings, 1994
 Africa: The Art of a Continent,
 1995*
Time Out
 *Sensation: Young British Artists
 from The Saatchi Collection,
 1997
 Apocalypse: Beauty and Horror
 in Contemporary Art, 2000*
Tractabel
 *Impressionism to Symbolism:
 The Belgian Avant-garde
 1880–1900, 1994*
UBS Wealth Management
 *Pre-Raphaelite and Other
 Masters: The Andrew Lloyd
 Webber Collection, 2003*
Union Minière
 *Impressionism to Symbolism:
 The Belgian Avant-garde
 1880–1900, 1994*
Walker Morris
 *Premiums, 2003
 Royal Academy Schools
 Final Year Show, 2003*
Yakult UK Ltd
 *RA Outreach Programme,
 1997–2002**
 *alive: Life Drawings from the
 Royal Academy of Arts & Yakult
 Outreach Programme*

**Recipients of a Pairing Scheme
Award, managed by Arts +
Business. Arts + Business is funded
by the Arts Council of England and
the Department for Culture, Media
and Sport.*

OTHER SPONSORS

Sponsors of events, publications
and other items in the past five
years:

Carlisle Group plc
Country Life
Derwent Valley Holdings plc
Dresdner Kleinwort Wasserstein
Fidelity Foundation
Foster and Partners
Goldman Sachs International
Gome International
Gucci Group
Rob van Helden
IBJ International plc
John Doyle Construction
Martin Krajewski
Marks & Spencer
Michael Hopkins & Partners
Morgan Stanley Dean Witter
Prada
Radisson Edwardian Hotels
Richard and Ruth Rogers
Strutt & Parker